ART ABOUT ART

Roy Lichtenstein's cover, which he designed for this book, is related to his recent series of paintings about Surrealism. It refers directly to one of his series of *Stretcher Frames* (done in 1968) that has been peeled away from the actual stretcher to reveal a surrealist scene. The landscape features a biomorphic shape and a floating eye which refers to his comic-strip *Crying Girl* paintings of 1963-64, but the teardrop has been transformed into surreal lips.

Jean Lipman was Editor of *Art in America* magazine for thirty years, then Editor of Publications at the Whitney Museum of American Art. She is the author of more than a hundred articles and a dozen books on various aspects of American art. Her most recent publications are *The Flowering of American Folk Art* (with Alice Winchester), *Bright Stars* (with Helen M. Franc), and *Calder's Universe.*

Richard Marshall is Assistant Curator of Exhibitions at the Whitney Museum of American Art. He has organized numerous exhibitions of American art, including *Clay, Maps by Contemporary Artists, Robert Irwin,* and *Calder's Universe* (with Jean Lipman).

Leo Steinberg is Benjamin Franklin Professor of the History of Art at the University of Pennsylvania. He is the author of *Other Criteria: Confrontations with Twentieth-Century Art, Michelangelo's Last Paintings,* and *Borromini's San Carlo alle quattro Fontane: A Study in Multiple Form and Architectural Symbolism.* He is also the author of numerous articles on subjects ranging from Leonardo da Vinci to Picasso.

ART ABOUT ART

Jean Lipman and Richard Marshall

Introduction by Leo Steinberg

 A Dutton Paperback

E. P. DUTTON · NEW YORK
in association with the
WHITNEY MUSEUM OF AMERICAN ART

This book was published on the occasion of an exhibition held at the Whitney Museum of American Art, New York, July 19–September 24, 1978; and shown the following year on a cross-country museum tour.

The authors, Jean Lipman and Richard Marshall, were assisted by Whitney Museum Intern Elaine Norkus. The publisher and authors wish to thank the museums, galleries, collectors, and photographers who supplied photographs for this book. Special thanks are due to Tom Armstrong, Director of the Whitney Museum; Margaret Aspinwall, Editor, Whitney Museum; Cyril I. Nelson, editor of Dutton Paperbacks; and Roy Lichtenstein for the cover design.

EXHIBITION SCHEDULE

Whitney Museum of American Art
New York, New York
July 19 –September 24, 1978

North Carolina Museum of Art
Raleigh, North Carolina
October 15 –November 26, 1978

The Frederick S. Wight Art Gallery
University of California, Los Angeles
December 17, 1978 –February 11, 1979

Portland Art Museum
Portland, Oregon
March 6 –April 15, 1979

CONTENTS

PREFACE

Since mid-century there has been an increasing number of works by contemporary American artists that take as their subject other art. This book and the exhibition that it accompanies present, for the first time, an isolated and in-depth survey of this phenomenon, which is noticeably gathering momentum.

Throughout art history artists have been borrowing from other art; however the American artists' use of previous art is characterized by certain unique factors. They are interested, in various ways and on many levels, in the materials and techniques of art and the styles and major figures of the history of art. The content or style, or both, of earlier works of art has been integrated into new works that comment, critically or satirically, on the art that provided the point of departure. It is the contemporary American artist's obvious practice, however, to make the borrowed art a recognizable, even blatant, element of the composition.

The art-about-art theme seems to be a pervasive ingredient of much of recent American art. It is a strong and important trend that has a large number of adherents; many of the major American artists of the last twenty-five years have made the subject of art central to their work. A number of artists first explored this area, and subsequently concentrated on this theme, at the onset of the Pop movement in the early 1960s. Pop's advocacy of the use of popular images, symbols, and visual clichés made art history a prime target. In fact, Richard Hamilton's prophetic collage of 1956, *Just What Is It That Makes Today's Homes So Different, So Appealing?*, often cited as the progenitor of all Pop imagery, contains a framed art reproduction in a cliché-ridden interior.

Many curators, critics, and artists have written about individual examples in relation to one artist's total body of work or dealt with it as an isolated occurrence; but perhaps because this trend involves such a wide variety of attitudes, styles, media, and scale, it has not been commented on as being a whole consistent area of interest.

A great many artists have devoted their entire careers to the art-about-art subject, or made it a focal concern. For this book, hundreds of examples of appropriate works were considered for possible inclusion, and the examples chosen reflect simply a broad cross section of available pieces. The works reproduced here were divided into five categories: About the Artist, About Old Masters, About Modern Masters, About Early American Art, About Recent American Art. The divisions allow the viewer to become aware of which American artists are interested in this theme, how they manifest their interest, and also what previous artists and specific works serve as favored source material. (Small reproductions of source works are included when they seem needed to clarify or dramatize the featured new versions.) Some possible aspects of the subject have inevitably been omitted. The need to select the strongest, most representative examples, and the ones that best reflect this trend as a whole, made it reasonable to omit less dominant, generalized areas such as art about architecture, about crafts, about classical antiquity, about decorative styles. There are relatively few examples in these categories, and they appear to be of less interest to artists.

Because the habit of utilizing previous art is not, in any way, a uniquely American phenomenon, we asked the art historian Leo Steinberg to contribute an introductory essay dealing with historical European examples of art that borrowed from other art. His fascinating and scholarly essay describes how and why previous generations borrowed from earlier art. It also clarifies, by providing comparison with the American examples presented in the body of the book, the distinct features that characterize the American artists' continuation of this age-old practice.

The reasons that artists, American and European, borrow from other art are multiple and varied. Basically, art is always about art, and art history is a cumulative progression of what has come before. Artists, because of their obvious interest in and knowledge of art, draw on this knowledge and familiarity as readily as they draw on other experience. An artist may reuse

existing images, along with other elements, because they are available and suitable; and because they may give the borrower and the newly formed work a place within the ongoing history of art. Robert Motherwell emphasized the importance and value of previous art in a broader sense when he said: "Every intelligent painter carries the whole culture of modern painting in his head. It is his real subject, of which everything he paints is both an homage and a critique." (*The New York Times,* June 19, 1977)

There are some major characteristics that distinguish the utilization of earlier art by contemporary American artists from that of previous generations. The American borrowings are direct and undisguised, reflect a reliance on and interest in art reproductions and photographic reproduction processes, and often display impudent humor, satire, and parody. As the examples illustrate, American artists are totally frank about their obvious usage of earlier works or of details from their own work. Rather than camouflage a borrowed element in the total composition, and so obliterate any reference to its originator, the contemporary artist boldly uses the most recognizable quotations. He deliberately encourages the viewer to participate in discovering the genesis of the work.

There is clearly an expanded awareness of and interest in art history on the part of artists during the last decades. With art history as their subject, American artists have paraphrased, excerpted, and anthologized other art in numerous styles and forms. There also seems to be an ambivalent attitude toward the historical art—it is newly presented with either admiration or irreverence, or often both.

The emergence about 1950 of this direction in American art suggests some possible theories. Since Revolutionary times, American artists have been evolving toward a freedom from Old World traditions—wanting to shed old precedents, examples, and controls. However, most eighteenth- and nineteenth-century American artists still looked to Europe for stylistic guidance. It was actually not until the second quarter of the twentieth century that American artists began to establish confident artistic independence. Having achieved this independence, they felt free to turn to European art with fresh interest and the assurance to boldly reinterpret the traditional historic sources. While the history of art was thoroughly entrenched in the cultural atmosphere abroad, in America it could now be seen as something new, removed, nonthreatening, and challenging. The attitudes of Pop art, surfacing in the late 1950s and early 1960s, demystified the famous works of art history and bolstered the American artists' confidence in adapting the European masters to reflect the American experience. And more recently, the Super Realists' concentration on the exact duplication in paint of a photographic image evidently made it a challenge to re-create accepted masterpiece paintings in an equally difficult but totally new style.

Concurrent with the strengthening of American art at mid-century was the increase of media coverage of the arts, and mass production and dissemination of art reproductions. The American artists' use of color reproductions as the subject for their art is clearly significant. Quite often the artist emphasizes that it is the reproduction that he is re-creating, rather than, as in past art-about-art, the original work that served as the subject. Several of the foremost art-about-art proponents include on the canvas the reproduction's white border, emphasizing the flatness of the reproduction and, in effect, depicting an illusionistic rendering of a piece of printed paper. Not only do the visual characteristics of a color reproduction become of prime concern, but the actual processes and techniques of printing become the basis of the artist's style. As a result, some of the strongest and most original art-about-art works interpret not only the reproduced image but the technique, taking as their subject a printed reproduction of an artwork and executing it in a technique derived from photographic printing processes.

The idea of creatively reinventing acknowledged masterpieces from ordinary color reproductions is a high-risk challenge that contemporary artists seem to welcome. There is also a new predilection for objectivity on the part of the artist—at the opposite pole from Abstract Expressionism, the representational art-about-art works are objective in a quite literal sense: the source art reproduction is the object. This new style relates to many artists' current concern with technology, process, transformation, and to popular media and mass-audience interests. It is, however, far from simplistic—it presents a provocative paradox and a challenging ambiguity, which is to be resolved by the observer who is offered conceptual re-presentations of familiar representational art that is devoid of its previous connotations and references.

THE GLORIOUS COMPANY

Leo Steinberg

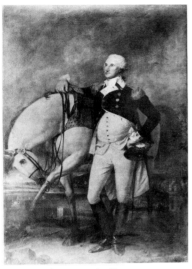

Fig. 1. John Trumbull.
Portrait of General Washington,
1790. Oil on canvas.
City Hall, New York.

Fig. 2. Robert Strange after
Van Dyck. *Portrait of King
Charles I,* 1782. Engraving.
The Metropolitan Museum of Art,
New York; Bequest of
Miss Susan Dwight Bliss.

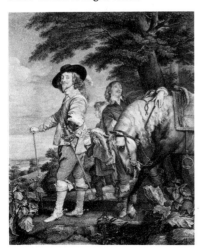

I. RUSTLING

The City Fathers who in 1790 commissioned an official portrait of General Washington for New York's City Hall wanted a true-to-life likeness and were confident they would get it (fig. 1). No one was better qualified to execute the commission than Colonel John Trumbull, aged thirty-four, a soldier turned painter, foremost documentary artist of the American Revolution and a recent guest at Mount Vernon.[1] The picture promised to be a likeness taken, if not from the life, at least from vivid personal recollection, and City Hall's national icon would be—like paintings of the Madonna attributed to St. Luke—a firsthand record of the sitter's figure and stance. But what about the General's horse?

The question is not entirely frivolous because the answer is interesting. A milk white steed may have issued from the President's stable, but its careful posture—left knee gently raised towards a velvet mouth—belongs to the dapple-gray in Van Dyck's famous portrait of King Charles I, a work engraved just eight years before (fig. 2). The derivation is unmistakable, and is confirmed by Trumbull's awkward handling of the hindquarters, for which the truncated model offered no guide.[2]

But Trumbull took more than half a horse from his predecessor. It was the very principle of appropriation which he emulated, for whether he knew it or not, the hunter behind Van Dyck's dismounted king was already a steal. During his travels in Italy—looking, as painters do, avidly at other paintings—the great Fleming had been struck by the careful posture of a certain white horse, the mount of the elder king in Titian's *Adoration of the Magi*—its left knee gently raised towards a velvet mouth (fig. 3). Van Dyck recorded the royal horse in his sketchbook and, in due time (encouraged by similar adaptations in Rubens), quartered it behind his own patron. No dishonor to be lifting from Titian; the less so since Titian was not the horse's original owner. As Oskar Fischel discovered in 1917, the canny Venetian had found his motif on an ancient gem (fig. 4), an oval carnelian bearing the image of a lone courser, its left knee gently raised . . . and so on. Did the anonymous gemcutter use his invention or a purloined design? Given the nature of the game, it seems probable that he filched. But either he or his precursor devised the mouth-to-knee contact as a way of adjusting the equine profile to its surround.[3]

Titian's monumentalization of the motif is a masterstroke. The horse in his *Adoration* shines in mid-foreground, destined for the first glance. Yet so far from upstaging the sacred characters of the drama, it initiates the theme of solemn reverence. As Ti-

8

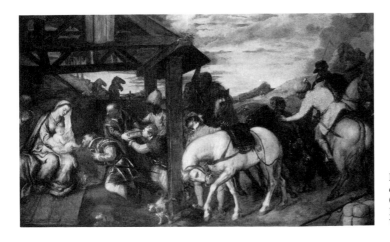

Fig. 3. Titian. *Adoration
of the Magi*, c. 1560.
Oil on canvas. The Cleveland
Museum of Art; Mr. and Mrs.
William H. Marlatt Fund.

tian stages the action, animal nature in its finest manifestation is
implicated in the event. For if the ox and the ass (as Isaiah says)
know their master—which accounts for their devout attendance
in painted Nativities—then the noble horse knows for sure. Ob-
serve how its deferential bow contrasts with the misconduct of
the adjacent cur! And was it not, perhaps, the pathos of the ani-
mal neck bowed in the presence of majesty that commended the
pose to Van Dyck? In his portrait of the proud Stuart king, the
inclination of the horse's head serves again to diffuse the theme
of obeisance into the regal ambience. Bending low, Van Dyck's
horse abdicates its own summit, leaving the king's head in chief,
the monarchical grandeur unmatched even by the height of a
magnificent charger—a pressing consideration seeing that His
Royal Highness was somewhat short.

But General Washington had no such problem, and Trumbull's
reasons for assigning the curtsey due to an English king to the
founder of the Republic are unascertainable. He could have had
several motives, conscious or otherwise. The possibilities, the-
oretically, run from want of invention and labor saving (why re-
invent an already existing device?) to an elaborate symbolism of
supercession.[4] Or else—my preferred explanation—the painter, in
"borrowing" from Van Dyck, realized a subliminal aspiration to
become part of a chain, to join and prolong the historic relay
from Antiquity, through Renaissance and Baroque, to Revolu-
tionary America; suing for membership in that glorious com-
pany of horsethieves which is the performing cast of the history
of art.

The case is common enough to suggest some aphoristic conclu-
sions. For instance: Whatever else art is good for, its chief effec-
tiveness lies in propagating more art. Or: Of all the things art has
an impact on, art is the most susceptible and responsive. All art
is infested by other art.

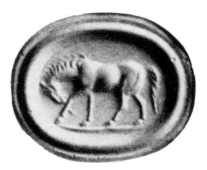

Fig. 4. Antique carnelian.
Berlin. (Reproduced
from Fischel, fig. 14.)

But these are commonplaces; and the wording is unsatisfactory.
What sense is there in investing "Art" with the momentum of a
personification, or a virulent plague? We are strangely careless
in mythifying our subject; as when (following German usage) we
speak of "migrating motifs"—*Wanderungen eines Motivs*—as if
the motif itself had the wanderlust and the itch to shift from one
work to another. Let me rephrase, this time with emphasis on the
doers: In their traffic with art, artists employ preformed images

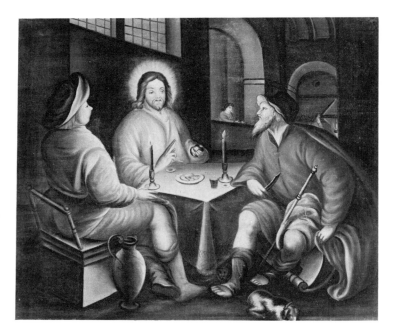

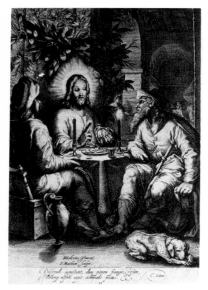

as they employ whatever else feeds into work. Between their experience of nature and their experience of other art they allow no functional difference. Foraging where they live—that is to say, among precedents—they exploit their environment and, like all living organisms, avail themselves. Hence the recycling observable in all art fresh or stale, the perennial recirculation of recognizable antecedents and, consequently, at the receiving end, those triumphs of recognition that constitute the emotional life of your art historian.

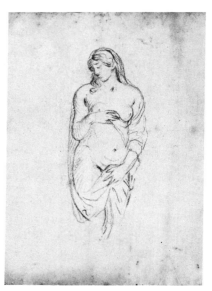

II. THE STAINLESS STEAL

Thumbing a catalogue of early American paintings at the Albany Institute of History and Art, the historian stops short at a *Christ at Emmaus*: Painter anonymous, first quarter of the eighteenth century (fig. 5).[5] According to the catalogue entry, "the head of Christ looks as if it may have come from an engraving." And so it does; and not only the head of Christ but the whole system, down to the cat under the table. All but the oblong format and the maladroit window paning is transposed from a Goltzius design engraved by Jacob Matham, who died in 1631 (fig. 6). The modest Colonial limner—some may feel that his bloated shapes improve on the model—would probably not have tackled such a complex three-dimensional set without a pattern to follow.

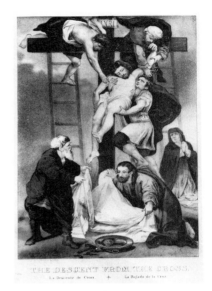

Stop next at plate 6b in the catalogue of *Drawings by Benjamin West* at the Morgan Library (compiled by Ruth S. Kraemer, 1975)—a black chalk drawing of a half-draped female nude (fig. 7).[6] The figure is posed to recall the antique "Modest Venus," the *Venus Pudica* whom everyone knows. But it surprises us to discover that the drawing is a faithful transcription of the bashful Eve in Bronzino's *Descent into Limbo* at S. Croce in Florence (fig. 8). West may or may not have made the sketch for use in a projected narrative composition—one suspects that Bronzino's nude caught his attention as a lesson in adaptability. For Bronzino had inducted a freestanding effigy into a crowd, and diverted it from a pagan context into a Christian. And West, in transcribing Bronzino's pudicity symbol, in arrogating an already reworked convention to his own use, would have felt, no less than his pupil John Trumbull, like one entering upon an inheritance.

Fig. 9. Currier and Ives. *Descent from the Cross*. Hand-colored lithograph.

One more example: The long forgotten output of religious prints published by Currier and Ives includes a *Descent from the Cross* (fig. 9)—a composition distilled from Daniele da Volterra's altarpiece in S. Trinità dei Monti, Rome (fig. 10).[7] The legend given in English, Spanish, and French suggests that the American lithograph was produced for a Catholic market. And either because that market was held to be somewhat unskilled in the reading of images, or because the artist himself was unequal, or inimical, to the complexity of his model, the Currier and Ives version has become a reader's digest, reversed and drastically simplified. The press of figures is eased, reduced from sixteen to seven, the number of ladders brought down to three. The half-clad youth reaching over from a right-hand ladder in the original composition has been supressed, the huge gap left by his disappearance being acknowledged (in the upper left of the lithograph) by one feeble extremity, a leg lamely appended to the bare-shouldered figure beetling over the transverse beam of the cross. That this leg falls on the wrong side of the ladder is an absurdity which the artist hoped no one would notice.

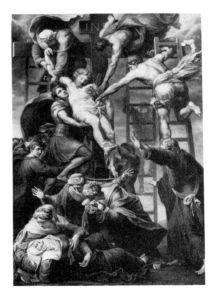

Fig. 10. Unidentified nineteenth-century engraver after Daniele da Volterra. *Descent from the Cross*.

But more was involved than ineptitude in simplification, for the attitude of our copyist is positively derogatory. He must have asked himself: Why so much noisy gesticulation when there's work to be done? Why so many more figures than you can

Fig. 11. Jean de Court. *Faith.*
Enamel and copper plaque.
The Metropolitan Museum of Art,
New York; Robert Lehman
Collection.

Fig. 12. Jacob Matham after
Goltzius. *Faith.*
Engraving, Bartsch III, 264.

count? Why all those extras in dimming space pockets when the action can be rendered more legibly in silhouette? And why the imbalance? Daniele's cross is off-center, and a preponderance of figures weights the composition heavily to one side; better to center the cross and gain equilibrium. And then, finally, the swooning Madonna. In Daniele's altarpiece she falls backward with parted limbs, recumbent, immense, a giantess supplanting two-thirds of the ground. Screened by three women attendants, her throes surely allude to the poignant metaphor of Mary-Ecclesia, her perpetual parturition, laboring at the foot of the cross as she gives birth to the mystic body of Christ which is the Church.[8]

Needless to say, such arcana would have struck the Currier and Ives lithographer as outlandish—and as unseemly in a picture designed for the home. Accordingly, in his revision, Daniele's grief-stricken women are replaced by two men of a practical turn; the corpse will have to be washed and the utensils must be got ready. The Virgin, meanwhile, recedes to a decorous distance, permitted to wring her hands as befits a party bereaved, but without that forced union of mystic and robust physicality so offensive to advanced taste. The Currier and Ives artist did indeed copy the Renaissance composition, but he copied to set it right.

There is nothing peculiarly American, nor suspiciously un-American, in the propensity to look abroad for importable goods. Everyone does it. And the spotting of imported items requires little more than a superabundance of comparative images at one's elbow; as the late Erwin Panofsky defined the art-historical enterprise, "He who has the most photographs wins." I adduce three more examples.[9]

12

Fig. 13. Frontispiece to von Muralt's *Kinder Büchlein,* Zurich, 1689. Woodcut. New York Academy of Medicine Library.

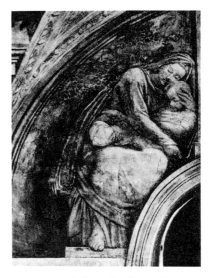

Fig. 14. Michelangelo. *Booz.* Fresco. Sistine Chapel, The Vatican.

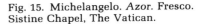

Fig. 15. Michelangelo. *Azor.* Fresco. Sistine Chapel, The Vatican.

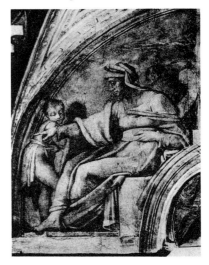

The 1959 catalogue of the Lehman Collection reproduces a sixteenth-century enamel plaque showing an allegorical figure of Faith; which the catalogue (on the strength of the initials IDC) attributes to Jean de Court, with a consequent date "about 1550–1575" (fig. 11). But neither date nor attribution can be correct, since the image is carefully copied from a Dutch print (fig. 12), an engraving once again by Jacob Matham, who in 1575 was only four. (The work may be by Jean de Court's less illustrious son of the same name, documented at Limoges from 1580 to 1617.)

Turn next to an early obstetrical handbook, von Muralt's *Kinder Büchlein,* published in Zurich in 1689. Its frontispiece, signed "Joh. Meyer fecit," presents a three-generation family scene (fig. 13): a young mother hugging a swaddled child, a grandam pointing and, like a St. Joseph capping a Holy Family with St. Anne, a bearded man, presumably Aesculapius, with a physician's caduceus at his shoulder. He looks gauche enough to be new; but the women, being drafted from two separate Ancestor lunettes of the Sistine Ceiling (figs. 14, 15), are old acquaintance.[10]

Or consider the little sketch of a youth preparing to draw by George Morland (English, 1763–1804; fig. 16): would you honestly doubt that it was drawn straight from life? And after seeing Stefano Della Bella's etching (fig. 17), can you doubt that it was drawn from the print? At the same time, can you resist admiring the grace of the translation? Morland made use of his model much as Jasper Johns used the American flag—because (as Johns put it) he didn't have to design it, leaving him free to work on other levels. The difference being that the design of the Stars and

13

Fig. 16. George Morland.
The Artist in a Landscape.
Ink and wash on paper. Collection
of Mrs. Stephen Ruddy, Jr.,
Southampton, New York.

Stripes in a Johns remains in full evidence, whereas Morland's
somewhat obscurer source is submerged.

III. THE COVER-UP

Uncovering Morland's source in Della Bella, we strip his draw-
ing of the disguise of being (in Cézanne's phrase) "a piece of na-
ture," the direct analogue of an observed appearance; and we
restore the work to where it belongs. It becomes again what it
was in its genesis, art out of art—art modified by fresh observa-
tion (as in the boy's updated footwear), but out of art nonethe-
less. Nor do we feel disappointment at the disclosure, rather a
certain pleasure. And we take pleasure not, I think, because one
more looter has been caught *in flagrante delicto* (as if the store-
house of art were a cookie jar in which every practitioner keeps
guilty fingers), but because, in locating the artist's source, we are
made privy to some part of his process. No longer outsiders, we
become, in some measure, initiates. I do not mean that each eso-
teric source for each work must be known to permit an insider's
approach; but rather that the genetic principle underlying the
operation should be assumed and welcomed in each confirma-
tion; the purpose being not merely to inventory the loot, but to
isolate the new from the antecedent that's being modified. For
the difference between the outsider's and the insider's percep-

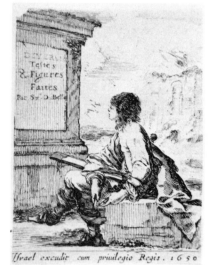

Fig. 17. Stefano Della Bella.
Titlepage to *Diverses Testes &*
Figures, Rome, 1650. Etching,
de Vesme, 308.

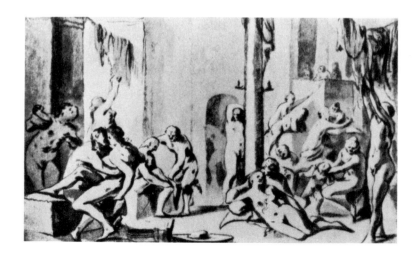

Fig. 18. Anonymous seventeenth-
century artist. *Interior*
with Nude Figures. Sepia drawing.
Location unknown.

tion of art comes down to this: that the insider recognizes an image as being first of all, in one way or another, a modification of foregone art; whereas you tell the outsider from his anxiety to relate art at once to the phenomenal world and the realm of experience, to see the image as an immediate response to its ostensible subject—to imagine, in other words, that Morland drew his young draftsman from life.

But don't blame the outsider; he is merely following alternative clues. The blame rests on the artists. It is they who traditionally—before the catastrophic unmasking performed by twentieth-century art—covered up what they were doing. It was their thing to deliver quotations as if they were improvised, to incorporate borrowed goods with their own, to naturalize every immigrant presence as if it were native, making the most studied rehearsal of previous art emerge like a novelty, a first glimpse. They were terribly good at it; and only occasionally, like classical actors addressing asides to the audience, would they let us in on the act, promoting us to the dignity of accomplices.

A case in point. On my desk lies a seedy paperback called *Love's Picture Book* (Veta Publishers, Copenhagen, 1963), subtitled "The History of pleasure and moral indignation from the days of classic Greece until the French Revolution." The book sweeps up assorted erotica and teeters towards pornography, captions abetting. One of the pictures, an anonymous seventeenth-century sepia drawing, represents a spacious interior with nudes of both sexes at play. The legend under it reads: "Life in a bathhouse . . . A Picture of love-making in public so common at that time" (fig. 18). Isn't it thrilling: in public, and common too. But relax, it is only art. Comes your spoilsport with his bagful of other art and exposes this alleged documentary as a sham, a patchwork wherein several of Agostino Carracci's so-called "lascivious" engravings on Biblical and mythological themes are conglomerated. The embracing pair in left foreground is lifted from Carracci's *Lot and His Daughters* (fig. 19); the scene in right middle ground is Carracci's nymph having her toenails pared, while a small satyr underpropping her leg searches her privates (fig. 20). I have yet to identify the couple at center—they clearly repeat a symplegma of fabulous lovers, such as Venus and Adonis. Even the male nude at right is a standard "anatomy";

Fig. 21. Johann Heinrich Schönfeldt. *Life Class* (detail), c. 1630. Oil on canvas. Alte Galerie, Graz.

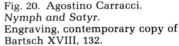
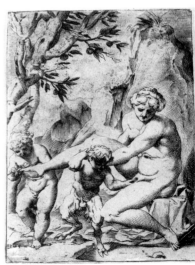

Fig. 20. Agostino Carracci. *Nymph and Satyr.* Engraving, contemporary copy of Bartsch XVIII, 132.

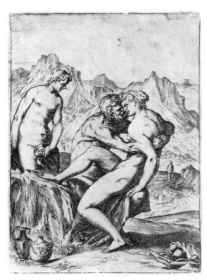

Fig. 19. Agostino Carracci. *Lot and His Daughters.* Engraving, Bartsch XVIII, 127.

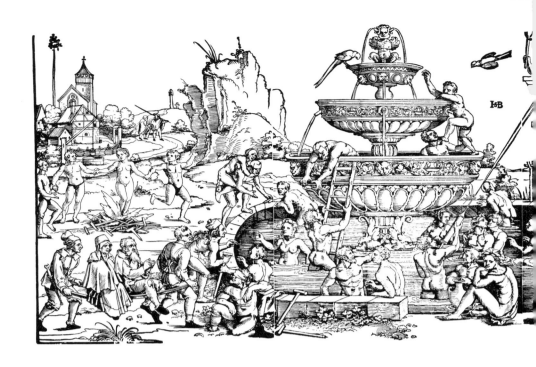

Fig. 22. Hans Sebald Beham.
The Fountain of Youth. Woodcut
impression from four blocks,
Geisberg 263–266.

Fig. 23. Marcantonio Raimondi
after Michelangelo. *Les Grimpeurs.*
Engraving, Bartsch XIV, 487.
The Metropolitan Museum of Art,
New York; Joseph Pulitzer Bequest.

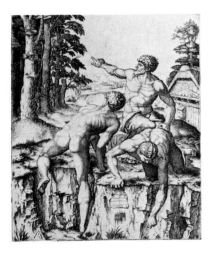

compare the early painting by Johann Heinrich Schönfeldt
(1609–1682/83), where exactly this figure, holding onto a rope,
poses for a life class (fig. 21)—as Professor Gert Schiff recognized
in one winning flash.

Our anonymous seventeenth-century draftsman was not even
the first to treat a licentious bath-house as a congeries of graphic
motifs. It had been done a century earlier in a large woodcut by
the Nuremberg printmaker Hans Sebald Beham (fig. 22).
Beham's subject is the old folktale of the Fountain of Youth,
shown here with adjacent facilities, including bath-house and
terrace dining. A place intriguing enough to merit a guided tour.

We perceive, arriving at left, senior citizens crippled by age and
accident. Following their dip in the magic pool they are rejuven-
ated, dancing about a bonfire of discarded crutches. Meanwhile,
in the right half of the picture, earlier beneficiaries of the foun-
tain bathe, urinate, sleep, and make love, with more of them
carousing upstairs. The rendering throughout is, of course, real-
istic. Yet the mythical tenor of the event is conveyed—conveyed
not so much by the faerie subject, the prodigy of restored youth,
as by a prodigality of quotations designed to inject inauthentic-
ity. Begin with the bearded man in the left foreground (three-
quarter front view, looking and pointing backward): he is one of
Michelangelo's Bathing Soldiers—off-duty but, true to character,
surprised at the bath; and lest we mistake his identity, he repeats
himself inside the bath-house (second intercolumniation from
left). The latter's neighbor, a backview nude climbing out of the
water, is the so-called *Grimpeur* from the same Battle Cartoon—
both bathers being transmitted by Marcantonio's three-figure
engraving after the Michelangelo (fig. 23), a plate famous for
stealing its landscape background from Lucas van Leyden. The
nude backview of a woman just right of center (first intercolum-
niation) belonged formerly to the Minerva in the *Judgment of
Paris* engraved by Marcantonio after Raphael (fig. 24)—a compo-

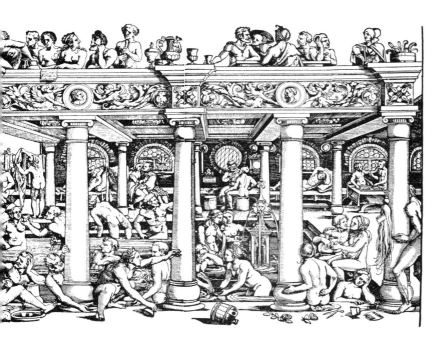

sition which supplied Beham's center foreground with yet an-
other excursionist, the ivy-crowned damsel of the frank eye,
squatting with elbow on knee. (Since Manet brought this very
figure to his *Déjeuner sur l'herbe*, one wonders whether he con-
sciously followed tradition even in raiding that famous print.)
And the female sleeper in the right background of Beham's
woodcut is none other than the Vatican *Ariadne*, as engraved
once again by Marcantonio (fig. 25). Indeed, all these habitués of
the magic fountain were recruited from Marcantonio prints
which presumably littered Beham's workbench as he composed.
And the fact that at least one of his recruits is conspicuously
doubled suggests that Beham's make-believe was meant tongue
in cheek: the fantasy was to be understood as ironic.

Nor was the irony lost on the draftsman of our seventeenth-cen-
tury public bath (fig. 18). I imagine him musing on Beham's
Fountain (or on the small reversed engraving of it by Jan Theo-
dore de Bry), and remarking how neatly an erotic fantasy is un-

Fig. 24. Marcantonio Raimondi
after Raphael. *Judgment of Paris.*
Engraving, Passavant VI,
137, copy A.

Fig. 25. Marcantonio Raimondi
after the antique. *Ariadne.*
Engraving, Bartsch XIV, 199.

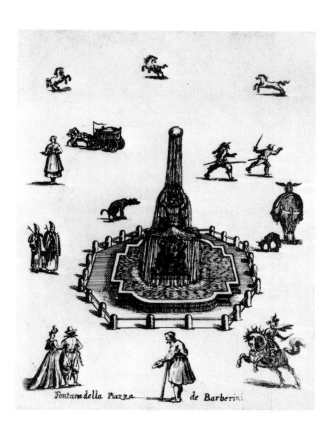

Fig. 26. Anonymous. *Piazza Barberini, Rome,* c. 1640. Etching.

Fontana della Piazza — de Barberini

strung by delivering itself in quotations. The scene reproduced in my *Love's Picture Book* is as remote from authentic voyeurship as the old woodcut was, and as far from recording actual sexual practice as our next illustration, fig. 26, is from documenting city life in Rome's Piazza Barberini during the 1640s.

Forgive the naïveté of this sorry print and look at it closely.[11] In the midst of it rises Bernini's *Tritone,* about to drink from his shell. All around teem little figures representing, you say, the urban scene. But truth will out. The romping horses, the beggar, the cavalier, the *promenade amoureuse* in the lower left, even the mongrel doing his bit behind the fountain—each of these weeny urbanites has been clipped from one or another of Callot's *Capricci di varie figure* (figs. 27–31). And just as the draftsman of our public bath had spliced Carracci's *Petites pièces lascives* to feign an orgy, so the anonymous etcher of our piazza assembled a sheaf of Callots to simulate an environment; evidently with less success, for he had neither the skill, nor perhaps the intention, to cover his tracks.

Think of that unlikely bath-house and that improbable city square as two in a series and add a third, one more place of delight, Saul Steinberg's personal *hortus conclusus* (fig. 32). In Saul's luscious garden, all the lovely growing things are typographical ornaments and vignettes, cut up and pasted down from an old foundry catalogue. Interspersed are some rubber stamps. Only the feline gardener with his watering can, a few birds chirping and pecking, plus one puzzled rabbit seem to be real inasmuch as Steinberg really drew them. For the rest, all of this bookish verdure, the tidy rows of sprout and seedling, paraphs and curlicues in printer's ink, shoots of anthemion and arabesque, beds of meander and Vitruvian scroll, the cursive

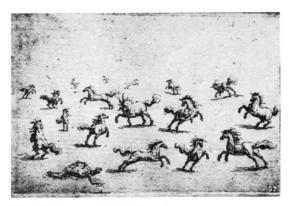

Fig. 27. Jacques Callot. Plate from
Capricci di varie figure,
Florence, 1618. Etching, Lieure, 224.

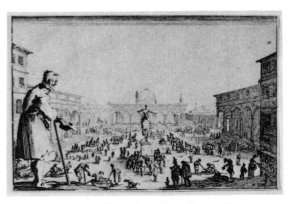

Fig. 28. Jacques Callot. Plate from *Capricci
di varie figure,* Florence, 1618. Etching, Lieure,
257. The Metropolitan Museum of Art, New York;
Jacob S. Rogers Fund.

Fig. 29. Jacques Callot. Plate from *Capricci
di varie figure,* Florence, 1618. Etching, Lieure,
254. The Metropolitan Museum of Art, New York;
Jacob S. Rogers Fund.

Fig. 30. Jacques Callot. Plate
from *Capricci di varie figure,*
Florence, 1618. Etching,
Lieure, 222.

Fig. 31. Jacques Callot. Plate
from *Capricci di varie figure,*
Florence, 1618. Etching, Lieure,
250. The Metropolitan Museum of
Art, New York; Jacob S. Rogers Fund.

tree (genus: Art Nouveau), the twin house and environs—all
flourish, like those bogus bathers and that pseudo-populace, as
tokens of prefabrication. Yet with this difference, that the seven-
teenth-century draftsman disguised his readymades by integra-
tion; whereas Steinberg divulges all, like a conjurer airing his

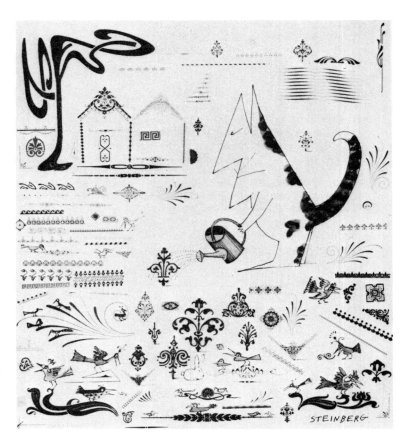

Fig. 32. Saul Steinberg.
Cover design for *The New Yorker,*
May 16, 1964.

paraphernalia: the birdie is out in the open, the rabbit out of the
hat, the cat out of the bag. Where the seventeenth-century scene
had been ostensibly about its subject, Steinberg's drawing is pal-
pably about art. It gives notice that it is signs we are reading,
Flora's remote mental offshoots whose existence is purely ma-
nipulative. The drawing harks back to the beginnings of orna-
ment in the stylization of plants, notes the progressive
fossilization of once-vegetal forms and their abasement into
printers' clichés, and restores them, by dint of a horticultural
setting, to botany. A reflexive imagery, historiographic and ag-
gressively modern, promoting the kind of self-consciousness in
which everyone shares. There are no outsiders. Saul's enclosed
garden is the open secret of art.

IV. CACONOMASIA

The impressive title we have awarded this section is a Greek
nonce word coined by John Hollander, signifying "the state of
being ill-named." It is intended to introduce the reflection that
we have plenty of bad-mouthing caconyms for the phenomenon
under discussion, but no decent name.

In present use to describe the reappearance of old motifs in new
art are terms of two kinds. One set of terms depersonalizes the

20

process, negating intentionality and the variety of motivations artists bring to their tasks. A second set allows the process to be volitional, but in a reprehensible sense, as though the will involved were delinquent.

In the terminology of the first group, the artist who deploys a pre-existent motif is said to be inspired by the earlier work, or undergoing its influence, or deriving something from it as from a source. The metaphor latent in all these terms is that of a reflex, an involuntary response to a stimulus, as in the linkage of cause and effect. None of these terms fits the cases discussed—e.g., Beham's cunning appropriation of figures from Raphael, or Saul Steinberg's cannibalizing a pattern book. Neither Beham nor Steinberg were "influenced" or "inspired" by their respective "sources"—any more than Picasso, in his first collage, was influenced by a patch of oil-cloth with a chair-caning pattern. Even the innocuous metaphor of the "source" is insidious in that it suppresses the possibility of deliberateness. Things that spring from a source—such as rivers or rumors—have no power to choose from which source to flow. But artistic decisions are not reactions to irresistible causes; artists find serviceable material and put it to work.

The remaining terms used to describe our inter-art traffic have again this in common, that not one of them is indigenous, evolved in, or proper to, the experience of art; all are fetched from elsewhere. As the notion of "wandering motifs" was imported from zoology or ethnology (the model, I suppose, being the group behavior of migrating animals or nomadic tribes), so the common terms "quotation" and "plagiarism" come to us by literary analogy; while "stealing" and "borrowing," which are even commoner, derive from economic malpractice and the management of private property. "Minor poets borrow, major poets steal," said T. S. Eliot, shuffling the old misnomers.

Suppose we describe a painter who takes a motif from another picture as "quoting" from it. At once, a whole set of attitudes appropriate to literary quotation goes into action. To begin with, a quoter who fails to acknowledge his author is designated a kind of thief. As Synesius wrote nearly sixteen centuries ago: "It is a greater offense to steal dead men's labors than their clothes." Accordingly, when Robert Burton (1577–1640) set out to defend the overdose of quotations in his quote-ridden *Anatomy of Melancholy,* he invoked the simple criterion whether the source were concealed or confessed. "I have wronged no author," says he, "but have given every man his own . . . I cite and quote mine authors, I have borrowed, not stolen." [12]

By this test, all pictorial "quotation" stands condemned as inexcusable plagiarism, what Burton calls "felony." For one is hard put to think of a painting in which a quoted item properly credits its source. Take, for instance, the Renaissance painter Bachiacca's picture of the first human family (fig. 33): You observe that the infant clinging to Eve is not homegrown; it was "quoted," or rather, kidnapped, from a different household— from the arms of Noah's wife as designed by Raphael in the Vatican Logge (fig. 34). Bachiacca adopted the Raphael child, as it were, into his family; and must have done so to show off his skill in assimilating a foreign growth. Yet one searches the changeling in vain for an ID tag to declare its true parentage. Its origin in

Fig. 33. Bachiacca. *Adam and Eve.* Oil on panel. Philadelphia Museum of Art; John G. Johnson Collection.

Fig. 34. Marcantonio Raimondi after Raphael. *God Commanding Noah.* Engraving, copy A of Bartsch XIV, 3.

other art is not confessible. Because there is no place in Renaissance pictures for footnotes, credit lines, or quotation marks, whether these pictures "quote" from the moderns or from the ancients, as they habitually do. The quotations, if that's what they are, go unacknowledged. Therefore, if we admitted the term "quotation" for the Renaissance habit of sporting old hats, we would automatically condemn a good deal of what the Renaissance was about.

We should have to condemn Velázquez's teacher Pacheco most harshly, for he did have occasion to confess a "quoted" or "borrowed" item, yet let it pass. The book he completed in 1638, entitled *Arte de la Pintura,* offers a detailed account of his *St. Sebastian Nursed by St. Irene* (fig. 35), a painting of 1616 whose most interesting feature Pacheco describes as "a window through which the saint is seen in the open, tied to a tree and shot full of arrows." [13] And that's all he says. No indication that this window view (which represents a flashback in the narration, either as an affect of memory or as "background" to the saint's story)—never a hint that this *ventana,* so like a picture behind a hinged panel, is but the précis of a once popular com-

22

position by Hans von Aachen, best known in Jan Muller's engraving (fig. 36).[14] In Pacheco's *Sebastian* the recessed mental picture is appropriately remote in style from the prosy present—another reality level, a gusty vision to threaten stylistic coherence; on purpose, of course. Such sophistication is hard to reconcile with the rest of Pacheco. But it is typical of the youthful Velázquez. I suspect the seventeen-year-old apprentice of being responsible for this story-within-a-story, this frank importation which Velázquez's aging master subsequently could not bring himself to admit. Entirely inadmissible would have been the inscription of von Aachen's or Muller's name on a depicted windowsill in the painting. Such extraneous data have no place in devotional pictures; and if quotation by definition requires acknowledgment, then the word had best stay out of art.

The word "borrowing" is even less apt. As if you could borrow without a lender's consent, without temporarily dispossessing the owner, or promising restitution. In fact, nothing that pertains to this economic transaction qualifies borrowing as a model for what passes between artists and art. The anomaly is apparent in the criterion commonly used for distinguishing between thieving and borrowing in painting and poetry. Thus Sir Joshua Reynolds: "He who borrows an idea . . . and so accommodates it to his own work that it makes a part of it, with no seam or joining appearing, can hardly be charged with plagiarism." But, in the name of the law, why not? If there has been a transfer of property with suspicion of illegality, how is that transfer legitimized through successful incorporation into the robber's house? On the other hand, if the taker be culpable for letting "seam or joining appear," then let him be faulted for bad joining, whether the congredients were his or another's. In other words, if the principle holds, the model does not.[15] And just so in Milton (*Iconoclastes*, chap. 23): "If it [a lifted passage] be not bettered by the borrower, among good authors [it] is accounted plagiary." A cu-

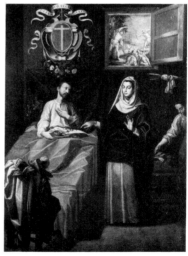

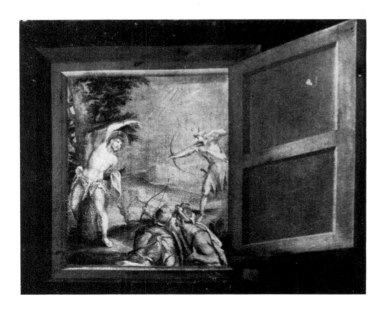

Fig. 35. (and detail) Francisco Pacheco. *St. Sebastian Nursed by St. Irene*, 1616. Formerly Alcalá de Guadaira (Seville).

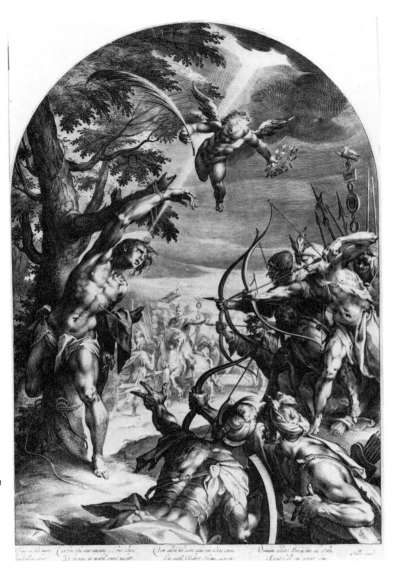

Fig. 36. Jan Muller after
Hans von Aachen. *The Martyrdom
of St. Sebastian*. Engraving,
Bartsch III, 23.

rious twist: suppose you had borrowed my Gideon Bible and left
it just as you got it; should you on that account be branded a
thief? or a museum that neglects to improve a painting borrowed
for a loan show? Milton and Reynolds are right, of course, but
their wording is trapped in the misfit of a malaprop model.

And there's harm in it, for the application of inappropriate terms
to artistic practice has toxic side effects. It activates certain atti-
tudes, censorious or defensive, which fit only the original terms,
not their new referents. No wonder that Rembrandt Peale, exhib-
iting *The Roman Daughter* in Philadelphia, 1812, found himself
nearly ostracized when someone fancied he recognized similar-
ities to an earlier rendering of the subject; and that the painter
was stung into self-defense, offering to donate the maligned pic-
ture to the Pennsylvania Hospital "if any person could prove (by

comparison) that I had copied it in whole, or in part, from any painting, print, or drawing whatsoever. . . ."[16] No wonder it was held against Manet ("only too true, alas!") that his *Déjeuner sur l'herbe* recycled a compositional grouping from the Marcantonio-Raphael *Judgment of Paris;* and that, to this day, the foremost authority on Impressionism sees Manet's "borrowing" as proof of a "lack of imagination." The fact that the picnickers' limbs were not rearranged is taken as evidence of internal poverty (though Manet's transposition of Renaissance deities into modernity was surely a brilliant feat of visual imagination).[17] And so again in the case of Picasso's variations on themes from old masters. A growing chorus of hostile critics interpret Picasso's play with earlier compositions in a negative light: he snatches at what is not his, because his own stock is depleted.

In all these instances, which could be endlessly multiplied, the operative model is that of the borrower, and a borrower is one who takes. But the record of art reveals that giving, lending, imparting, may be equally suitable metaphors for the sort of transaction we are considering. There are instances by the score where the artist invests the work he takes from with renewed relevance; he bestows on it a viability hitherto unsuspected; he actualizes its potentialities—like a Brahms borrowing themes from Handel or Haydn. He can clear cobwebs away and impart freshness to things that were moldering in neglect or, what is worse, had grown banal through false familiarity. By altering their environment, a latter-day artist can lend moribund images a new lease on life.

In the meantime, our conventional jargon continues to muddle the issue by arousing our tenderest feelings about possessions. Terms such as "borrowing" and "stealing" empoison our judgment, and they reduce the abundant spiritual intercourse between artists and art to a uniform pattern; as if an artist's recourse to precedent necessarily betrayed a deficiency; as if this aspect of creativity could be covered by a simplistic word.

Is there, then, no satisfactory designation for this trucking out of and into art? I doubt if there even should be, for we are not dealing with any one thing. When Sir Joshua Reynolds discussed "Imitation" in the sixth of his *Discourses,* he tossed out, as his context kept changing, the following terms: Borrowing; Gathering; Depredation; Appropriating; Assimilating; Submitting to infection (or contagion); Being impressed—as wax or molten metal is—by a die; Being fertilized like a soil; Being impregnated. A single term that would comprehend such miscellanea as impregnation, contracting infection, and depredation is hardly worth having. And the reality is bigger still. The varieties of artistic trespass or repercussion (or whatever you call it) are inexhaustible because there is as much unpredictable originality in quoting, imitating, transposing, and echoing, as there is in inventing. The ways in which artists relate their works to their antecedents—and their reasons for doing so—are as open to innovation as art itself, and so much for that.

But I want to cite three more instances from the many that come to mind to recall the range of incentives, the hospitableness, and the wit that induces artists to join other art to their own.

Michelangelo. His *Madonna Medici* sits with legs crossed as no Madonna had done in thirteen centuries of Christian art (fig. 37).[18]

I have shown elsewhere that the sculptor's point of departure was a Hellenistic marble—perhaps the one now in Oxford representing a Muse (fig. 38).[19] Between the two figures the similarities are too close to be coincidental. Monumental draped female figures, seated in cross-legged pose and designed for a frontal view, were not common in Michelangelo's day, and he followed the rare antique prototype in the turn of the upper body and the retraction of the supporting arm no less than in disposing the lower limbs.

But he added the child; not as an addendum but as the efficient, formal, and final cause, as if whatever impelled the child stirred and necessitated the mother's response. Though the adult figure was given and the other invented, Michelangelo's group is interactive, every maternal motion counterpointing the will of the child. The mother leans forward meeting the boy's backward thrust. To the possessive grasp of his left hand she lowers a yielding shoulder, bows down as he seems to rise. As his legs spread and his arms cross, her arms open and her legs close. And, most significantly, if we rethink the sculptor's initial thought as it projects the two bodies into the block—conceive

Fig. 37. Michelangelo. *Madonna Medici*. Medici Chapel, S. Lorenzo, Florence.

Fig. 38. Hellenistic sculpture. *Muse*. Ashmolean Museum, Oxford.

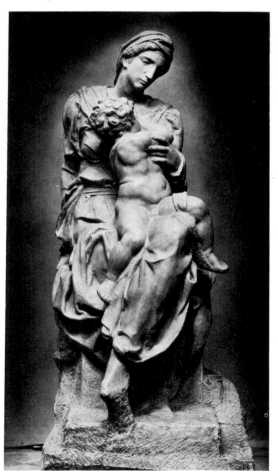

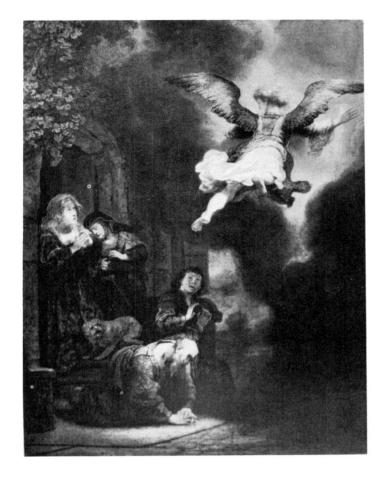

Fig. 39. Rembrandt.
The Angel Leaving Tobias, 1637.
Oil on panel. Louvre, Paris.

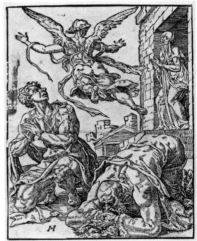

Fig. 40. Maerten van Heemskerck.
The Angel Leaving Tobias, 1563.
Woodcut, Hollstein VIII, 6.

them in plan as well as in contour and elevation—then the boy turns and swerves on his axis within the core of the stone, while the Madonna's slow counterrotation, from her withdrawn hand to the hovering tip of her foot, forms a matrix, an encompassing orbit. The two figures exist together in a perpetual reaffirmation of complementarity; their every motion is responsive, reciprocal. Michelangelo did indeed found his Madonna on ancient precedent; but rather than imitate the given action, he reconceived that action as a consequence, re-creating the ancient pose only to cause it anew. Nor was there ever a more original exercise of creative imagination.

But why did Rembrandt in his *Angel Leaving Tobias* of 1637 (fig. 39) paint the departing angel from a woodcut of the same subject made some seventy years earlier by Maerten van Heemskerck (fig. 40)? Was he too indolent to prod his invention? We gather from Rembrandt's drawings that air-borne, foreshortened figures fall from him at the flick of a wrist; it would have been easy to launch a new angel. And it must have taken attention and meticulous labor to translate Heemskerck's figure—altering one of its arms, but the rest intact, even to the cast shadow at the back of a knee. What accounts for such exact piracy?

27

Pose that kind of question and you are driven to speculate. Rembrandt, the connoisseur, art collector, and teacher, obviously admired the old Haarlem master—though woefully out of fashion. By 1637 nobody looked at Heemskerck anymore. But Rembrandt's gaze habitually cut through the barriers of period style—in Heemskerck's case, a jerky, piecemeal figuration—to discern merit and strength. I imagine him snapping at some of his students, the callow novelty seekers among them, activists for the modernism now called Baroque, who held that art began at the turn of the century and considered the likes of Heemskerck *passé*. To whom Rembrandt (I am warming up to my fiction) responds like Hans Sachs in the *Meistersinger: Verachtet mir die Meister nicht*—Despise not the Old Masters! And proceeds to climax his own latest enterprise with a feature lifted conspicuously from a despised, brittle woodcut, so that Heemskerck's seraphic glider becomes once more operational; proving the old master's continuing viability. Great teaching, this, and a blow struck for intergenerational fellowship.

But why, someone asks, why commit such a baseless figment to print in the absence of documentation? Because, as Baudelaire observed, *le possible est un des provinces du vrai*. My fantasy will collapse gladly in the face of a better explanation of why Rembrandt transcribed Heemskerck's figure. As I see it, he did not crib, quote, or borrow from need; he adopted from an overplus of generosity. He did not copy to supply a want of imagination, nor to mock or parody—you can see that the transcription is made with reverence and affection—but rather to give a forgotten oldtimer what he stood most in need of, a seat up front, a free ride into the modern world, reviving him, as it were, by a change of stylistic environment. Which is also, I think, what Manet intended for Raphael, Picasso, for Lucas Cranach.

But what was it Charles Addams intended when he took Mona Lisa to the movies (fig. 41)? Here's a radical change of venue. And not for the lady only. What is altered is the miasma of stale opinion that molds our image of her. At sight of Addams's cartoon we address Leonardo's creation at last with a fresh question. Instead of asking why Mona Lisa smiles, we wonder what keeps her from laughing.

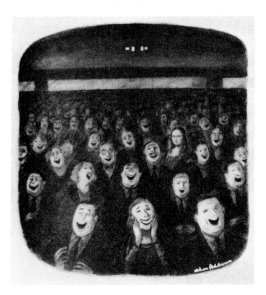

Fig. 41. Charles Addams. Cartoon from *Monster Rally*, 1950, p. 89.

NOTES

1. The City Hall picture was an enlarged replica of a small portrait (now at Winterthur) which Trumbull had painted in his New York studio from drawings done at Mount Vernon for presentation to Mrs. Washington. See Edgar P. Richardson, "A Penetrating Characterization of Washington by John Trumbull," in *Winterthur Portfolio*, III (1967).

2. Three sources record the genesis of the Winterthur version of Trumbull's Washington portrait. The first is an entry in *Washington's Diary for July 1790*: "Tuesday 8th—Sat from 9 o'clock till after 10 for Mr. Jno. Trumbull, who was drawing a portrait of me at full length, which he intended to present to Mrs. Washington. . . ." The second is a letter of November 10, 1825, written by the aged painter and addressed to Lloyd Rogers, Esq., who then owned the picture: "The small whole-length portrait of General Washington . . . was painted by me in this city [New York] in the year 1790. . . . Painted *con amore* in my best days. . . ." Four years later Trumbull described the picture more fully as "a small whole length Portrait of General Washington, standing by a White Horse, leaning the right arm on the Saddle, & holding the bridle reins: in this picture not only the Head & Person of the General, but every part of the Dress, the Horse, & horse furniture were carefully painted from the real objects. . . ." Finally, Mrs. Washington's grandson, George Washington Parke Custis, recalled in his memoirs: "In the execution of this fine work of art, the painter had *standings* as well as sittings—the white charger, fully caparisoned, having been led out and held by a groom, while the chief was placed by the artist by the side of the horse, the right arm resting on the saddle. In this novel mode the relative positions of the man and horse were sketched out and afterwards transferred to the canvas." (The above quotations from Richardson, pp. 22, 21, and 10.)

Custis's "relative positions" can refer only to the General's stature and resting right arm—not to the stance of the horse. That unstable pose was found and fixed in the studio, whose equipment evidently included Robert Strange's engraving after Van Dyck. As for the "novel mode [of] the relative positions of man and horse," here again Trumbull had been anticipated—by Sir Joshua Reynolds in the *Portrait of Captain Orme* (London, National Gallery).

3. For the four known versions of Titian's *Adoration of the Magi*, see Harold E. Wethey, *The Paintings of Titian, I: The Religious Paintings* (London, 1969), pp. 63ff. In the 1620s, when Van Dyck traveled in Italy, the Cleveland version here reproduced as figure 3 was in Genoa. For Rubens's role in mediating between Titian and Van Dyck, see Julius S. Held's exemplary essay "Le Roi à la Ciasse," *Art Bulletin*, XL (1958), pp. 139–149. Oskar Fischel's observation was first published in *Amtliche Berichte aus den Königlichen Sammlungen*, XXXIX (December 1917), pp. 59–64. (His final statement that the motif reappears in Romney seems to be a mistaken reference to Reynolds's *Captain Orme*.)

4. The background of the New York City Hall portrait depicts the British evacuation of Manhattan (November 1783). Prominent between the forelegs of the horse is the empty pedestal from which a statue of George III had just been pulled down, and for which a statue of Washington was intended. For this observation and other courtesies I wish to thank Mr. Donald J. Gormley, Executive Secretary of the Art Commission of the City of New York.

5. Janet R. MacFarlane, *Hudson Valley Paintings 1700–1750, in the Albany Institute of History and Art* (1959), p. 44.

6. Kraemer (cat. no. 19 and fig. 9) regards the drawing as a study for West's *William de Albanac Presenting His Three Daughters to Alfred III, King of Mercia*, a painting exhibited in 1778, destroyed by fire in 1816, but recorded in an engraving of 1782 by J.-B. Michel.

7. Daniele's celebrated composition was broadcast in at least half a dozen engravings. Established as a paradigm of high art, it had been recommended for imitation ever since the late sixteenth century—as in Armenini's, *De' veri precetti della Pittura* (Ravenna, 1587), p. 15.

8. The Virgin in labor on Calvary is a difficult theological concept whose powerful influence upon art remains to be studied. The notion is set forth by Rupert of Deutz (c. 1100): "The Virgin brought forth without sorrow the author of the Salvation of all of us, when the Word was made flesh in her womb; now, standing at the foot of the Cross, she brings forth again, but in Sorrow. . . . Hence she is the mother of all of us. . . ." Cf. Millard Meiss, *Painting in Florence and Siena after the Black Death* (Princeton, 1951), p. 151: "In the Middle Ages the Virgin was believed to be the mother and nurse not only of Christ but of all mankind. She was the *Mater omnium*." But the doctrine did not die with the Middle Ages. It was alluded to by Savonarola, was preached in a great sermon by Bossuet in the seventeenth century, and was given clear formulation in 1889 in the *Quamquam pluries* Encyclical of Pope Leo XIII: "The Virgin . . . is the mother of all Christians since she is the mother of Jesus and since she gave birth to them on the Mount of Calvary amid the unspeakable sufferings of the Redeemer." Cf. Bossuet: "Elle devient mère des chrétiens, parmi l'effort d'une affliction sans mesure. On tire de ses entrailles ces nouveaux enfants . . . , et on entr'ouvre son coeur avec une violence incroyable, pour y entrer cet amour de mère qu'elle doit avoir pour tous les fidèles" (*Sermons de Bossuet* [Paris, 1889], II, p. 644, "Sur la Compassion de la Sainte Vierge," 1660).

9. The examples discussed in these pages concern only actual "borrowings" or "quotations"—special instances of the larger truth that "whatever else it may be about, all art is about art." (See L. Steinberg, *Other Criteria* [New York, 1972], p. 76.)

10. Needless to say, the designer of von Muralt's frontispiece did not raid the Sistine Ceiling directly, but utilized one of those ubiquitous prints that purveyed Michelangelo's figures singly or in small parcels. The grandam in figure 15 appears alone in a drawing by Annibale Carracci, intended perhaps for later use. (See Donald Posner, *Annibale Carracci* [London, 1971], I, fig. 83.) Another of Michelangelo's lunette figures appears as Caroline, Duchess of Marlborough, in the Reynolds portrait at Blenheim. For Reynolds's ingenious use of the Michelangelo *Ancestor* in figure 14, see note 15 below.

11. The etching, apparently unrecorded, may be a posthumous additional plate to Giovanni Maggi's *Diverse Fontane di Roma*, first published in 1625 (Le Blanc II, 585).

12. Robert Burton in "Democritus to the Reader," introducing *The Anatomy of Melancholy* (1651), eds. Floyd Dell and Paul Jordan-Smith (New York, 1927), p. 19. Cf. Montaigne's essay "Of Physiognomy" (1588): Whereas others "make a show of their pilferings and take credit for them," he, Montaigne, is "glad to be able to filch a thing now and then, disguising and altering it for some new purpose. . . . Like a horse-thief I paint the mane and tail, and sometimes blind them in one eye; if the first owner used it as an ambler I make a trotting horse of it." For a return of these old problems in modern dress, see Roger Copeland, "When Films 'Quote' Films," *The New York Times*, September 25, 1977, sect. II, p. 1.

13. "Una ventana por donde se ve el Santo en el campo, atado a un árbol, donde le están asaeteando." Francisco Pacheco, *Arte de la Pintura* (1638; published 1649); modern ed. by F. J. Sanchez Cantón (Madrid, 1956), II, p. 328. The painting was destroyed in 1936.

14. Reproductive engravings are not so much a branch of art as the medium through which, for nearly four hundred years, all branches of art interacted. Hence the emphasis given them in these pages. Thus the Muller engraving after von Aachen was once a standard item in the artist's *musée imaginaire*. The print underlies a Netherlandish plaquette with Martyrdom of St. Sebastian, recently offfered in a German auction catalogue, and there misdated by a half century because mistaken for an original composition (Weinmüller, Munich, December 6, 1961, no. 894). And von Aachen's figure of the nude saint, ingeniously tied to his tree by wrist and ankle, turns up as a youth getting undressed in Bloemaert's *Baptism of Christ* (Ottawa), signed and dated 1602. Abraham Bloemaert in Utrecht, the sculptor of the plaquette, Pacheco in his Seville studio—every one of them put his Jan Muller print to good use.

15. My Reynolds quotation is from the *Discourses on Art*, Discourse VI, December 10, 1774. For the literature on Reynolds's theory of imitation see note 68 in R. Wittkower's comprehen-

sive essay "Imitation, Eclecticism, and Genius," in Earl R. Wasserman, ed., *Aspects of the Eighteenth Century* (Baltimore, 1965). Wittkower (p. 156) quotes the following from Horace Walpole: "Sir J. Reynolds has been accused of plagiarism for having borrowed attitudes from ancient masters. Not only candour but criticism must deny the *force* of the charge. When a single posture is imitated from an historical picture and applied to a portrait in a different dress and with new attributes, this is not plagiarism, but quotation: and a quotation from a great author, with a novel application of the sense, has always been allowed to be an instance of parts and taste; and may have more merit than the original." Cf. Fuseli in his Third Lecture (1801): "We stamp the plagiary on the borrower, who, without fit materials or adequate conceptions of his own, seeks to shelter impotence under purloined vigour; we leave him with the full praise of invention, who by the harmony of a whole proves that what he adopted might have been his own offspring though anticipated by another. If he take now, he soon may give" (John Knowles, *The Life and Writings of Henry Fuseli* [London, 1831], II, p. 181).

For a fine example of a "borrowed idea accommodated to his own work," see Reynolds's *A Mother and her Sick Child* (Dulwich Gallery), an oblong picture showing a watchful young woman protecting her child while Death, shamed and discomfited, stalks off to left. The solicitous mother, right, repeats Michelangelo's *Ancestor*, our figure 14. As Emerson put it: "Only an inventor knows how to borrow."

16. "For," Peale continued, "although historical painters from Raphael to West have always been permitted to borrow ideas, and even figures—no such advantage was taken. . . . Every lover of the arts, and every gentleman who knows the value of character, [ought to] interest himself in discountenancing a groundless aspersion against an artist, who would value no acquirement nor fame that were purchased at the expense of his integrity. . . ." (See William Dunlap, *A History of the Rise and Progress of the Arts of Design in the United States* [1834], reprinted, New York, 1969, II, part 1, p. 53.) I am indebted to Phoebe Lloyd of the City University of New York for bringing this incident and other valuable matter to my attention.

17. "A curious lack of imagination repeatedly led Manet to 'borrow' subjects from other artists"—John Rewald in *The History of Impressionism* (rev. ed., New York, 1961), p. 86. In subsequent editions of this fundamental work, Rewald fortifies his position by borrowing from Degas: "Manet . . . had no initiative . . . and did not do anything without thinking of Velázquez and Hals. When he painted a fingernail, he would remember that Hals never let the nails extend beyond the fingers themselves, and proceeded likewise."

Unfortunately, this is not Degas at his best. He had failed to observe that fingernails never "extend beyond the fingers themselves," but are clipped short and square in all antique art and again in Renaissance painting and sculpture (through Michelangelo, Caravaggio, Bernini, etc.). It follows that the retroussé fingertips of Manet's Olympia (with no nails projecting) are classical rather than imitations of Hals. Degas, as might be expected, had noticed something, but his research was superficial. (To those who would deepen the investigation, I here offer my hunch that the early seventeenth century is a period of transition from short nails to long [see El Greco!]; and that even then nails growing past fingertips are felt to be slovenly.)

As for Manet's appropriation of Raphael's *Judgment of Paris* group to his *Déjeuner*: the disclosure was made in Ernest Chesneau's *L'Art et les Artistes Modernes* (Paris, 1864), p. 190. Unaware that one of those Raphael figures had long since been lifted by the faultless Poussin (*Bathing Nymphs*, Blunt, L. 117), Chesneau concluded his execration of Manet by discharging his exposé disdainfully in a footnote. But as footnotes tend to be overlooked, Manet's borrowing had to be rediscovered in 1908 by Gustav Pauli in *Monatshefte für Kunstwissenschaft*, I, p. 53f.; after which it was exalted in an imaginative cross-cultural meditation by Aby Warburg (see E. H. Gombrich, *Aby Warburg: An Intellectual Biography* [London, 1970], pp. 273–277).

18. One solitary exception is a Madonna on an Early Christian sarcophagus in the Cathedral of Mantua—seated cross-legged, profile to left, receiving the Magi. Style and conception are derived from a pagan model, and the type was rejected.

19. See L. Steinberg, "Michelangelo's *Madonna Medici* and Related Works," *Burlington Magazine*, CXIII (1971), pp. 145–149.

COLOR PLATES—SIXTEEN PAINTINGS

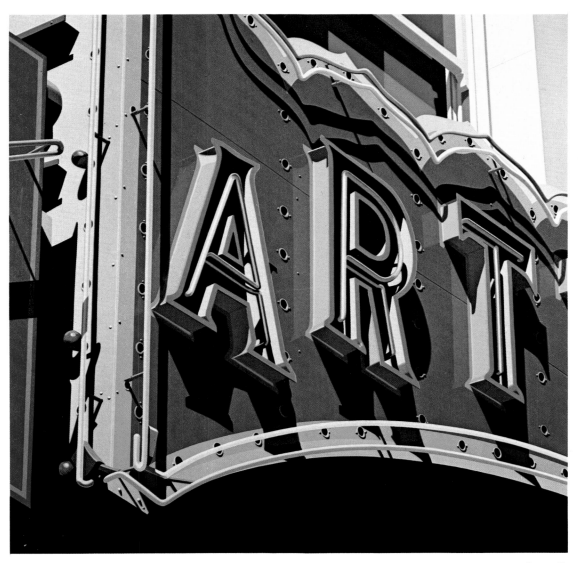

Robert Cottingham. *Art*, 1971. Oil on canvas, 77" x 77".
Collection of Jesse Nevada Karp, New York. Art about art.

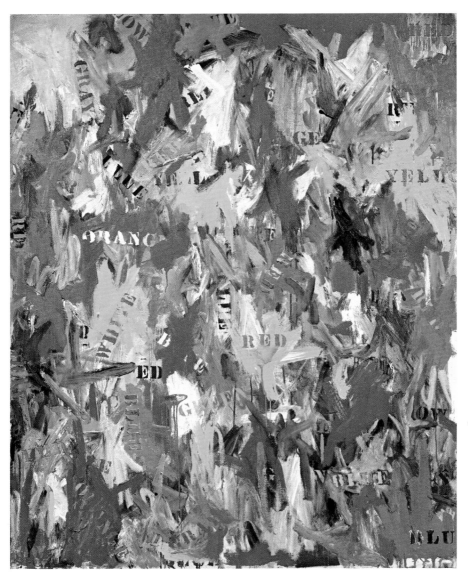

Jasper Johns. *False Start*, 1959. Oil on canvas, 67¼″ x 54″.
Collection of Mr. and Mrs. Robert C. Scull, New York. About color.

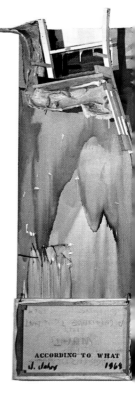

ACCORDING TO WHAT
J. Johns 1964

Jasper Johns. *According to What*, 1964. Oil on canvas with objects, 88″ x 192″.
Collection of Edwin Janss, Thousand Oaks, California.
Related to Marcel Duchamp's *Tu m'* (1918;
Yale University Art Gallery, New Haven, Connecticut).

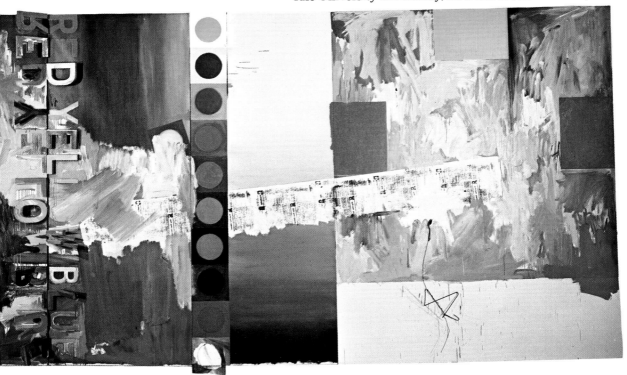

Andy Warhol. *Do It Yourself*, 1962. Oil on canvas, 70″ x 54″.
Museum Ludwig, Cologne, West Germany. About commercialized art.

Andy Warhol. *Mona Lisa*, 1963. Silkscreen on canvas, 128″ x 82″.
Collection of Eleanor Ward and Andy Warhol, New York.
Featuring da Vinci's *Mona Lisa* (c. 1502; Louvre, Paris).

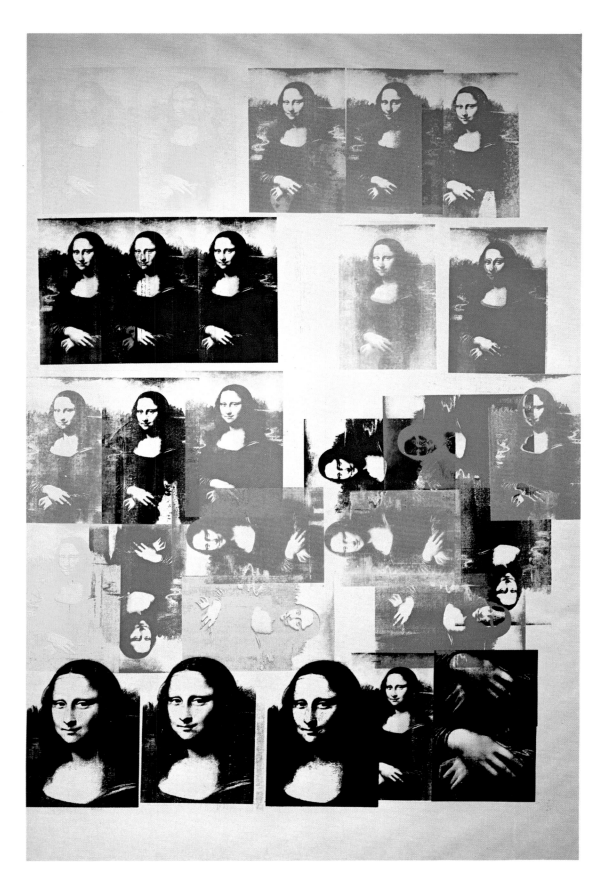

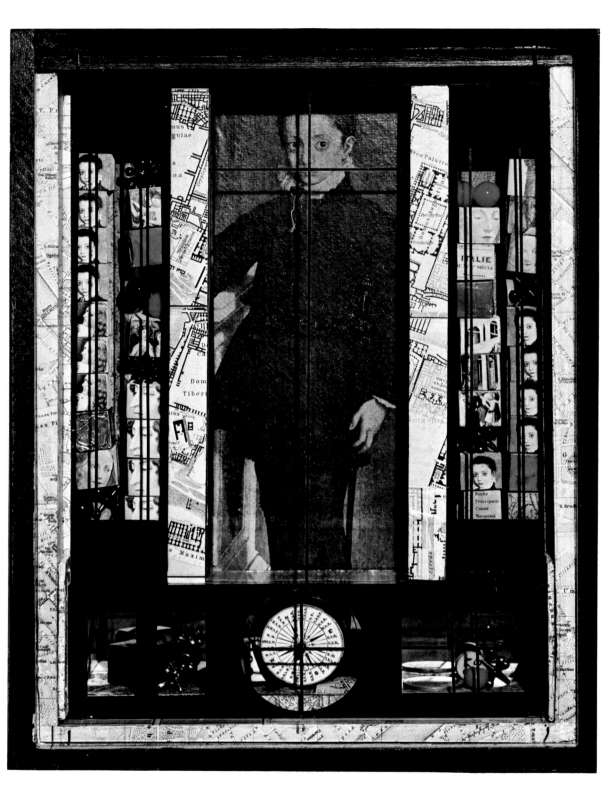

Joseph Cornell. *Medici Slot Machine*, 1942. Wood box construction
with reproductions, 15½″ x 12″ x 4⅜″. Private collection.
Featuring Moroni's *Portrait of a Young Prince of the Este Family*
(1550−1575; Walters Art Gallery, Baltimore).

Audrey Flack. *Leonardo's Lady*, 1974. Oil and acrylic on canvas, 74″ x 80″.
The Museum of Modern Art, New York.
Featuring da Vinci's *La Belle Ferronière* (1497; Louvre, Paris).

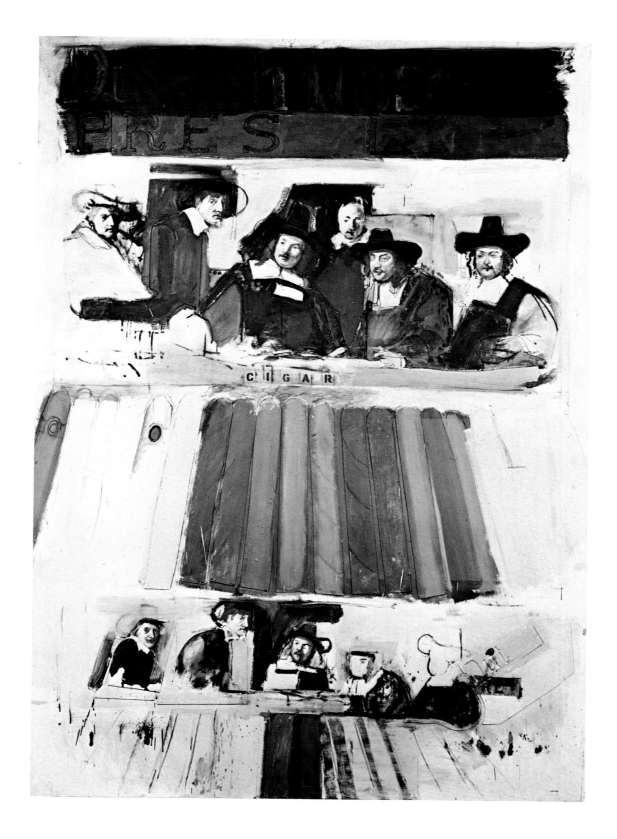

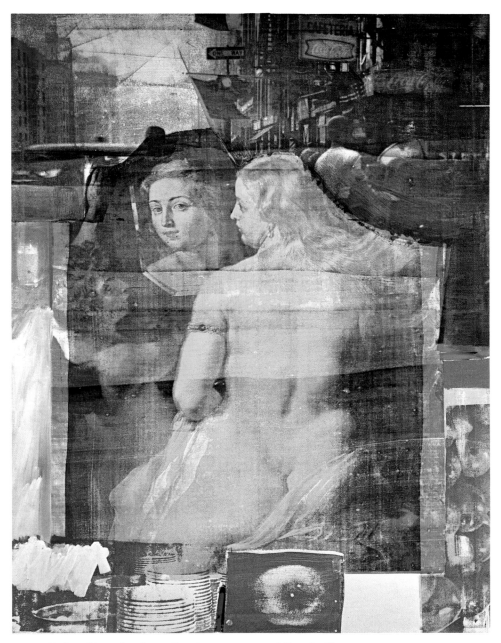

Robert Rauschenberg. *Persimmon*, 1964. Oil and silkscreen on canvas, 66″ x 50″.
Collection of Mrs. Leo Castelli, New York.
Featuring Rubens's *The Toilet of Venus* (1612−1615; Liechtenstein Gallery, Vienna).

Larry Rivers. *Dutch Masters and Cigars II*, 1963. Oil on canvas with collage,
96″ x 67⅜″. Harry N. Abrams Family Collection, New York.
After Rembrandt's *The Syndics of the Drapers' Guild*
(1662; Rijksmuseum, Amsterdam).

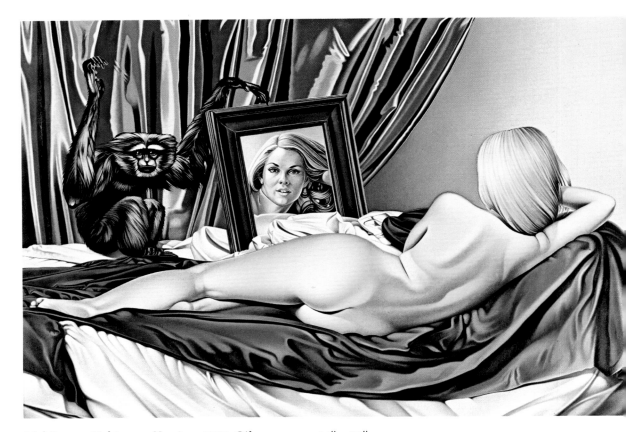

Mel Ramos. *Velázquez Version*, 1975. Oil on canvas, 44″ x 66″.
Collection of Charles Wilp, Düsseldorf, West Germany.
After Velázquez's *Venus and Cupid* (1645 −1648; National Gallery, London).

Tom Wesselmann. *Great American Nude #26*, 1962. Acrylic and collage
on composition board, 60″ x 48″. Collection of Mrs. Robert B. Mayer, Chicago.
Featuring a reproduction of Mattise's *The Rumanian Blouse*
(1940; Musée National d'Art Moderne, Paris).

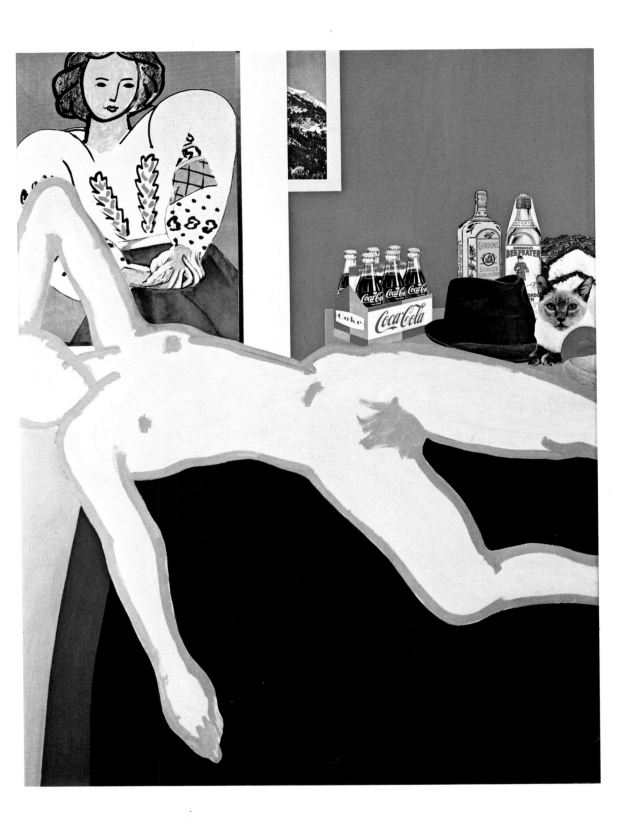

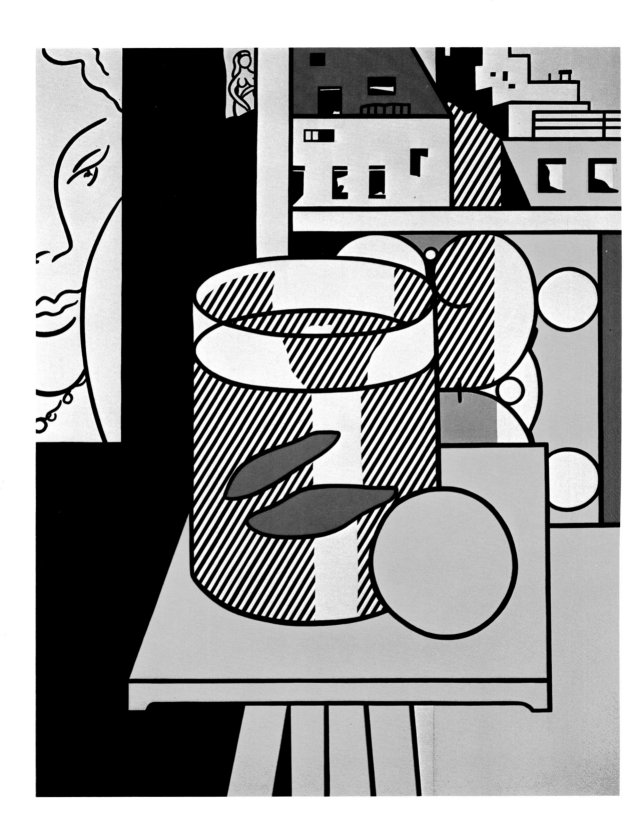

Roy Lichtenstein. *Still Life with Gold Fish*, 1974.
Oil and magna on canvas, 80″ x 60″. Philadelphia Museum of Art;
The Edith H. Bell Fund. After Matisse's *Goldfish*
(1915; The Museum of Modern Art, New York).

Roy Lichtenstein. *Little Big Painting*, 1964.
Oil on canvas, 68″ x 80″. Whitney Museum of American Art, New York;
Gift of the Friends of the Whitney Museum of American Art.
About Abstract Expressionism.

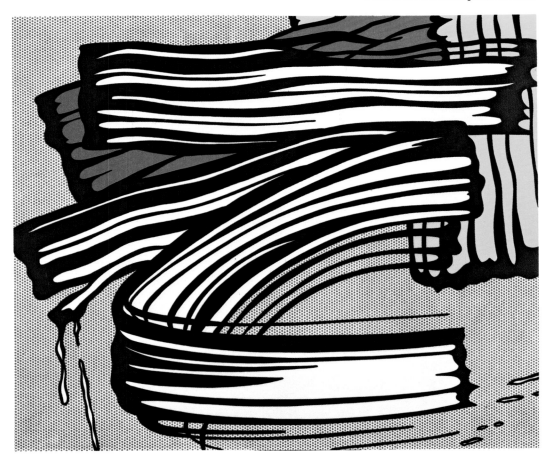

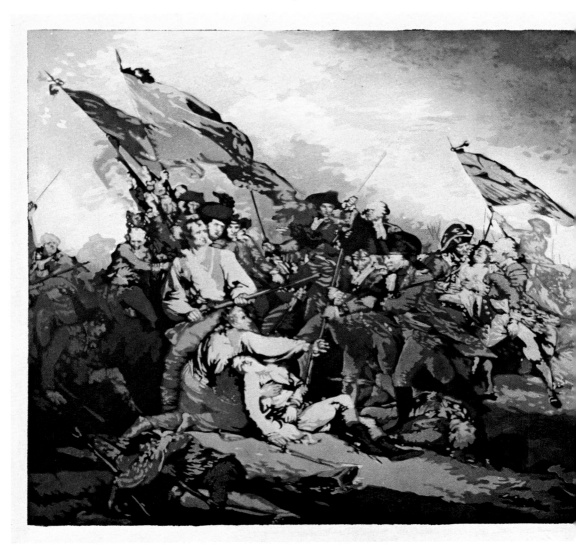

John Clem Clarke. *Trumbull—Battle of Bunker's Hill*, 1968.
Oil on canvas, 56″ x 80″. Whitney Museum of American Art, New York;
Gift of the Friends of the Whitney Museum of American Art.
After Trumbull's *The Battle of Bunker's Hill, Charlestown, Mass., 17 June 1775*
(1786; Yale University Art Gallery, New Haven, Connecticut).

Robert Indiana. *The Demuth Five*, 1963. Oil on canvas, 64″ x 64″.
Collection of Niva and Jay Kislak, Miami, Florida.
After Demuth's *I Saw the Figure 5 in Gold*
(1928; The Metropolitan Museum of Art, New York).

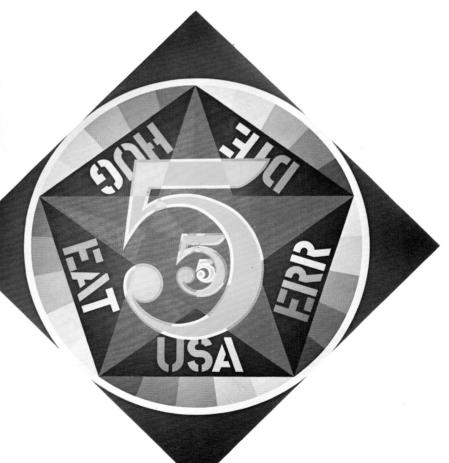

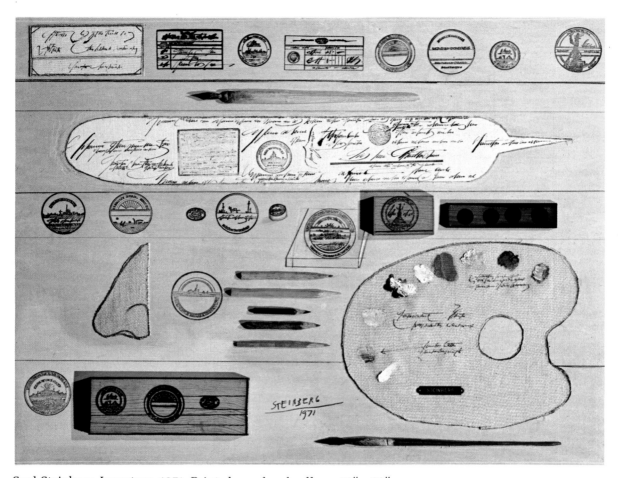

Saul Steinberg. *Inventory*, 1971. Painted wood and collage, 20″ x 26″.
Collection of Chermayeff & Geismar Associates Inc., New York. About artists' materials.

ABOUT THE ARTIST

The theme of art-about-art not only concentrates on direct references to specific works of art, but also includes works that use the materials and techniques of art as their subject. There exist precedents in eighteenth- and nineteenth-century American art for paintings-within-paintings and portraits of artists painting such as Matthew Pratt's *The American School* (1765) and Samuel F. B. Morse's *Exhibition Gallery of the Louvre* (1832–1833); however, contemporary American artists have refined their interest to focus on specific tools of painting—brushes, paints, stretchers, studios—rather than depictions of the act of painting. This chapter presents examples of works that have as their subject the materials of art. This choice of imagery is a recent phenomenon, although certain nineteenth-century trompe-l'oeil paintings of palettes and canvas backs by John Haberle and John Frederick Peto are certainly forerunners.

A paintbrush is, of course, a most familiar object to artists and an obvious subject for art. Jasper Johns cast a coffee can holding his brushes in bronze, painted it realistically, and aptly titled it *Painted Bronze*. His *Field Painting*, besides containing three-dimensional letters that spell RED, YELLOW, and BLUE, an actual paintbrush, and a palette knife, also makes direct reference to his own earlier work. This painting includes a Savarin coffee can and a Ballantine ale can, also the subject of a bronze cast, attached to the canvas; and both of these images recur frequently in his lithographs. *False Start* (color plate) is Johns's stylized color chart and palette, containing stenciled color names on color areas painted in contradictory colors.

Jim Dine has done numerous works about art materials, and has explained his interest in these objects in an interview: "More than popular images I'm interested in personal images, in making paintings about my studio, my experience as a painter, about painting itself, about color charts, the palette, about elements of the realistic landscape—but used differently." (*Art News*, November 1963) Saul Steinberg has also done works that are an autobiographical depiction of his worktable; *Relics III* and *Inventory* (color plate) include pencils, pens, a palette, and rubber stamps similar to those used by the artist for his drawings.

References to paint, in the tube and on the canvas, are abundant: John Clem Clarke's *Abstract #8* suggests a microscopic look at the surface of a nonobjective painting; Roy Lichtenstein's *Brushstrokes* and *Little Big Painting* (color plate) make reference to paint, to the act of painting, and to a style of painting. Lichtenstein discussed the *Brushstroke* paintings in an interview: "I was very interested in characterizing or caricaturing a brushstroke. The very nature of a brushstroke is anathema to outlining and filling in as used in cartoons. So I developed a form for it . . . to get a standardized thing—a stamp or image. The brushstroke was particularly difficult. I got the idea very early because of the Mondrian and Picasso paintings, which inevitably led to the idea of a de Kooning. The brushstrokes obviously refer to Abstract Expressionism." (*Artforum*, May 1967)

The actual support for a painting, the stretcher and canvas, is another recurring subject. The contemporary artist, working in his studio in constant contact with stretchers,

has chosen this object to become an artwork in itself, or has utilized the back of the canvas as the main point of interest. Lucas Samaras presents a mysterious bag of paintings; Lichtenstein's series of stretcher-frame paintings differ only according to their size and number of crossbar supports; Jasper Johns combines the reverse of an actual stretcher with other common objects; and Richard Jackson uses canvases as the instrument for making his wall installations, leaving the stretchers facing the wall to convey the sense of his process.

Art about commercialized, dime-store art is commented on by Johns in his drawing of one of his *Target* paintings, below which are a brush and watercolor disks inviting the viewer to join in completing the work; and by Warhol's *Do It Yourself* (color plate), which presents an enlarged and half-done paint-by-numbers picture as a work of high art.

The word *art* has also been transformed into works of art. Arneson's ceramic *Art Works*, Cottingham's neon marquee lettering of *Art* (color plate), and Lichtenstein's straightforward graphic *Art* present a tongue in cheek comment on both the subject and intention of the work.

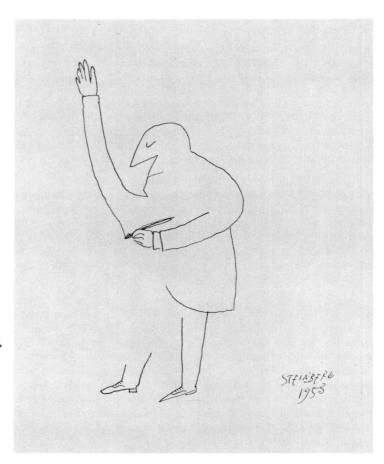

Saul Steinberg. *Untitled,* 1953. Ink on paper, 11″ x 8½″. Collection of Mr. and Mrs. Roy R. Neuberger, New York.

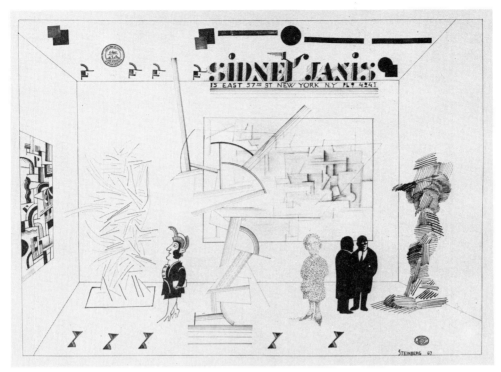

Saul Steinberg. *Sidney Janis Gallery*, 1967. Ink, crayon, and acrylic
on paper, 23″ x 29″. Private collection.

Saul Steinberg. *Relics III*, 1974. Painted wood and collage, 23″ x 28⅛″.
Sidney Janis Gallery, New York.

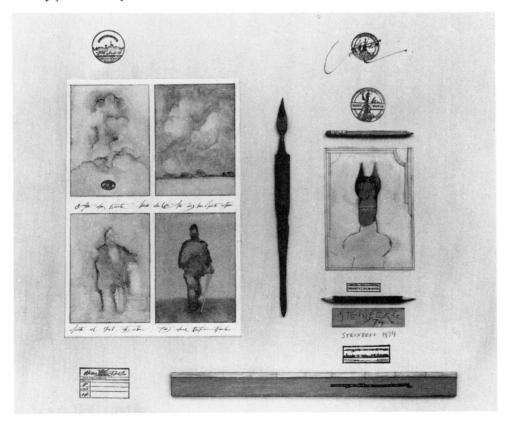

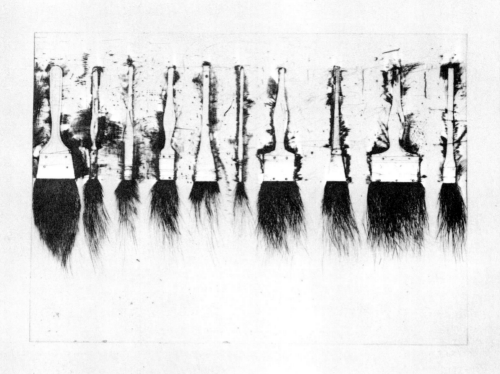

Jim Dine. *Five Paintbrushes III,* 1973.
Etching and aquatint, 29½″ x 35½″.
Brooke Alexander, Inc., New York.

Jasper Johns. *Painted Bronze,*
1960. Painted bronze,
13½″ x 8″. Collection of
the artist.

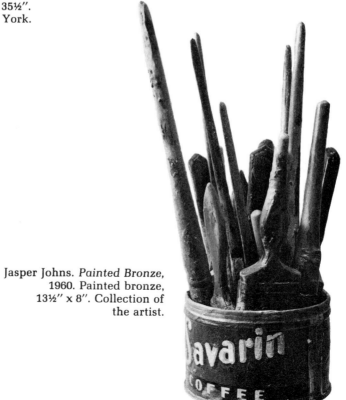

36

Jim Dine. *In My Cincinnati Studio*, 1963. Oil on canvas, 72″ x 96″.
Collection of Mrs. Elizabeth Blake, Dallas, Texas.

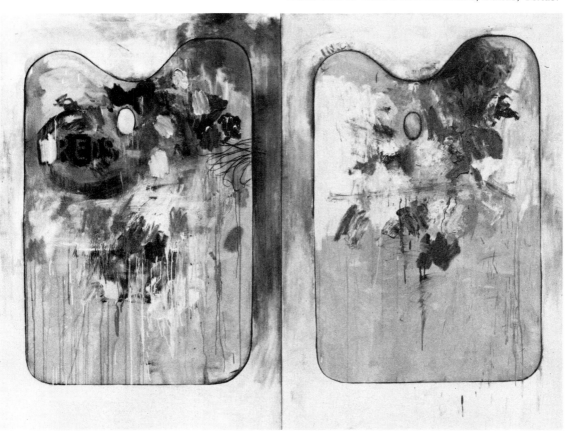

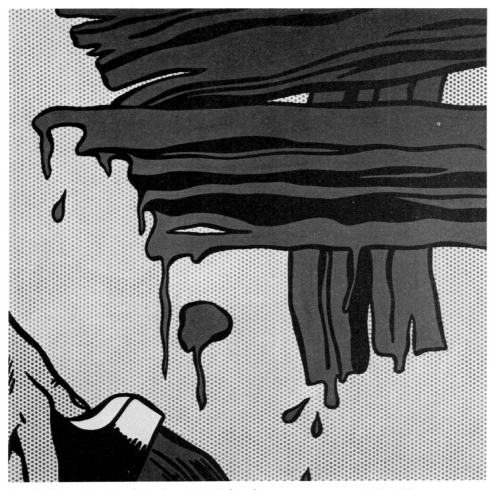

Roy Lichtenstein. *Brushstrokes,* 1965. Oil and magna on canvas, 48″ x 48″.
Collection of Mr. and Mrs. Bagley Wright, Seattle, Washington.

John Clem Clarke. *Abstract #8,* 1971. Oil on canvas, 69″ x 96″.
Collection of Mr. and Mrs. Raymond Goetz, Lawrence, Kansas.

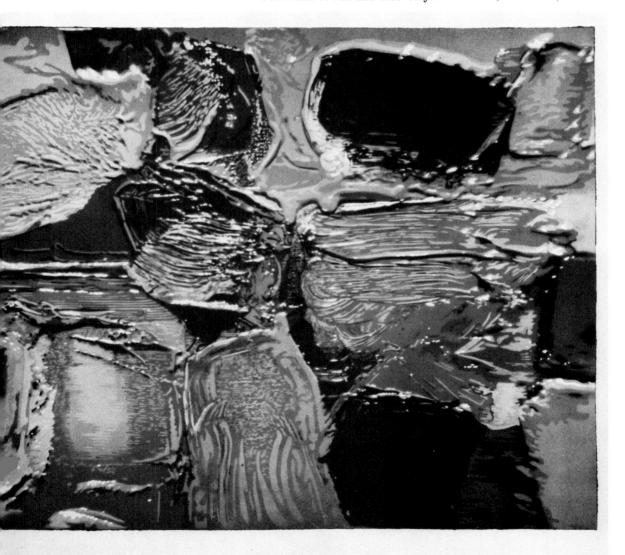

Audrey Flack. *Shiva Blue*, 1973. Oil on canvas, 35¾″ x 50″.
Collection of Dr. Jack Chachkes, New York.

Jasper Johns. *Field Painting*, 1963–1964. Oil on canvas with objects,
72″ x 36¾″. Collection of the artist.

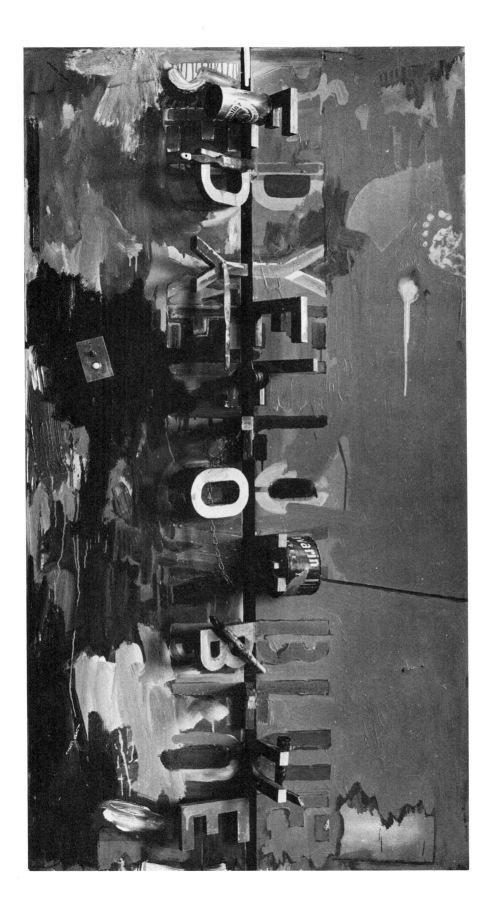

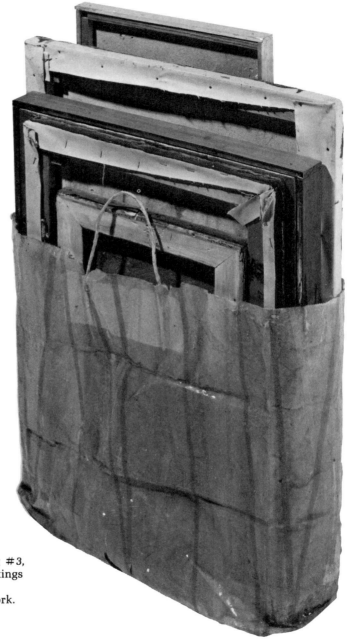

Lucas Samaras. *Paper Bag #3,*
1962. Paper bag with paintings
and mirror, 31″ x 22″ x 9″.
The Pace Gallery, New York.

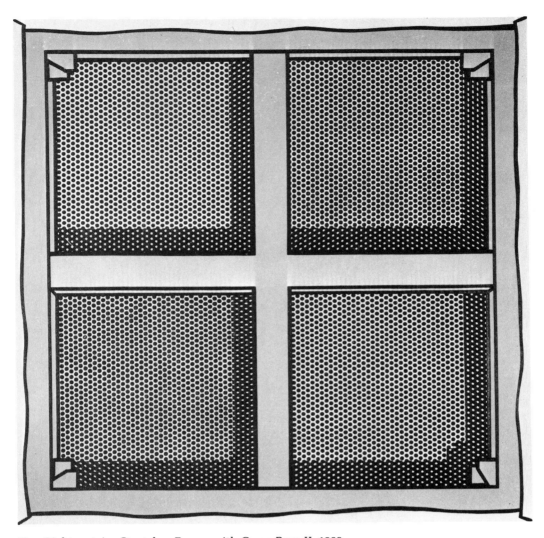

Roy Lichtenstein. *Stretcher Frame with Cross Bars II,* 1968.
Oil and magna on canvas, 48″ x 48″. Leo Castelli Gallery, New York.

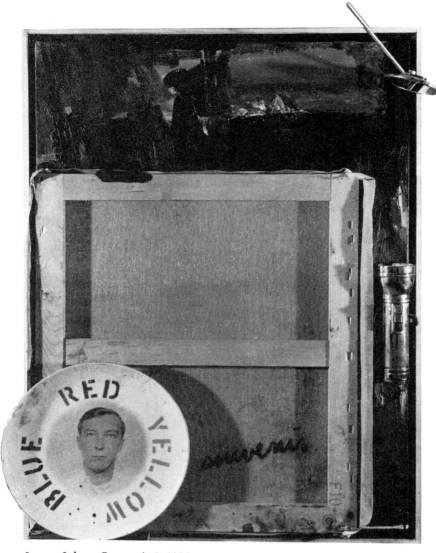

Jasper Johns. *Souvenir 2*, 1964.
Oil on canvas with objects, 28¾" x 21".
Collection of Mr. and Mrs. Victor W. Ganz, New York.

Richard Jackson. *Untitled Painting,* 1977. Acrylic, canvas, and wood; wall dimensions: 8' x 30'. Installed at the Institute for Art and Urban Resources, P.S. 1, New York.

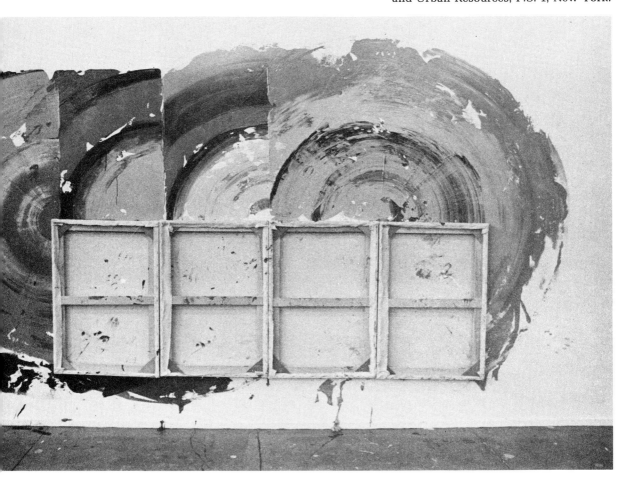

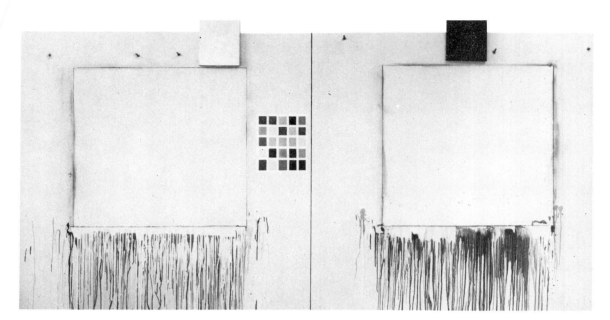

Jim Dine. *Double Studio Wall,*
1963. Oil on canvas and wood,
60″ x 120″. Collection of
Mr. and Mrs. David A. Wingate,
New York.

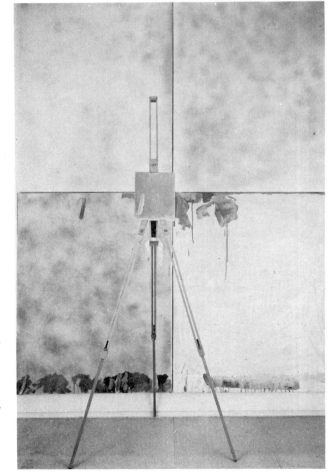

Jim Dine. *July London Sun 1969.*
Oil on canvas with easel,
96″ x 72″. Walker Art Center,
Minneapolis, Minnesota;
Intended gift of Mr. and Mrs.
Miles Q. Fiterman, Minneapolis.

Jasper Johns. *Studio,* 1964. Oil on canvas with objects, 88½″ x 145½″. Whitney Museum of American Art, New York; Gift of the Friends of the Whitney Museum of American Art.

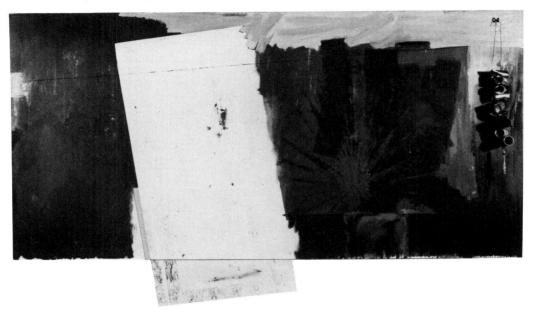

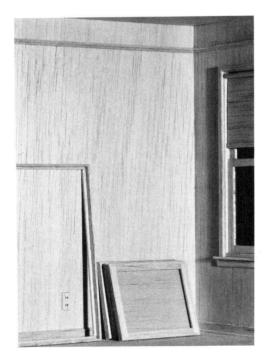

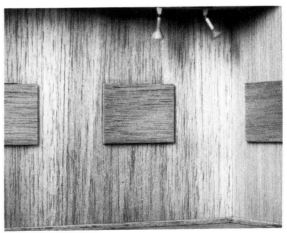

Michael Hurson. *Corner of a Studio/View of an Exhibition* (details), 1973. Balsa wood, 9⅛″ x 28″ x 8⅞″. Collection of the artist.

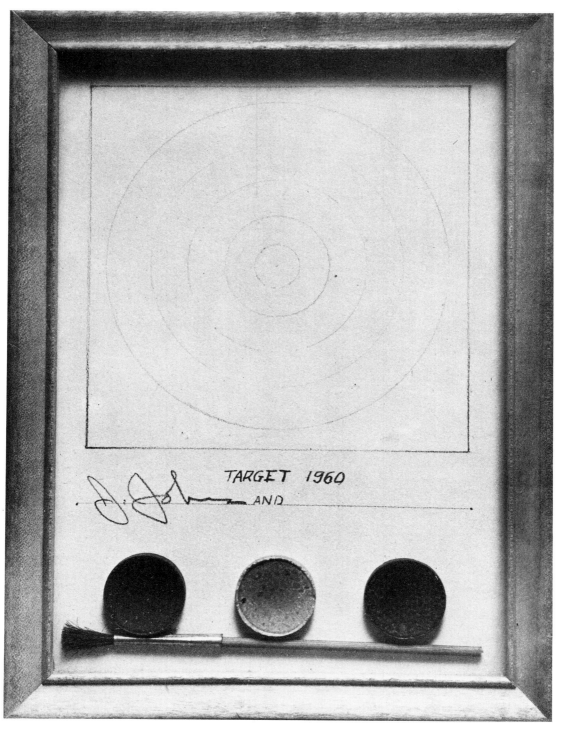

Jasper Johns. *Target,* 1960. Pencil on board with brush and watercolor disks,
6¾″ x 4⅝″. Collection of Ileana Sonnabend, Paris.

Andy Warhol. *Do It Yourself* (*Seascape*), 1962. Oil on canvas, 54″ x 72″.
Collection of Dr. Erich Marx, Berlin.

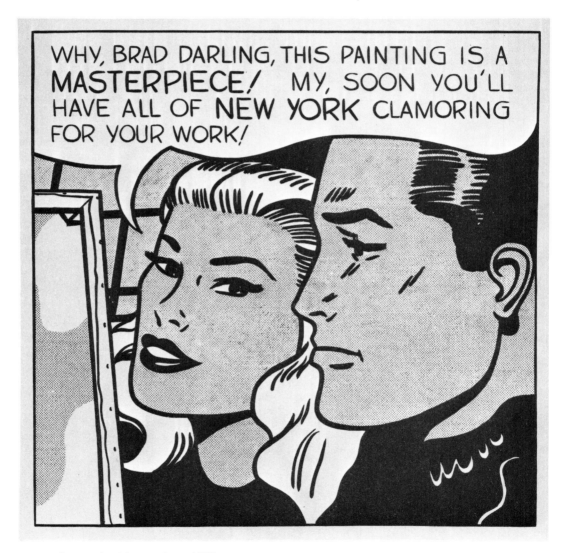

Roy Lichtenstein. *Masterpiece,* 1962.
Oil on canvas, 54″ x 54″. Private collection.

QUALITY MATERIAL - - -

CAREFUL INSPECTION - -

GOOD WORKMANSHIP.

ALL COMBINED IN AN EFFORT TO GIVE YOU A PERFECT PAINTING.

John Baldessari. *Quality Material*, 1967.
Oil and acrylic on canvas, 67¾″ x 56½″. Private collection.

Robert Rauschenberg.
Art Box, 1962–1963.
Painted wood crate,
30¾″ x 16⅝″ x 12¾″.
Collection of the artist.

Robert Arneson. *Art Works,* 1969. Glazed porcelain, 1″ x 7½″ x 4¾″.
Collection of R. Joseph Monsen, Seattle, Washington.

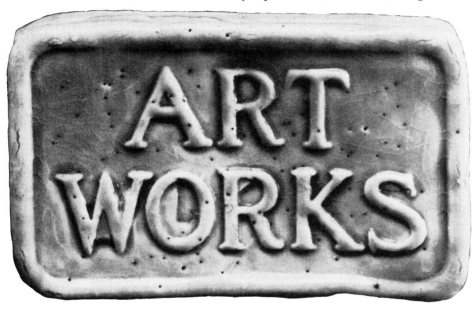

Roy Lichtenstein. *Art,* 1962. Oil on canvas, 36″ x 68″.
Collection of George Shea and Gordon Locksley, Rome.

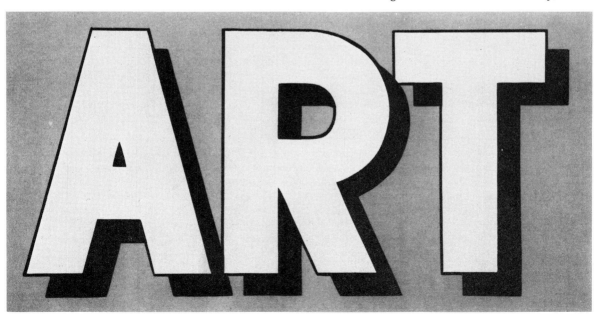

ABOUT OLD MASTERS

Throughout art history, artists have adapted to their own use the works of master artists they admire. This chapter presents works by contemporary American artists who use Old Master paintings as their point of departure. Old Masters, as used here, refers to famous artists from the Renaissance up until the neoclassic period at the beginning of the modern era. This group of Old Masters, ranging from fifteenth-century works by van Eyck through seventeenth-century paintings by Vermeer, is representative of the painters most often referred to in works by American artists. Artists represented in this chapter include van Eyck, Pisanello, Cranach, da Vinci, Michelangelo, Dosso Dossi, Rubens, Rembrandt, Velázquez, and Vermeer.

These Old Master works are well known, often reproduced, and thoroughly entrenched in our knowledge of the history of art. The fact that da Vinci, Rubens, Rembrandt, Velázquez, and Vermeer reappear so often in contemporary artworks is a reflection, not only of their greatness, but of their familiarity and availability in reproduction. Da Vinci's *Mona Lisa* is a star subject, as is his *Last Supper*; profile portraits of the early Renaissance abound; the most famous individual works by Rubens and Rembrandt are obvious choices; and Vermeer's serene interior scenes are rephrased again and again.

There are numerous reasons for the use of Old Master images, such as Rembrandt and Vermeer, as the model for a new work. Great technical expertise is exhibited by Malcolm Morley in his Photo Realist translation of Vermeer's *Artist in His Studio*; Rembrandt's complex composition of *The Night Watch* seemed particularly challenging to both Peter Saul and John Clem Clarke, although their paraphrasings are totally different in concept and effect; George Deem, who refers to his works as "Vermeer quotations," begins with Vermeer's basic composition but eliminates or adds figures, sometimes combining two different Vermeers into one painting; Josef Levi juxtaposes painted reproductions of a Pisanello portrait and an Oriental vase in a collagelike composition; John Clem Clarke restages Rubens's *Judgment of Paris,* posing his friends as the mythological characters, and executes the work in his stenciling technique; Lucas Samaras uses the pose of one of Michelangelo's Sistine Chapel figures for a Polaroid self-portrait.

A prominent feature of art about other art is the humor and wit exhibited, not only in the painting itself, but also in the titles. Warhol's title for the repeated silkscreen of *Mona Lisa* points out that *Thirty Are Better Than One*; Arneson's unlikely pairing of famous historical figures presents *George and Mona in the Baths of Coloma*; Arakawa's use of da Vinci's *Last Supper* is identified as being *Next to the Last*; and Colescott's transformation of van Eyck's portrait of the pregnant, and now black-faced, bride is titled *Natural Rhythm: Thank You Jan van Eyck*. The titles play a significant part in the re-presentation, further altering the subject and clarifying the new idea.

The various ways that Old Master images are used are as abundant as the images themselves. Joseph Cornell, one of the first contemporary American artists to utilize other art and especially Old Master works, included reproductions of Renaissance portraits in many of his enigmatic box constructions. *Medici Slot Machine* (color plate)

contains a variety of elements that are combined in a shallow box to create a rich and complex magic. Diane Waldman, in a 1967 Cornell exhibition catalogue for the Guggenheim Museum, wrote: "The image of the young boy, Moroni's *Portrait of a Young Prince of the Este Family,* in the Walters Art Gallery, Baltimore, is viewed as if through a gun-sight or lens. . . . The complex play of imagery, sequentially strung out . . . like a series of film clips, with the implication of movement both in time and in space, reconstructs the history of a Renaissance prince and juxtaposes these images of his imaginary childhood (diagrams of the Palatine fashioned from pieced-together Baedeker maps, etc.), with current objects (marbles and jacks) so that the Renaissance child becomes a very real and contemporary child. . . ."

Audrey Flack, in *Leonardo's Lady* (color plate), uses da Vinci's *La Belle Ferronière* as a prominent element in a Photo Realist still life. Flack's art-historical reference is not to the original oil painting, but to a reproduction included in an open book. Surrounding the lady, who peers intently at the viewer, are randomly arranged objects from a woman's dressing table.

A famous Rubens lady, from *The Toilet of Venus,* is seen reflected in her mirror in Rauschenberg's *Persimmon* (color plate). Rauschenberg has used a silkscreen of the Rubens, made from a commercial reproduction, as the central image of his collagelike painting. Because of the silkscreen technique, the details have become reduced to flat color areas, with the wide horizontal strokes of the squeegee—which forces inks through the screen—highly visible. The dominant image of Venus, combined with more vernacular scenes, takes on new meanings and makes her as much a creation of Rauschenberg as that of Rubens.

Larry Rivers draws on a famous Old Master work by Rembrandt, *The Syndics of the Drapers' Guild,* but not directly—he has borrowed from Rembrandt by way of a commercial product. Rivers's proto-Pop imagery is taken from commercial products and popular symbols, and *Dutch Masters and Cigars II* (color plate) contains dual references both to an Old Master work and to an ordinary cigar box. Rivers has done an abbreviated and sketchy version of the Rembrandt, repeating the group of figures twice as they appear on the inside of a cigar box. His palette of muted grays and browns mimics both the original and the Dutch Masters Cigars packaging. As with his rephrasing of David, Manet, and Cézanne, Rivers has revised the intent of the original works and given his paintings contemporary references and unexpected associations.

Mel Ramos has retained the basic composition of Velázquez's *Venus and Cupid* but has drastically altered and updated the images. His *Velázquez Version* (color plate) depicts Venus in the glossy, slick, and voluptuous style of girlie-magazine photography. Ramos's *Playboy*-style parodies of Velázquez, Ingres, Manet, and Boucher present an ironic combination of traditional eroticism and contemporary eroticism. He has further altered the original by replacing Cupid with a comical and unlikely monkey. Rauschenberg has used this same Old Master painting, but in a very different way; in *Crocus* he uses a silkscreen of the Velázquez, which he combines with other images in an overall composition. Whereas Ramos has sharpened the color, altered the content, and reversed the meaning, Rauschenberg presents a monochrome Venus, stripped of her eroticism and randomly placed among disparate images.

A fundamental difference between contemporary borrowing from Old Masters and borrowings done in previous centuries becomes highly apparent. As discussed by Leo Steinberg in the Introduction to this book, previous generations of artists disguised what they were doing. The contemporary artist encourages, and in fact expects, the viewer to be aware of the origin of his subject and of his deliberate restyling.

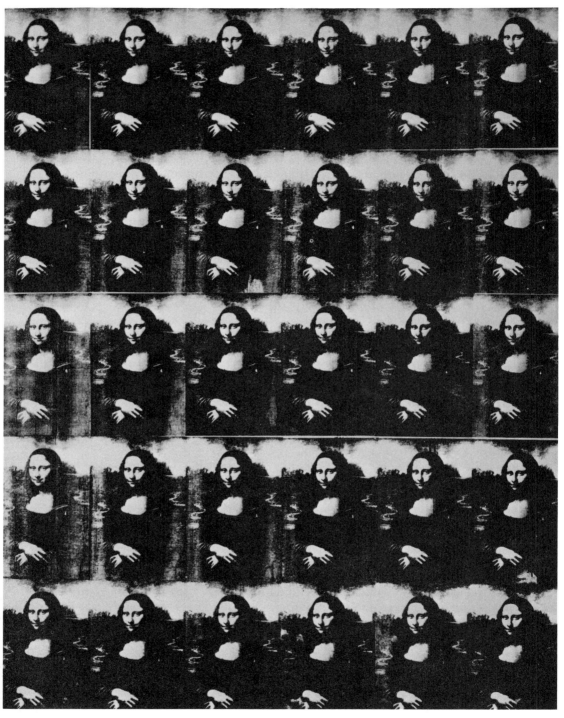

Andy Warhol. *Thirty Are Better Than One,* 1963. Silkscreen on canvas, 110″ x 82″.
Collection of Mr. and Mrs. Peter M. Brant, Greenwich, Connecticut.

Leonardo da Vinci's *Mona Lisa* (c. 1502; Louvre, Paris) is one of the most popular icons of art history, and reproductions of her famous countenance and enigmatic smile are available throughout the world. One of the earliest and most renowned alterations of a work of art was Duchamp's Dada desecration of the *Mona Lisa*, *L.H.O.O.Q.* (1919; Private collection), in which he penciled a mustache and goatee on a cheap reproduction. Duchamp continued his play on *Mona Lisa* in 1965 by singing an unaltered reproduction that appeared on playing cards and titling it *L.H.O.O.Q. Shaved.* Philippe Halsman has given the mustachioed Mona an added dimension by substituting Dali's equally famous face.

With the advent of Pop art, revised versions of the *Mona Lisa* proliferated; representative examples are shown here. Lawrence Alloway, in *American Pop Art*, discussed the use of this repeated silk-screened image by Andy Warhol: "In *Thirty Are Better Than One*, 1963, there are five rows of six Mona Lisas each; in *Mona Lisa*, 1963, the images are all scattered, not serial, with complete color changes; some images are tilted, and in addition, two details of the painting are added. The result is a jumpy and restless composition, in which the Mona Lisa's status as a cliché of twentieth-century art is celebrated. The thirty Mona Lisas stacked in alignment, however, has an hypnotic calm which makes the annexed image comparable to Marilyn or the soup cans."

Rauschenberg's colored transfer drawing repeats the head and bust as part of a rich mix ranging from sharp lettering to sweeping brushstrokes. His transfer technique, in which solvent-loosened inks are transferred to paper by rubbing, results in the reversal of the image. Jasper Johns integrates *Mona Lisa* into a lithograph of the *Figure 7.* Tom Wesselmann's colorful painting, which includes actual objects, establishes the *Mona Lisa* as an important part of Pop iconography and features her famous smile, echoed and exaggerated in the mouth that has been collaged onto the bold pink nude. Robert Arneson's ceramic parody shows America's national hero (nude) smirking lustfully at France's number one treasure (also nude), whose formerly mysterious smile now seems quite obvious. Marisol's wood sculptures frequently portray her own striking good looks, and this version, hewn from one wood block, transforms Mona into a self-portrait stele.

Leonardo da Vinci.
Mona Lisa, c. 1502.
Oil on panel, 30″ x 21″.
Louvre, Paris.

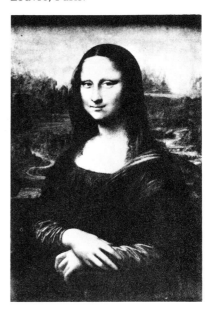

Robert Rauschenberg.
Mona Lisa, 1958.
Ink, pencil, and watercolor
on paper, 22¾″ x 28¾″.
Collection of Ethel
Redner Scull, New York.

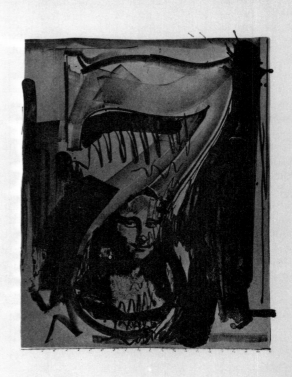

Jasper Johns. *Figure 7,* 1969.
Lithograph, 37″ x 30″.
Gemini G.E.L., Los Angeles.

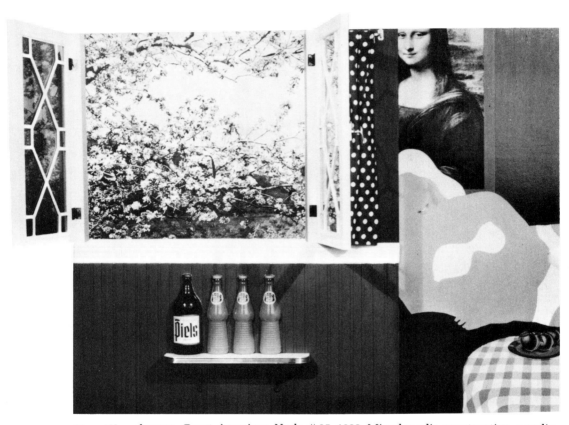

Tom Wesselmann. *Great American Nude #35,* 1962. Mixed-media construction, acrylic, enamel, and collage on composition board, 48″ x 60″. Collection of Frances and Sydney Lewis, Richmond, Virginia.

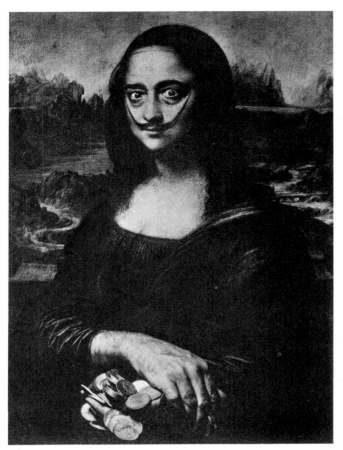

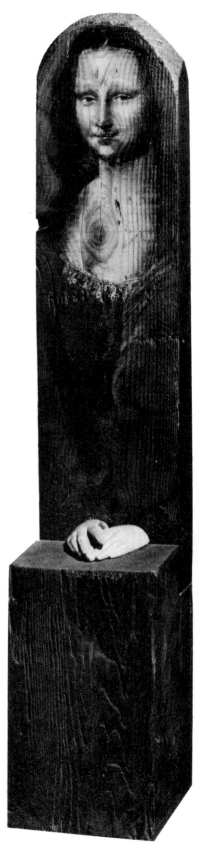

Philippe Halsman. *Mona Dali*
(*What Dali sees when he looks at Mona Lisa*), 1954.
Photograph. Copyright © by Philippe Halsman.

Marisol. *Mona Lisa*, 1961–1962.
Painted wood and ceramic, 65″ x 12″ x 12″.
Collection of Mrs. Babette Newburger, New York.

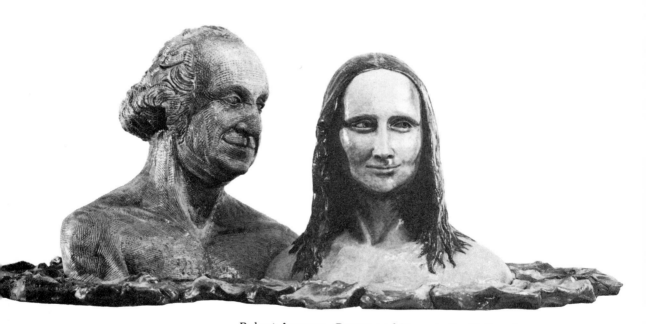

Robert Arneson. *George and Mona in the Baths of Coloma*, 1976. Glazed ceramic, 30″ x 57″ x 25″. Stedelijk Museum, Amsterdam.

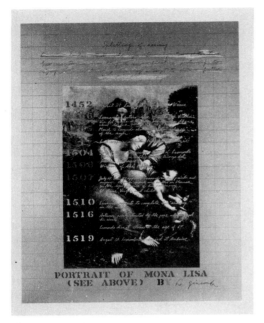

Arakawa's *Mona Lisa* could be considered a conceptual self-portrait of the famous figure. It features a silkscreened version of a reproduction of another da Vinci painting, *St. Anne, the Virgin, and the Infant Christ, with a Lamb* (1510-1511; Louvre, Paris), overlaid with stenciling and handwriting that chronicle events in da Vinci's life. The work is ironically signed by "La Gioconda." Arakawa pays homage to da Vinci in another print, *Next to the Last,* which presents a schematic outline of *The Last Supper* (1494-1497; S. Maria delle Grazie, Milan). The entire composition has been squared and numbered, the figures are silhouetted with a spectral line, and elements and locations in the painting are identified with stenciling and arrows. Arakawa's humorous title suggests that the

Shusaku Arakawa. *Portrait of Mona Lisa,* 1971. Silkscreen, 44½″ x 33½″. Multiples/Marian Goodman Gallery, New York.

Shusaku Arakawa. *Next to the Last,* 1971. Silkscreen, 27¼″ x 42 5/16″. The Museum of Modern Art, New York; Reiss-Cohen Fund.

print is da Vinci's last preparatory drawing before commencing the final *Last Supper.*

Edelson is a devout feminist and has said of her early work: "My canvases were divided into threes with the woman placed in the central panel, the center of the Trinity." *(Arts Magazine,* November 1975) In this work photographs of prominent women artists are collaged on a reproduction of *The Last Supper* by Leonardo da Vinci (1494–1497; S. Maria delle Grazie, Milan), and seated according to Edelson's opinion of the proper protocol. Georgia O'Keeffe is Christ, with Louise Nevelson fully as prominent. The artists, seated and making up the border, are all identified with typewritten labels.

Mary Beth Edelson.
Some Living American Women Artists, 1972. Offset lithograph, 24½" x 38". A.I.R. Gallery, New York.

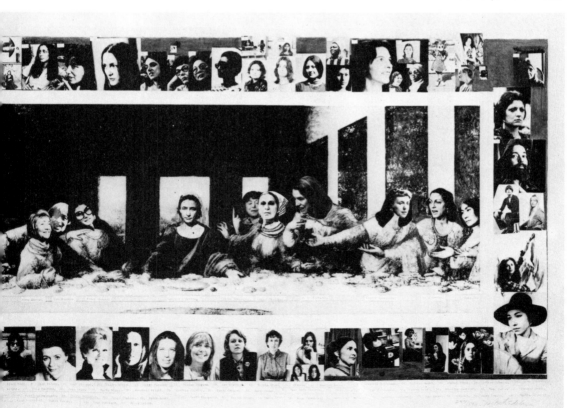

SOME LIVING AMERICAN WOMEN ARTISTS

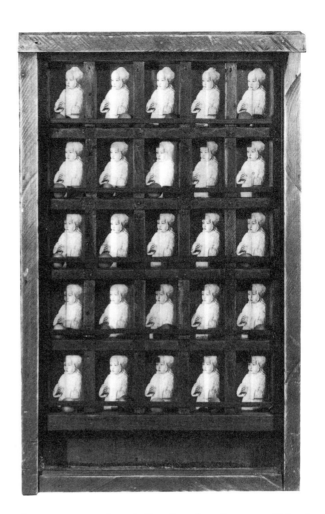

Joseph Cornell. *Flemish Child,*
c. 1950. Box construction with
reproductions, 21″ x 12″ x 3¼″.
Collection of Mr. and Mrs. Edwin
A. Bergman, Chicago.

The concept of serialization has been strikingly
prevalent in recent years, and several articles have
discussed the ways various artists compose in
terms of grid or film-strip repeats. Cornell has de-
signed a great many of his boxes in this mode, not
primarily with the intellectualized notion of serial
imagery, but rather with a romantic sense of lyrical
rhythm. He always created a subtle magic, "like the
ritual repetition of the alchemist," as Dore Ashton
describes it in her *Joseph Cornell Album. Flemish
Child* is divided into twenty-five miniaturized
boxes, varied only by the loose wooden balls,
which move at random. The repetition of color
reproductions of the fifteenth-century Flemish
child, J. Piel's *Mlle. de Moulins,* is discussed by
Diane Waldman in *Joseph Cornell* as prefiguring
"Warhol's use of silkscreen images of famous
movie stars like Elizabeth Taylor, Marilyn Monroe,
and Elvis Presley. Cornell's interpretation of the
film still as a repetitive image, with or without

Brice Marden. *Homage to Art 13*, 1974. Postcards, graphite, and wax on paper, 30¼″ x 20¾″. Collection of Elisabeth de Laage, Paris.

variations, can be both poetic and plastic in significance. For Cornell, the repeated image is the starting point for a series of complex developments, for multiple possibilities and associations. . . ."

Brice Marden has done a series of *Homage to Art* collages, repeating images and making direct references to admired artists. Linda Shearer, in the Guggenheim Museum *Brice Marden* catalogue, notes that: "Brice Marden has consistently professed and acknowledged his ties with traditional painting. He sees himself, like Manet, combining and balancing a modern sensibility with earlier sources." This collage combines a series of postcard reproductions of Cranach's *Venus, with Cupid Stealing Honey* (1537; Rijksmuseum Kröller-Müller, Otterlo) with Marden's familiar gridded rectangles. The repetition of the image, balanced and edged by the monotone rectangles, activates the relatively flat and static surface.

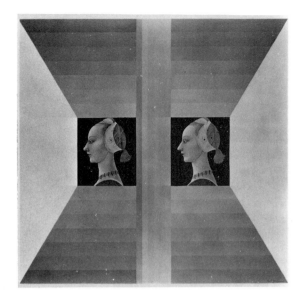

Sante Graziani.
Renaissance Jewel, 1968.
Acrylic on canvas, 35" x 35".
Private collection.

These two paintings are among the numerous contemporary works that comment on the great profile portraits of the early Renaissance. It seems that these Quattrocento masterpieces have been especially congenial to contemporary artists who value minimal form, expressive line, and clear, flat color. Josef Levi's copy of Pisanello's *Princess of the House of Este* (1438–1440), a Louvre treasure, is presented as a handsome design, as are the figures on the Ming vase; the Photo Realist bulk of the apple in the foreground, emphasized by its shadow, dramatizes the flatness of the background figures. Sante Graziani's painted shadow box crops, doubles, and frames the *Portrait of a Lady* by the Master of the Castello Nativity; the original "Renaissance jewel" is owned by the Isabella Stewart Gardner Museum in Boston. Both Graziani and Levi have devoted their entire work to art-about-art subjects in great variety, with Levi's compositions consistently featuring flatly patterned reproductions of artworks with three-dimensional fruits or vegetables in the foreground.

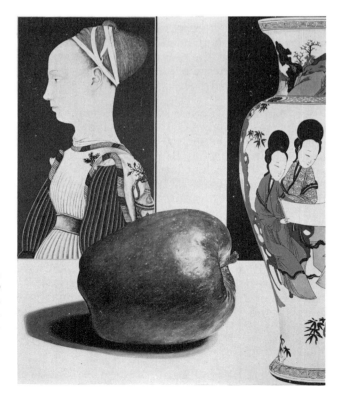

Josef Levi.
*Still Life with Pisanello
and Ming Vase,* 1975.
Acrylic on canvas, 34" x 29".
A. M. Sachs Gallery, New York.

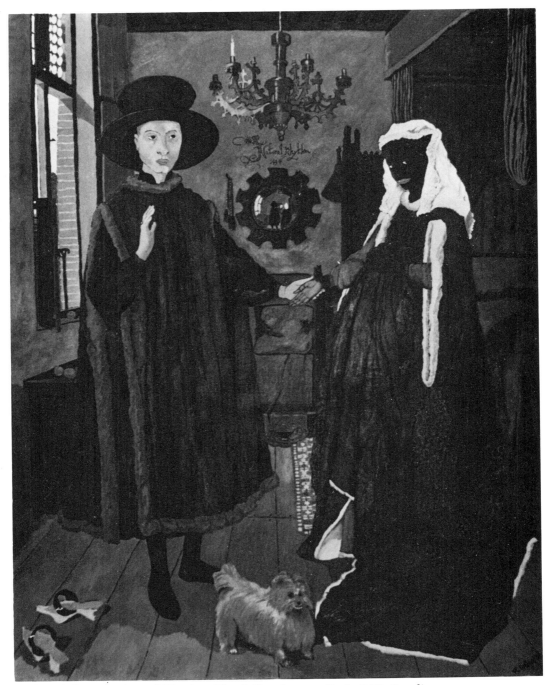

Robert Colescott. *Natural Rhythm: Thank You Jan van Eyck*, 1975. Acrylic on canvas, 78″ x 66″. Collection of R. H. Orchard, St. Louis, Missouri.

In Jan van Eyck's time the marriage rite was a simple symbolic act, requiring only that groom and bride join hands. His famous *Giovanni Arnolfini and His Wife* (1434; National Gallery, London) seems, at first glance, only slightly altered by Robert Colescott, a black artist who does ethnic satires of famous paintings. Colescott has reproduced the original work as a straight point of departure for his parody and, by blackening the skin of the bride, has intensified the double entendre, making this small visual alteration especially bold.

Lucas Samaras, a sculptor and painter, has done several major series of Polaroid photographs using himself as subject. For one group he has used poses that specifically refer to Michelangelo's Sistine Chapel ceiling frescoes; the posture in the Polaroid illustrated here is directly modeled after one of the figures from the Sistine Ceiling. In an essay introducing his first *Autopolaroids,* Samaras wrote: "I allowed satire of my art education to enter into the compositions." (*Art in America,* November–December 1970)

Lucas Samaras.
Autopolaroid, 1970.
Photograph, 3¾" x 2⅞".
The Pace Gallery, New York.

Michelangelo.
Sistine Ceiling (detail),
1511. Fresco.
Sistine Chapel, The Vatican.

Audrey Flack has done a number of large-scale, photograph-inspired paintings of religious images, including a series of paintings of seventeenth-century wood carvings of Madonnas. This painting presents Michelangelo's *David* (1501–1504; Galleria dell'Accademia, Florence) in frontal view; and Flack has minimized the sculptural unity of the marble statue by breaking up the heavily muscled figure with strong areas of light and shadow, and flattened it by making the richly painted stonework of the background as important as the figure. The prominent allover texturing of background and figure, a tour de force of exactly opposite intent from trompe-l'oeil painting, transforms a monumental figurative sculpture into a painterly abstraction.

Audrey Flack.
David, 1971.
Oil on canvas,
64″ x 45½″.
Private collection.

John Clem Clarke. *Velázquez—Maids of Honor*, 1972. Oil on canvas, 56″ x 52″.
Morgan Gallery, Shawnee Mission, Kansas.

Juan Downey.
Still from *Las Meninas*
(*The Maidens of Honor*),
1975. Color video,
21 minutes. Electronic
Arts Intermix, New York.

Diego Velázquez.
Las Meninas, 1656–1657.
Oil on canvas, 125″ x 108½″.
Museo del Prado, Madrid.

Velázquez's *Maids of Honor* has been a prime source for twentieth-century artists. Picasso's major series of paintings inspired by this masterpiece, which he gave to the Barcelona Museum, is a prominent example. John Clem Clarke's detail exactly follows the original, altered, of course, by Clarke's personalized stencil and airbrush technique; the detail reads as a cohesive whole— cropped to make the figures focus closely on the centered princess. Clarke's entire career has been devoted to art-about-art subjects.

Juan Downey's videotape is organized to interpret the Velázquez painting rather than to show portions of it for its own sake. Dancers perform with gestures appropriate to the painted figures; the actors and the Velázquez subjects are skillfully combined so that the nobles in the painting seem to perform with the dancers.

71

Robert Rauschenberg.
Trapeze, 1964. Oil and
silkscreen ink on
canvas, 120″ x 48″.
Galerie Sperone, Turin.

Beginning in 1962, Rauschenberg did a series of silkscreen paintings that juxtaposed diverse and disparate images into a visually active and balanced composition. He selected images he liked from newspapers, magazines, and art books, and had them photographically transferred onto silkscreens by a commercial firm. Using silkscreen inks, he would compose various combinations of these images on the canvas, followed by direct rubbing and splattering of paint. Rauschenberg described his use of silkscreens for Calvin Tomkins (*The Bride & the Bachelors*): "When I get the screens back from the manufacturer the images on them look different from the way they did in the original photographs, because of the change in scale, so that's one surprise right there. Then, they look different again when I transfer them to canvas, so there's another surprise. And they keep on suggesting different things when they're juxtaposed with other images on the canvas, so there's the same kind of interaction that goes on in the combines and the same possibilities of collaboration and discovery."

The silkscreen paintings of 1962 to 1964 incorporate three specific art-historical references: the Sistine Chapel and two different depictions of Venus. *Crocus* is one of the first of this series of paintings and is done entirely in black and white. The central silkscreen image is Velázquez's *Venus and Cupid* (1645–1648; National Gallery, London) surrounded by an army truck, mosquitoes, and the Cupid as a detail. *Trapeze*, done in 1964, utilizes red, yellow, and blue silkscreen inks and features Rubens's *The Toilet of Venus* (1612–1615; Liechtenstein Gallery, Vienna) surmounted by overlapping parachutists. Rauschenberg reused the silkscreens in a number of paintings: the Velázquez appears in *Barge*, *Exile II*, *Bicycle*, *Transom*, and *Overcast III*; the Rubens, or a detail, appears in *Tracer*, *Axle*, *Buffalo II*, *Press*, *Flush*, *Creek*, and *Persimmon*.

Rauschenberg's use of acknowledged masterpieces of art history serves as an appropriate foil to the more vernacular images used in the paintings. The similarity of the two images of Venus, seen from the back, looking into a mirror held by Cupid, suggests an intentional choice made by the artist. The traditional and mythological image of beauty reflected in the mirror perhaps suggests a parallel to the manner in which Rauschenberg's paintings become a reflection of contemporary, urban environment.

Robert Rauschenberg.
Crocus, 1962. Oil and
silkscreen ink on canvas,
60″ x 36″. Collection of
Leo Castelli, New York.

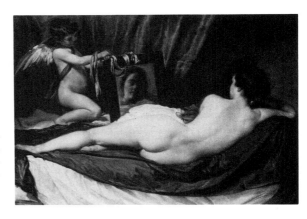

Diego Velázquez.
Venus and Cupid, 1645–1648.
Oil on canvas, 47⅞″ x 69¼″.
National Gallery, London.

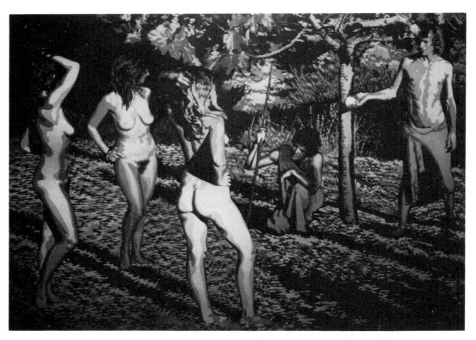

John Clem Clarke. *Judgment of Paris,* 1970. Oil on canvas, 79″ x 108″.
Collection of Mr. and Mrs. M. H. Rapp, Toronto.

The mythological theme of the Judgment of Paris has been a favorite subject of painters and sculptors for centuries. Cranach, Rubens, Boucher, and Renoir have all depicted the three undressed figures parading before the judging Paris. John Clem Clarke's composition follows the Rubens version closely, but his controlled spray technique and comic updating of the scene totally alters the mood. Clarke has posed friends and acquaintances in positions similar to the source painting—two groups, Paris and Hermes on the one hand and the three competing goddesses on the other. But the contemporary look and postures of the figures totally modernize this mythological scene.

David Bourdon has discussed the recently popular practice of updating classical subjects, mentioning Alfred Leslie's "Neo-Neo-Classical" figures that modernize Jacques-Louis David, and commenting on Milet Andrejevic's series of allegorical scenes anachronistically set in New York's Central Park. Andrejevic does not directly follow Old Master models, but, as Bourdon points out, "His pictures (painted in egg tempera and oil) feature muted colors, soft light, and an atmosphere of Apollonian calm that recall the cool classicism of Poussin, the 17th-century master, as well as the stagy allegorical compositions of the 19th-century painter, Puvis de Chavannes." (*The Village Voice,* March 22, 1976)

Peter Paul Rubens.
The Judgment of Paris, c. 1635.
Oil on canvas, 57″ x 75″.
National Gallery, London.

Milet Andrejevic. *Judgment of Paris*, 1970. Egg tempera on paper, 22¼″ x 19½″.
Collection of Mr. and Mrs. Adam Aronson, St. Louis, Missouri.

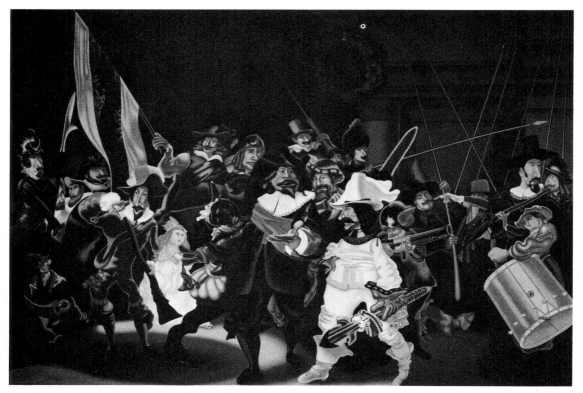

Peter Saul. *The Night Watch*, 1974–1975.
Acrylic on canvas, 88″ x 128″.
Allan Frumkin Gallery, New York.

Rembrandt. *The Company
of Captain Frans Banning
Cocq and Lieutenant Willem
van Ruytenburch
[The Night Watch]*, 1642.
Oil on canvas, 137¾″ x 172½″.
Rijksmuseum, Amsterdam.

Peter Saul is devoting his entire attention to rein-
terpreting well-known paintings. Rembrandt's
model for Saul's *Night Watch* includes twenty-
nine full-length figures, sharpshooters led by their
captain, who surge outward from the background
in a dramatic flow of color, light, and movement.
Saul has not only exaggerated but caricatured
every detail. Distortions of scale, exaggerating the
sizes of the hands, hats, and weapons, and overall
distortion of shapes and contours produce figures
that look as if they were reflected in amusement-
park fun-house mirrors. The odd portrait of a
young girl, whose presence is surprising even in
the Rembrandt painting, is flattened and high-
lighted to become a peculiarly featured figure, as
much so as the burgher prominent in the fore-
ground. Rembrandt's subtle tonalities and color
are made crude and garish, his figures ridiculously
rippled, his portrait heads violently caricatured;
and it all adds up to a lively pictorial spoof of the
most famous tourist attraction in the Rijks-
museum.

76

Half of a color reproduction of Dosso Dossi's *Circe and Her Lovers in a Landscape* (c. 1525; National Gallery of Art, Washington, D.C.) is the featured element in this lyrical collage. Circe's rounded form seems to relate formally to the planets centered at the top, and these spheres, in turn, are part of the arrangement of geometrical forms. All the elements of the collage, including the Dosso reproduction, are connected by the Mondrian-like linear grid. This recalls Cornell's continuous interest in Mondrian, as do the colors; the background is white with some strong red and blue that dominate the more subdued colors.

Joseph Cornell. *Cassiopeia*, 1966. Collage and oil on board, 9″ x 11¾″.
Collection of Mr. and Mrs. Edwin A. Bergman, Chicago.

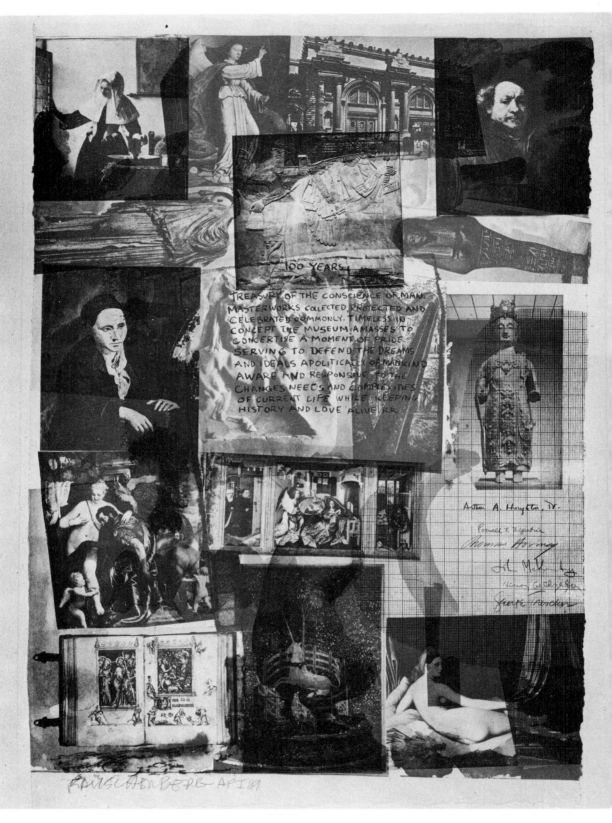

100 YEARS

TREASURY OF THE CONSCIENCE OF MAN.
MASTERWORKS COLLECTED PROTECTED AND
CELEBRATED COMMONLY. TIMELESS IN
CONCEPT THE MUSEUM AMASSES TO
CONCRETISE A MOMENT OF PRIDE
SERVING TO DEFEND THE DREAMS
AND IDEALS APOLITICALLY OF MANKIND
AWARE AND RESPONSIVE TO THE
CHANGES NEEDS AND COMPLEXITIES
OF CURRENT LIFE WHILE KEEPING
HISTORY AND LOVE ALIVE. RR

When The Metropolitan Museum of Art celebrated its hundredth anniversary, Rauschenberg was commissioned to do a commemorative lithograph; an anthology theme was a logical choice for the occasion. Both the content and technique of this lithograph—printed from two stones and two aluminum plates in red, yellow, blue, and brown—represent Rauschenberg's special interests, and the choice of the artworks from the museum's collection are his. The graph-paper stone had been used in a previous Rauschenberg print, *Visitation 1*, which adds a direct reference to his own work. The complex composite of superimposed art images, including examples by Vermeer, Rembrandt, Picasso, and Ingres, is in a sense an exaggeration of Rauschenberg's typical series of silkscreen paintings, transfer drawings, and related prints that include similar references to works of art.

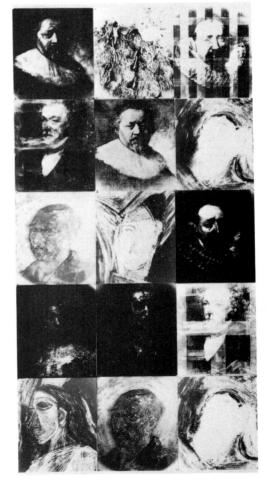

Agnes Denes. *Introspection III—Aesthetics*, 1972. X-ray photographs, 86″ x 42½″. Collection of the artist.

Agnes Denes has deliberately extended the traditional realm of art to include concepts of science. In this piece her grid arrangement of X-ray photographs of portrait heads by van Gogh, Picasso, and various Old Masters suggests critical comment on art history, produced as if in a laboratory. The artist explains that "X rays are taken at various layers, as if we were reversing the process of painting to reveal intermediate stages available only to the artist at the time." Peter Selz wrote of this work: "Instead of using methods of art history and art criticism, she turns to the physical object—the painting—and penetrates its layers to disclose working habits and painting techniques. Her aim is to reverse the process of paint application, as it were, in order to come face to face with the beginnings of structure itself—and thereby stretch the artist's mind." (*Art in America*, March-April 1975)

Robert Rauschenberg. *Centennial Certificate M.M.A., 1969*. Color lithograph, 36⅛″ x 24″. Whitney Museum of American Art, New York; Gift of Mr. and Mrs. Stanley L. Helfgott.

Jan Vermeer's *The Artist in His Studio* (1665–1670; Kunsthistoriches Museum, Vienna) seems to be, after the *Mona Lisa,* the most popular for contemporary artists doing paintings about paintings. A number of Vermeer updatings have been done, a few of which are reproduced here.

Malcolm Morley's version follows the original in every detail, and the orchestration of pure, cool colors, subtle tonal contrasts, and mood of serenity retain the aura of the Vermeer. It is actually only the conceptual approach that justifies the effort: Morley has produced a Photo Realist copy of a painting from a color reproduction with just the same attitude and precision that he has copied postcards and photographs of ocean liners. His method is to mark off the reproduction in a ruled grid and then copy it square by square. Here the blank edge of the reproduction, included in his painting, emphasizes the fact of the painting being a reproduction of a reproduction, with emphasis on the flatness of the paper as opposed to the illusionistic depth of a Vermeer painting.

James McGarrell has fractured and recombined, altered and added to, and updated the same Vermeer masterpiece. The artist is now a self-portrait of McGarrell; his model and the furniture are also updated. His architectonic composition remains based on the Vermeer, but he has complicated the idea with the repeat pose and similar dress of his and Vermeer's model. The prominent striping of McGarrell's tucked jacket and Vermeer's doublet again focuses attention on the complex pictorial replay of the original Vermeer scene.

Carole Caroompas's collaged *Ladies in Waiting* includes a number of Vermeer ladies; centrally placed is the model from *The Artist in His Studio* flanked by the *Kitchen Maid* (1658; Rijksmuseum, Amsterdam), and *Girl Reading a Letter Near the Window* (1657; Gemäldegalerie, Dresden). Other collaged reproductions, including photographs of the artist herself, combine to form a complex, colorful, and humorous statement.

Sante Graziani doubled Vermeer's self-portrait to make a symmetrical foreground pattern, which occupies only a fraction of the canvas. The rest is an abstract design of dots that recalls Roy Lichtenstein's technique stripped of his content.

George Deem, who has done numerous Vermeer-inspired paintings, has used *Lady at the Virginals with a Gentleman* (1660; Buckingham Palace, London) as the source for his *George Washington Vermeer*. Deem has, however, removed the lady and gentleman and placed Gilbert Stuart's *George Washington* in what was previously a framed mirror, leaving George to stare into an empty and unlikely setting. Two years after he did this painting, he invented an elaborate Vermeer scene in which he restored the figures to the *Lady at the Virginals* composition and combined that painting with a revised portion of *The Artist in His Studio,* a painting he has paraphrased in several other versions. Deem, who has been incorporating European and American masterpieces in his work for the last fifteen years, has done numerous paintings and drawings that he describes as "all employing Vermeer quotations."

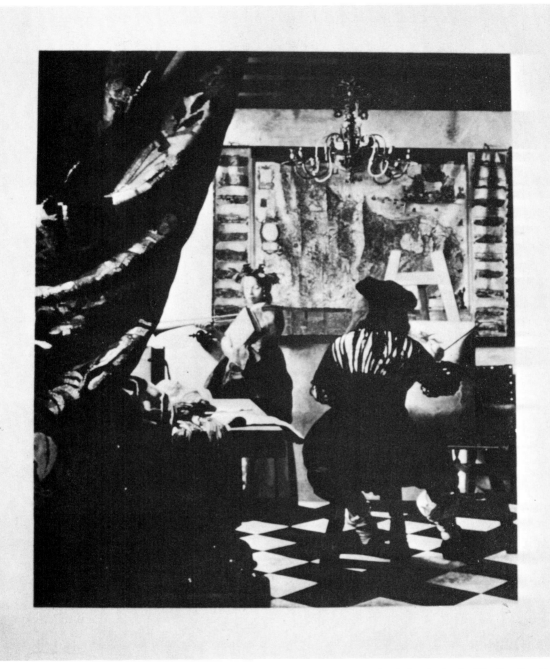

Malcolm Morley. *Vermeer—Portrait of the Artist in His Studio,* 1968.
Acrylic on canvas, 105″ x 87″. Private collection.

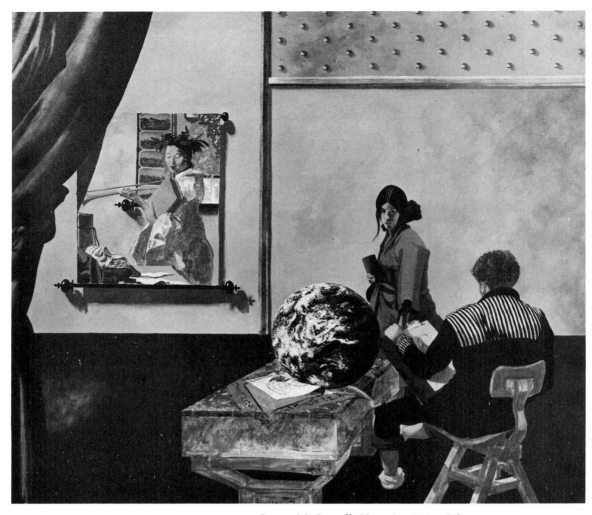

James McGarrell. *Veracity,* 1969. Oil on canvas,
61⅛″ x 71″. Hirshhorn Museum and Sculpture
Garden, Smithsonian Institution, Washington, D.C.

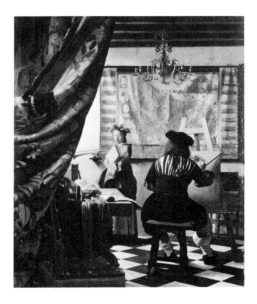

Jan Vermeer. *The Artist in His Studio,*
1665–1670. Oil on canvas, 52″ x 44″.
Kunsthistorisches Museum, Vienna.

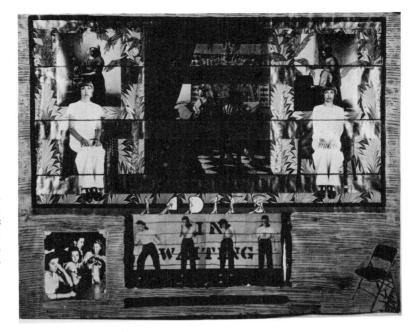

Carole Caroompas.
Ladies in Waiting, 1975.
Collage and acrylic
on paper, 20⅛″ x 24⅞″.
Ellie Blankfort Gallery,
Los Angeles.

Sante Graziani.
Vermeer and His Model,
1968. Acrylic
on canvas, 35″ x 35″.
Private collection.

George Deem.
George Washington Vermeer,
1974. Oil on canvas, 32″ x 28″.
Collection of the artist.

George Deem.
Vermeer Interior, 1976.
Oil on canvas, 29″ x 36″.
Collection of R. H. Orchard,
St. Louis, Missouri.

Jan Vermeer's *Portrait of a Young Girl* (1660–1665; Mauritshuis, The Hague), cut from a color reproduction, seems to look out from a Vermeer window in a geometrical abstraction of a Vermeer room. Dore Ashton, in her *Joseph Cornell Album,* devotes several pages to analyzing Cornell's inspiration, identifying Vermeer as "the remote friend whose sensibilities matched his own." Cornell had written in a letter that Vermeer was "gyroscopic" in his life. Vermeer's basic form is actually quite like Cornell's—a box into which one peers at a quiet, luminous scene. The Mondrian-like grid in this *Grand Hôtel* box strengthens the recall of Vermeer's architectonic divisions of space. (Cornell knew Mondrian in New York in the 1940s and his works of the 1950s show definite influences—the classic purity of design, geometric partitions, predominantly white color accented with blue and red.) Everything is fused and personalized by the alchemy of Cornell's poetic and technical subtlety. Notice, for instance, the strengthened contour of the young girl's face, made by leaving a bit of the dark background when he cut out the head; the splashes of white paint on the portrait, a casual transition between the Vermeer reproduction and Cornell's collaged and painted background; the holes punched in the top wood strip that parallel and emphasize the lettering. John Bernard Myers, in the catalogue for the ACA Gallery show that first exhibited this box, ends his essay by saying: "like Vermeer, Cornell made small works of art; it was his genius to imply the Cosmos."

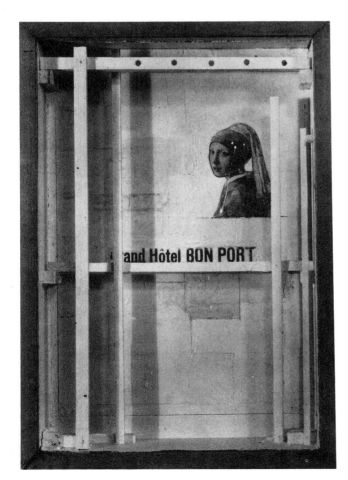

Joseph Cornell.
Grand Hôtel Bon Port,
c. 1950. Box construction
with reproductions, 19" x 13".
Collection of Mr. and Mrs.
Edwin A. Bergman, Chicago.

ABOUT MODERN MASTERS

Just as many of the most advanced European artists of the nineteenth and twentieth centuries turned to the Old Masters for provocative subject matter, many American artists have referred to the great international Modern Masters in a variety of novel ways. The European artists whose works have served as the source for contemporary redoings include the predominant figures of Impressionism, post-Impressionism, and Cubism. And although many of the American works are parodies and spoofs of acknowledged masterpieces of modern art, they are not done in a completely irreverent tone but display a certain amount of respect and compliment. Such innovative artists as Roy Lichtenstein, Mel Ramos, Larry Rivers, and George Segal have reinterpreted famous works of art in terms of their own personal styles, looking at the Modern Masters for subject matter rather than for technical solutions.

The Modern Masters who serve as sources constitute a minicourse in modern art history. Artists represented here include David, Ingres, Delacroix, Manet, van Gogh, Renoir, Monet, Cézanne, Matisse, Brancusi, Braque, Picasso, Mondrian, Dali, Magritte, and Duchamp. Picasso seems to be such a valuable source for inspiration that contemporary works included in this chapter draw from all phases of Picasso's career—from the 1920s through the 1960s. In addition, early-nineteenth-century Japanese woodcuts by Hokusai and Kuniyoshi, which were of great interest to artists such as Manet and Degas, are also the source for reinterpretation by contemporary artists as diverse as Larry Rivers and Masami Teraoka.

The manner in which artists have drawn upon and translated works by the Modern Masters is extremely diverse. Overall, however, contemporary artists are direct and frank in their borrowings from earlier works. Their adaptations of Modern Masters make straightforward and recognizable reference to the source, and do not, as was common in earlier centuries, mask the borrowed element by blending it with other elements of the composition. Wesselmann, for instance, collages actual reproductions of Matisse, Mondrian, and van Gogh into his *Great American Nude* paintings; Rivers freely recomposes a David or a Cézanne, retaining only the dominant images, and loosely reworks the entire composition; Red Grooms makes wildly comic constructions of events in an artist's life—Picasso walking on the beach or Monet painting in his garden; Lichtenstein redesigns a Monet cathedral or a Picasso woman in his own distinctive style; Peter Saul reworks Picasso's *Guernica* into a surprisingly humorous lesson in art history; and John Clem Clarke redoes a Delacroix painting, paying special attention to its surface qualities, its compositional color areas, and its characteristics as a commercial reproduction.

Two different works by contemporary American artists that borrow from Matisse offer examples of how earlier works are reused and revitalized. Roy Lichtenstein has devoted the major part of his career to paraphrasing Modern Master paintings and has not done translations of Old Masters. His *Still Life with Gold Fish* (color plate) is a bold reworking of Matisse's *Goldfish* (1915; The Museum of Modern Art, New York), which also combines elements from other Matisse paintings and results in a new version of a hybrid Matisse. Matisse's *Goldfish* is the last of a series of six paintings on this theme,

and the most abstract. In it Matisse has positioned a table, fish, flowers, and a piece of fruit in front of a wide black vertical plane, behind which is visible a window railing. In his painting Lichtenstein has made a number of interesting alterations. He has enlarged and centered the goldfish bowl, rendering the water as uniform and parallel diagonal lines, broken by blank white reflective areas. The table and circular fruit form, both done in the same bright yellow, become even more flattened than in the original Matisse. Lichtenstein has retained the window grillwork, but where there was a plain blue background, he has added a view of buildings seen through the window, borrowed from Matisse's earlier *Interior with Goldfish* (1914; Musée National d'Art Moderne, Paris). Lichtenstein has also taken the liberty of borrowing from yet another Matisse work. In the upper left he has added a detail of a Matisse line portrait—something Matisse often did himself in such works as *Lady in Blue* (1937; Philadelphia Museum of Art). The resultant Lichtenstein painting is surprisingly original in content and distinctive in style. He has strictly composed elements drawn from three sources, simplified the composition and palette by strongly outlining areas of yellow, red, and white, and executed the work in his powerful shorthand style. Lichtenstein has carried his art-about-art involvement even further by making painted bronze sculptures of images taken directly from his own paintings. *Gold Fish Bowl* is a three-dimensional depiction of a two-dimensional image derived from his painting *Still Life with Gold Fish*.

Tom Wesselmann pays tribute to Matisse in a completely different manner. His *Great American Nude #26* (color plate) makes reference to Matisse's paintings of nudes done in simple outline and also incorporates an actual color reproduction of a Matisse painting. His utilization of Pop imagery, such as collaged reproductions of commercial products and reference to erotic nude pinups and centerfolds, makes this painting particularly relevant to our subject. The American nude depicted here is closely related to Matisse's *Pink Nude* (1935; The Baltimore Museum of Art). Wesselmann has used the same pink color, similar pose, and broad, rough outline, merely changed from black to dark pink. This painting is discussed in *Bright Stars* (by Jean Lipman and Helen M. Franc): "Deployed on a dark blue cloth, with one hand upraised beneath her head in a pose originated in antiquity to indicate sleep, the shocking-pink figure is brought up to the frontal plane and is cropped at the edges of the canvas as in a film close-up. Behind her at the upper left is a reproduction of Matisse's painting *The Rumanian Blouse,* (1940; Musée National d'Art Moderne, Paris), the model's demure posture and modest costume contrasting wittily with the flamboyant shamelessness of the nude. Such visual quotations of earlier works are frequent within twentieth-century art; here, Wesselmann pays homage to a master he particularly admired."

Jasper Johns acknowledges and excerpts from an artist he greatly admires in his 1964 painting *According to What* (color plate). This is a pivotal work in Johns's career and a broad statement of his debt to Marcel Duchamp; it occupies a position in his career similar to that of *Tu m'* in Duchamp's. Much of the composition and imagery in *According to What* is patterned after Duchamp's *Tu m'* (1918; Yale University Art Gallery). Duchamp referred to this painting as an inventory of all his preceding works. Contained in it are tracings of the shadows cast by three of his Readymades—*Bicycle Wheel, Corkscrew,* and *Hat Rack*—and the outlines of the three templates of *Standard Stoppages*. Also included is a series of overlapping paint samples that Duchamp copied from a color chart, and a trompe-l'oeil tear in the canvas, mended by three real safety pins, from which protrudes a real bottle brush.

Johns's painting, also done in a large horizontal format, parallels Duchamp's inclusion of self-referential works, stylized color charts, and real objects. *According to What* draws various elements from earlier Johns works such as *Diver, Arrive/Depart, Field Painting,* and *Watchman*. The bent coat hanger, dangling from a wire attached to a spoon and casting shadows on the canvas, refers directly to Johns's own *Coat Hanger*

and indirectly to both the real bottle brush and the shadow drawings in *Tu m'*. A direct reference to Duchamp is concealed inside the hinged canvas attached at the lower left of the work, where Johns has redone Duchamp's *Self-Portrait in Profile* (1958; Private collection). Johns later made a lithograph of this same detail, *Fragment—According to What—Hinged Canvas,* which illustrates another dimension of the art-about-art theme—works that, in addition to being about other artists' work, are also about their own work.

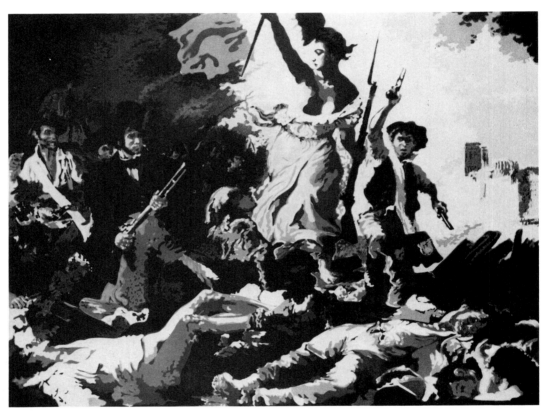

John Clem Clarke. *Delacroix—Liberty Leading the People,* 1968.
Oil on canvas, 67⅞″ x 84″. Yale University Art Gallery, New Haven, Connecticut;
Lent by Richard Brown Baker, New York.

In choosing this subject, John Clem Clarke took on a technically challenging venture, something a number of artists who are paraphrasing complicated masterpiece paintings seem eager to do. Clarke copied exactly the complex, dynamic composition of Delacroix's *Liberty Leading the People* (1830; Louvre, Paris), executing it in new terms of simplified tone and color to produce a compositional parallel but an opposite kind of painting. His stenciled and airbrushed application of paint brings the three-dimensional depth of Delacroix's painting straight to the surface of the canvas almost as if he was re-creating it as a stenciled wallpaper. As in all of Clarke's "copies," the exact repetition of content leaves the strongest possible impression of the difference—his original style.

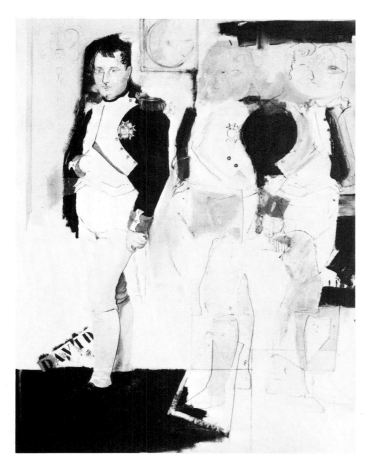

Larry Rivers.
The Greatest Homosexual,
1964. Oil and collage on
canvas, 80½" x 72". Hirshhorn
Museum and Sculpture Garden,
Smithsonian Institution,
Washington, D.C.

Jacques Louis David.
Napoleon in His Study, 1812.
Oil on canvas, 80¼" x 49¼".
National Gallery of Art,
Washington, D.C.;
Samuel H. Kress Collection.

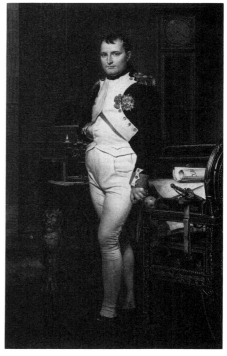

Larry Rivers's general interest in art-historical sub-
jects and specific fascination with the Napoleon
image resulted in this painting, a free copy after
David's *Napoleon in His Study* (1812; National Gal-
lery of Art, Washington, D.C.). Sam Hunter, in his
1965 catalogue for the Rivers exhibition organized
by Brandeis University, commented: "Napoleon's
imperious pose struck Rivers suddenly as affected,
narcissistic and somehow ludicrous, and he could
not resist dubbing the finished painting *The Great-
est Homosexual.* . . . Napoleon's figure is modu-
lated from a tenuous tracing to a full-blown
pictorial reality which has, however, a ghoulish,
waxworks irrefutability. Sewn plastic sections,
raised and attached lettering, the play of opacities
and transparencies of surface against refined draw-
ing leave a visible and vibrant record of image and
idea in their successive states of development, and
thus restate as the work's essential content the art-
ist's own fantastic personal creativity."

Mel Ramos's punning title seems as lighthearted as his altered version of Ingres's *Grande Odalisque* (1814; Louvre, Paris). The technical challenge, however, is most seriously met. In an interview for *Art International* (November 1973), Ramos said he was always interested in art history, and he also mentions his liking for *Playboy* and girlie books as sources for figure styles: "I couldn't have the kind of models I wanted, and I had to get them out of magazines—particularly *Playboy*." Ramos's series of paintings that combine *Playboy* girls and Modern Master paintings is illustrated here with his updated Ingres. He explains: "I became interested in all the great erotic paintings of the past, and what they were, and what they were about, and the peculiar things about all of them was that prurient interests—whatever that is—didn't seem to vary much from one civilization—or one culture or one generation—to the next. . . . One painting I'm using was done in the 19th century and another in the 18th century, and they are essentially the same. And I became interested in that consistency. So what I am trying to do is to take all of these paintings by Velasquez and Manet's 'Olympia' and Boucher's and Ingres' figures and try to get them into one kind of consistent visual format. They're all going to be predominantly neutralized backgrounds and very saturated figures. I'm just sort of updating it all and paying tribute to art history."

Richard Pettibone, who has devoted his entire career as a painter to the art-about-art idea, has copied the Ingres exactly in every detail from a color reproduction. The photograph of the racing car is painted in exactly the same way and presented as equal to the Ingres in tonal, color, and aesthetic values. The overlap emphasizes the dual reproduction source, as if the two pictures were part of a magazine layout designed to point up the similarity between a sleek racing car and a sleek reclining nude. Pettibone has generally been considered a miniaturist; he disclaims this and, in conversation with the authors, said, "I'm not a miniaturist. All my works are done in actual size from reproductions of paintings or photographs."

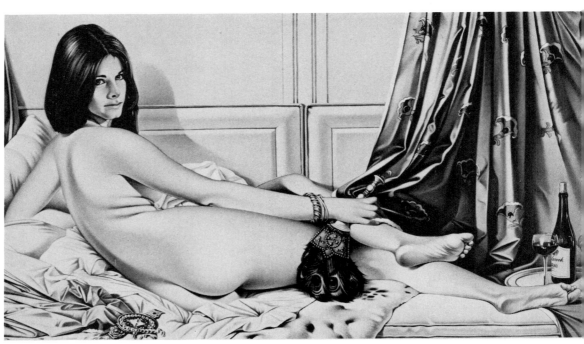

Mel Ramos. *Plenti-Grand Odalisque,* 1973. Oil on canvas, 38″ x 66″.
Collection of Daniel Filipacchi, Paris.

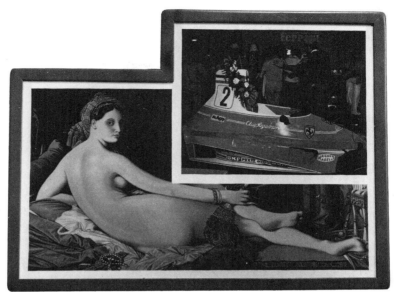

Richard Pettibone.
Ingres, Grande Odalisque,
1814; and Clay Regazzoni's
Ferrari After Winning
the U.S. Grand Prix at Long
Beach, Cal., 1976, 1976.
Oil on canvas, 8″ x 10⅛″.
Collection of the artist.

Red Grooms's three-dimensional construction gives us a surprising glimpse of Claude Monet in his garden at Giverny in the early 1920s, complete with Japanese footbridge and water lily pool. The artist has been interrupted in his work by the sudden emergence of a water nymph, lilies still balanced on her head. Monet, palette and brush in hand, stands before an easel holding an in-progress painting of his *Nymphéas.* Grooms's exaggerated cartoonlike portrait of Monet is a continuation of his interest in the art-about-art theme; he has depicted Rembrandt and Picasso in the same hilarious manner.

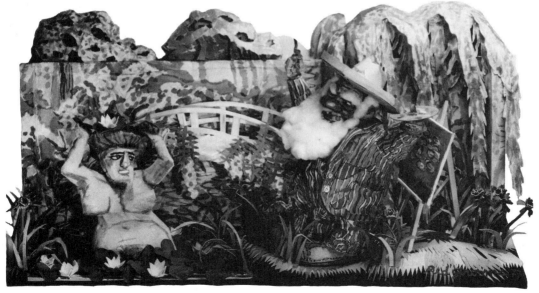

Red Grooms. *Monet,* 1977. Gouache on paper and cardboard, 25¼″ x 45½″ x 17¼″.
Galerie Roger d'Amécourt, Paris.

Roy Lichtenstein's triptych, after three of Monet's views of Rouen Cathedral, translates Monet's brushwork into a simulated four-color-process reproduction. Painted as if a reproduction was seen through a magnifying glass, Lichtenstein visibly enlarged and separated the Benday dots (applying paint with a toothbrush through a perforated screen). This exactly reverses the Impressionists' *pointilliste* and *tachiste* techniques, which fuse the bits of paint imperceptibly in the eye of the viewer and create the impression of a real scene. Allan Kaprow, writing for a 1977 catalogue (*Roy Lichtenstein at CalArts*), remarked that "The Monet Cathedrals serialize not Monet's method but schoolish theories about optical painting." Lichtenstein had said in an interview: "The *Cathedrals* are meant to be manufactured Monets . . . it's an industrial way of making Impressionism—or something like it—by a machinelike technique. But it probably takes me ten times as long to do one of the *Cathedrals* or *Haystack* paintings as it took Monet to do his . . . although Monet painted his *Cathedrals* as a series, which is a very modern idea, the image was painted slightly differently in each painting. So, I thought using three slightly different images in three different colors as a play on different times of the day would be more interesting . . . they deal with the Impressionist cliché of not being able to read the image close up—it becomes clearer as you move away from it." (John Coplans, *Roy Lichtenstein*, 1970)

Roy Lichtenstein.
Rouen Cathedral Set IV, 1969.
Oil and magna on canvas;
three panels, each 63″ x 42″.
Collection of Mr. and Mrs.
Horace H. Solomon, New York.

Claude Monet. *Rouen Cathedral: The Facade at Sunset,* 1892–1893. Oil on canvas, 39½″ x 25¾″. Museum of Fine Arts, Boston.

Claude Monet. *Rouen Cathedral,* 1894. Oil on canvas, 39¼″ x 25⅞″. The Metropolitan Museum of Art, New York; Theodore M. Davis Collection.

Claude Monet. *Rouen Cathedral,* 1894. Oil on canvas, 39½″ x 25⅞″. Louvre, Paris.

At first glance Masami Teraoka's skillfully rendered watercolors seem to be well-preserved master prints from the Edo period. However, on closer inspection it becomes apparent that these revised *Ukiyo-e* prints have been drastically updated. Patterned after Hokusai's *Thirty-six Views of Fuji* (1823), Teraoka's *New Views of Mt. Fuji: Sinking Pleasure Boat* depicts a group of revelers crowded into the bow of a boat to be imminently engulfed by the "Great Wave." All of the characters are wearing Edo costumes, but the prominent central figure has a camera and light meter dangling from his neck. In the midst of the confusion, one delicately delineated geisha attempts to take a photograph with her tripod camera, while a samurai-executive reaches for his golf clubs. As was the custom with *Ukiyo-e* prints, Teraoka has included small Japanese inscriptions within the scene. Ideograms near the golf clubs read "Golf Craze" and "Leave Wives Behind." Teraoka's ironic mixture of two cultures is further exemplified by his titles for other works: *New Views of Mt. Fuji: Flying Burger over La Brea Tar Pits* and *Thirty-One Flavors Invading Japan: French Vanilla.* Gerard Haggerty described Teraoka's watercolors as "the latest chapter in the continuing story of Admiral Perry. . . . For Teraoka, the mixture of form and content creates a wealth of bittersweet ironies. It is a situation where opposites sharpen one another." (*Artweek,* March 12, 1977)

Masami Teraoka. *New Views of Mt. Fuji:*
Sinking Pleasure Boat, 1976–1977.
Watercolor on paper, 11″ x 55″.
Collection of Dr. Michael Bléger, Los Angeles.

Larry Rivers dedicated an entire series of paintings done in 1974 "to Admiral Perry whose guns opened up Japan for us artists plus MacArthur whose arrogance created the proper spirit of love for those tiny yellow beauties." This quotation (*The Village Voice*, September 19, 1974) is followed by Rivers's explanation of how he began this series of painting. His comments clarify the use of boldly outlined and strongly colored versions of the eighteenth-century woodcuts by Utagawa Kuniyoshi on which this shaped-canvas painting, from Kuniyoshi's *Lives of Loyal Warriors* (1844–1852), is based:

"I walked into an art supply store and . . . saw a book called 'The Coloring Book of Japan.' You see the 'how-to' books have gotten very sophisticated over the years and there was this much more elaborate and arty thing on classical Japanese art. And because it was a coloring book, the color was removed.

"What it was, was a kind of structure of famous Japanese paintings without the color of those Japanese paintings. And for some reason, that made me enjoy it in a way that I

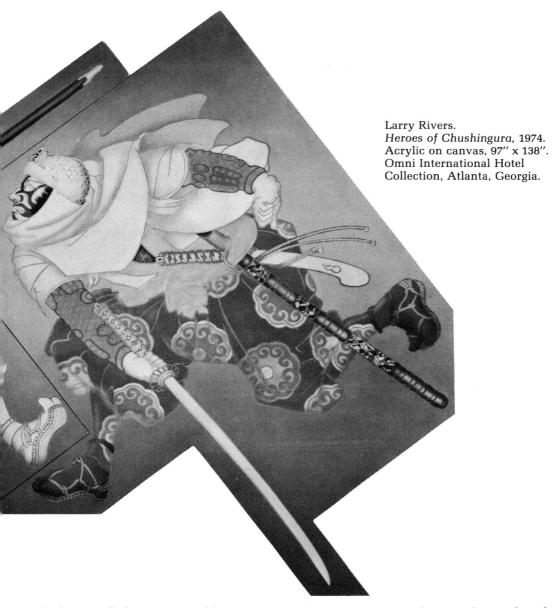

Larry Rivers.
Heroes of Chushingura, 1974.
Acrylic on canvas, 97″ x 138″.
Omni International Hotel
Collection, Atlanta, Georgia.

hadn't up till then. I mean I like Japanese works, I know van Gogh was influenced, and things like that, but for some reason it hadn't come across to me. Maybe the colors are too dead by the time you see them in reproduction or prints just don't have any juice. But in this book just the structure was there, and it interested me and I began using it as the basis of this work.

"I couldn't find the originals of any of these things so I worked from these coloring books and then fantasized the color myself. I've never seen the actual work in reproduction so I have no idea how close they are to the original work, but structurally speaking they are exact copies of the coloring book, with just a very few alterations. Things I thought weren't clear.

"And I also thought it would be funny from an artistic point of view to add a few other things not found in Japanese painting, like heavy shading, which they don't have at all. Maybe artists will get it, I don't know if other people will."

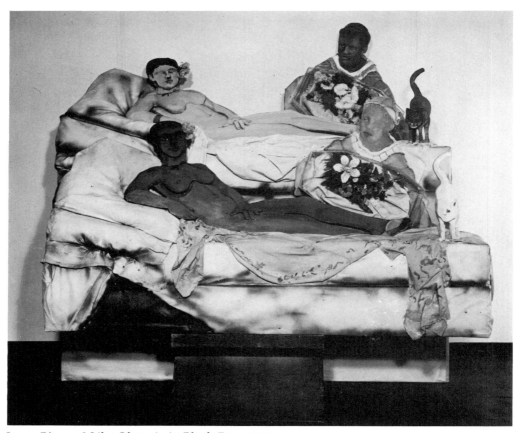

Larry Rivers. *I Like Olympia in Black Face*, 1970.
Mixed-media construction, 41″ x 78″ x 34″. Musée National d'Art Moderne,
Centre National d'Art et de Culture Georges Pompidou, Paris.

Manet's *Olympia*, first exhibited in 1865, has remained an extraordinarily potent icon
for artists. Personalized versions of this provocative image have been done by artists as
varied as Courbet, Gauguin, Picasso, Rivers, and Ramos. Manet's *Olympia* was directly
indebted to Titian's *Venus of Urbino* and indirectly to Goya, Ingres, and others, but his
re-creation was a daring pictorial statement about the decadence of his time.

Edouard Manet. *Olympia*,
1863. Oil on canvas,
51¼″ x 74¾″. Louvre, Paris.

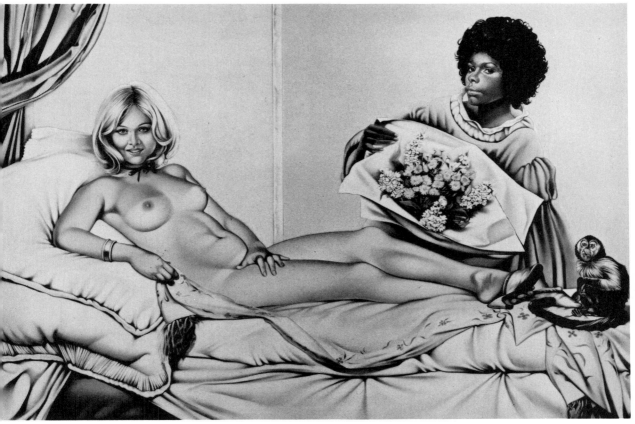

Mel Ramos. *Manet's Olympia,* 1974. Oil on canvas, 48″ x 70″.
Collection of Mr. and Mrs. Morton G. Neumann, Chicago.

Larry Rivers's painted construction doubled Manet's idea for another kind of social comment, showing, like a transformed mirror image, a new white servant for the new black Olympia, with her matching white cat. This painted relief construction was part of a commission by the Menil Foundation for the Institute for the Arts at Rice University, Houston; Rivers was invited to create an ensemble of works symbolizing the history and condition of the American Negro. Commenting on the whole project, Rivers said (quoted by the black writer Charles Childs in the exhibition catalogue, *Some American History*): "Black life is a whole spectrum of people I've met and come to know at various times. It is a perception of race and culture with as many variables and dimensions as people are variable."

Mel Ramos's title makes his straightforward satire immediately clear. His sleek, centerfold-type girl, with her bikini tan, wears Olympia's black ribbon around her neck, and her bracelet and shoe, all looking as right for the 1970s as for the 1860s. Her hairstyle and her servant's are noticeably updated however, and both women look at the unseen slick-magazine photographer with carefully fixed photogenic expressions. Details of drapery and dress are carefully true to the original, but a monkey casually replaces the cat.

Malcolm Morley's *The Last Painting of Vincent van Gogh* is a historically correct tableau that includes an open paint box, with paint tubes and palette, a replica of a late nineteenth-century gun, and a reconstructed easel that are all compatible with the time of van Gogh's death. On the easel is Morley's copy of van Gogh's last completed work, *Wheatfield with Crows* (1890; Vincent van Gogh Foundation, Amsterdam), done from a color reproduction that Morley ruled into grids and copied square by square. As recounted by the present owner of the work, Morley took the tiny bits of the sectioned reproduction and painted them into the painting, proclaiming, "now the original is there too in case anyone asks."

The assemblage is presented so that it not only refers back to a previous time, but actually situates the viewer in van Gogh's time. Morley's work may contain additional art references, as noted by Kim Levin: "In *The Last Painting of Vincent van Gogh*, construction becomes reconstruction. It is appropriate that it contains multiple references to recent history—to Rauschenberg's Combines, Rivers' last Civil War veteran, Dine's palettes, Segal's portrait of Sidney Janis with a Mondrian—as well as to the image of the painter at his easel in the Vermeer, and to Morley's own recent rough paint." (*Arts Magazine*, February 1973)

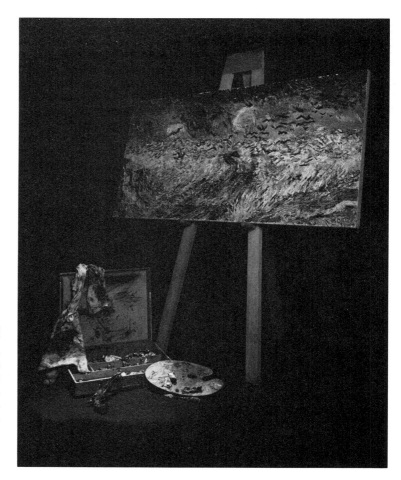

Malcolm Morley.
The Last Painting of Vincent van Gogh, 1972.
Mixed-media construction: easel: 78″ high; painting: 34″ x 70″.
Collection of Mr. and Mrs. Larry Meeker, Kansas City, Kansas.

Ann Wilson. Environment
from *Butler's Lives
of the Saints* [van Gogh's
Bedroom at Arles], 1977.
Paint on canvas and
wood, life size.
Creative Time, Inc.,
New York; installed at
88 Pine Street, New York.

Ann Wilson's environment and theater work, *Butler's Lives of the Saints,* presents a collage of architecture, sculpture, painting, opera, and dance. One of the environmental sets for this work is a three-dimensional reconstruction of van Gogh's *Bedroom at Arles* (1888; Vincent van Gogh Foundation, Amsterdam), in which an actor playing van Gogh sings an operatic libretto based on his letters. Other elements of this collaborative piece, which exist as painting and sculpture in addition to being a theatrical setting, include a reconstruction of the Diaghilev set from Igor Stravinsky's *Chez Petrouchka* and versions of paintings by Ryder and Goya depicted on large-scale scrims. Wilson's references to personages from the history of art, literature, theater, and dance present a sequence of images meant to unite the various disciplines. Her description of *Butler's Lives of the Saints:* "Each character in this piece saw visions and heard voices; it is the artist's moment of inspiration that I wish to portray. The operatic form suits the historic characters as well as the dramatic possibilities of the images that I am presenting."

101

Hermine Freed. Stills from
Art Herstory, 1974. Color video,
28 minutes. Castelli-Sonnabend
Tapes and Films, New York.

Hermine Freed has used the technique of video to explore art history and woman's role in that history. Among the art-historical sources are van Gogh's *L'Arlésienne* (1888), a woman from Renoir's *By the Seashore* (1883), and *A Portrait of a Woman with Lilacs and Eggs* (1725–1750) by a follower of Chardin (all The Metropolitan Museum of Art, New York). When asked by the authors, Freed described *Art Herstory* as "a videotape made with re-creations of the images of twenty-two paintings from the Middle Ages to the present. I play the central figure in each picture, alternating between playing the role and playing myself. The work is essentially about the perception of time through the historic process. Paintings are used for the images as they are the only available information, visually, about how people looked, dressed and pictured themselves throughout history, until the invention of the camera. The works, re-created in video, emphasize the disparity between traditional methods of image making and contemporary technology."

This large black-and-white painting is of an outline diagram by Erle Loran that, in his book *Cézanne's Composition*, explains Cézanne's compositional methods. The significance of this startling work, with another by Lichtenstein, *Man with Folded Arms* (1962), also from one of Loran's drawings, is discussed by John Coplans in *Roy Lichtenstein*: "The drawings fascinated Lichtenstein, if for no other reason than the attraction of outlining a Cézanne when the artist himself had noted that the outline had escaped him. To make a diagram by isolating the woman out of the context of the painting seemed to Lichtenstein to be such an over-simplification of a complex issue as to be ironical in itself. To be sure, all of Lichtenstein's images pre-exist in a flat form and are therefore 'reproductions of reproductions,' but by making paintings of these two images Lichtenstein raised a host of critical issues concerning what is a copy, when can it be a work of art, when is it real and when fake, and what are the differences. Lichtenstein's attitude was as startling to the art audience as Warhol's paintings of soup cans, which provoked similar questions; both artists challenged the art establishment—Warhol by ironically humanizing mass-produced products, and Lichtenstein by dehumanizing a masterpiece."

Roy Lichtenstein. *Portrait of Madame Cézanne,* 1962.
Magna on canvas, 68″ x 56″. Collection of Irving Blum, New York.

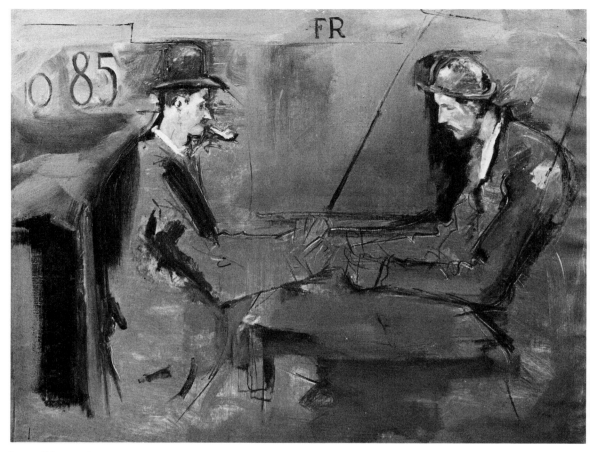

Larry Rivers. *Cézanne Stamp*, 1963. Oil on canvas, 42″ x 54″.
Hirshhorn Museum and Sculpture Garden, Smithsonian Institution, Washington, D.C.

The title and lettered francs indicate that Rivers's version of Cézanne's *Cardplayers* is a stamp concept related to his *French Money* series. The Cézanne composition has been freely paraphrased by Rivers, and the style exactly reversed. Rivers's typical light drawing in paint with his swift broken line and fluid color replaces Cézanne's strong, solidly structured brushwork.

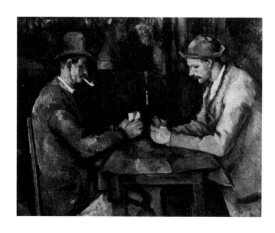

Paul Cézanne. *The Cardplayers*, 1890–1892. Oil on canvas, 17¾″ x 22½″. Louvre, Paris.

Recollections of a Visit to Leningrad refers to the great Matisse collection in the Hermitage, which so impressed Richard Diebenkorn that Matisse became a key influence on his work. This painting, with its specific reference to Matisse's decorative toile-de-Jouy patterning, is a singular key for understanding the work of this acclaimed California artist. The painting is one of the few Diebenkorn works that makes a literal reference to Matisse, incorporating decorative elements found in Matisse works such as *Harmony in Red* (1908–1909; Hermitage, Leningrad). Diebenkorn said in an interview: "I think I'd name Matisse as the one who has most engaged me since I was first aware of painting." (*The Soho Weekly News,* June 23, 1977)

Gerald Nordland, in his essay in the Albright-Knox Art Gallery catalogue for the Diebenkorn exhibition, writes: "*Recollections of a Visit to Leningrad* is an homage to the originality and genius of Matisse as those great works of 1908–09 were transformed in the mind of the American painter." Nordland also points out that Diebenkorn had known Matisse paintings from Alfred H. Barr, Jr.'s, *Matisse: His Art and His Public*. *The Piano Lesson* (1916; The Museum of Modern Art, New York), a Matisse painting whose influence can be seen in Diebenkorn's *Ocean Park* series, was described by Barr as having a "grave and tranquil elegance," a phrase that could also describe Richard Diebenkorn's paintings.

Richard Diebenkorn. *Recollections of a Visit to Leningrad,* 1965.
Oil on canvas, 71½″ x 83″. Private collection.

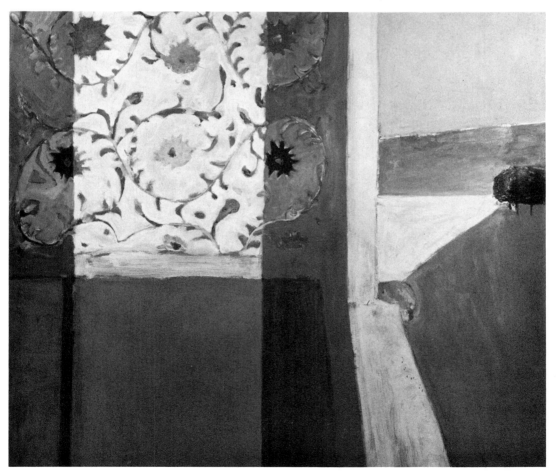

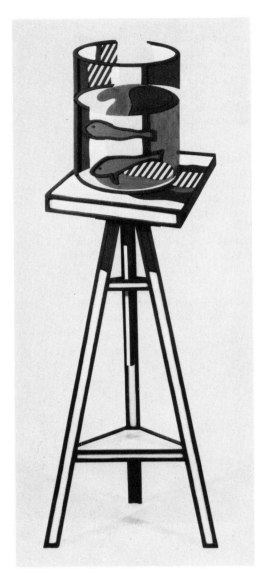

Roy Lichtenstein.
Gold Fish Bowl, 1977.
Painted bronze, 77½″ x 25½″ x 18¼″.
Whitney Museum of American Art,
New York; Gift of the Howard
and Jean Lipman Foundation, Inc.

Roy Lichtenstein's new series of painted bronze sculptures develops his personal painting style in three dimensions. This one derives directly from his own *Still Life with Gold Fish* (color plate), which was in turn based directly on Matisse's *Goldfish* paintings.

Josef Levi has featured Matisse's *Red Studio* (1911; The Museum of Modern Art, New York), copied from a reproduction, as the dominant element of his composition. The foreground fruit, prominent in scale and bulk, emphasizes the flatness and linear abbreviation of the Matisse. Allen Ellenzweig has discussed Levi's use of this particular Matisse painting: "That Levi should quote *Red Studio* is significant because it concretizes several of his own concerns. It is an image in which an artist quotes other paintings, his own, at the same time depicting a glass, a plant, a dish, and other 'real' objects of utility and decoration which coexist with the internal, autobiographic objects of his aesthetic life. As Matisse equalizes these objects by giving each importance in the composition, he succeeds in portraying the art *in* his life as well as the art *of* his life." (*Arts Magazine*, December 1976)

Roy Lichtenstein's *Artist's Studio* is one of a series on this theme and refers directly to Matisse's *Red Studio*, but it totally revises the composition. The vase with a stylized nasturtium vine is the same, and the stacked and hung paintings parallel Matisse's idea. The paintings, as were Matisse's, are his own: *Still Life* (1964), *Baseball Manager* (1963), and *Stretcher Frame* (1968). The cups and saucers refer specifically to his *Ceramic Sculpture XII* (1965); the circular painting to his *Mirror* series; and the wall dado to his *Entablatures*. Lichtenstein talked at length about his *Studio* paintings and their relation to Matisse in an interview with Jean-Claude Lebensztejn: "A couple of years ago I started some paintings that had my own paintings in them, and which were similar to the Matisse studios. There was one difference. . . . When I reproduce one of my own paintings in my painting, it's different from Matisse reproducing one of his paintings in his painting, because even though in both paintings the depicted painting is submerged for the good of the whole work, it's much more so in Matisse. I wanted my paintings to read as individual paintings within the work, so that there would be some confusion. There's no remove in my work, no modulation or subtlety of line, so that the painting-of-a-painting looks exactly like the painting it's of." (*Art in America*, July–August 1975)

106

Josef Levi. *Still Life with Matisse*, 1975. Acrylic on canvas, 35″ x 35″. A. M. Sachs Gallery, New York.

Roy Lichtenstein. *Artist's Studio*, 1973. Oil and magna on canvas, 60″ x 74″. Collection of Mr. and Mrs. David A. Wingate, New York.

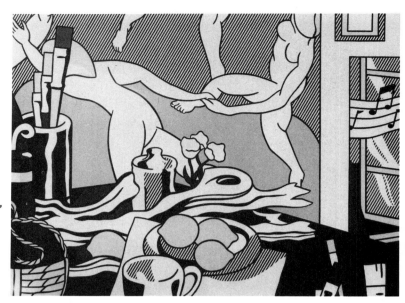

Roy Lichtenstein.
Artist's Studio—"The Dance,"
1974. Oil and magna on
canvas, 96″ x 128″.
Collection of Mr. and Mrs.
S. I. Newhouse, New York.

Including paintings within paintings was a common theme for Matisse, and he featured his *Dance* in several works. One of these, *Still Life with the "Dance"* (1909; Pushkin Museum, Moscow), is the subject of Roy Lichtenstein's *Artist's Studio—"The Dance."* Besides redesigning the Matisse as a bold painted drawing, Lichtenstein has played freely on many levels with the master's composition, adding artist's brushes, and a detail from his own *Sound of Music* (1964; Private collection) that refers, like a graphic pun, to Matisse's *Music,* a companion piece to his *Dance II* (both 1910 and in the collection of the Hermitage in Leningrad). In an interview Lichtenstein answered the question of whether his painting was a derision of Matisse by saying: "No, no. Not at all. I might have been dealing with the popular image of Matisse in the way I did with the popularized version of Picasso. . . . I'm making a painting of my particular image of Matisse. . . . When I started to do still-lifes, I looked at other artists' still-lifes and I thought of Matisse. Then I started to do still-lifes that were much more directly based on Matisse. But I think maybe the contradiction in style is one of the things I'm interested in. Matisse was so interested in a certain kind of flavor that's almost completely antithetical to my own—his interest in the color quality. I don't really feel it's different basically, but I feel that in style—his sense of touch and materials, his sense of line—he's almost completely opposite." (*Art in America,* July–August 1975)

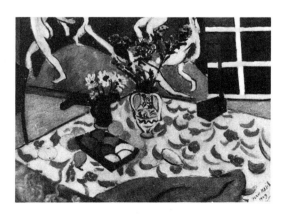

Henri Matisse.
Still Life with the "Dance,"
1909. Oil on canvas, 35½″ x 41¾″.
Pushkin Museum, Moscow.

108

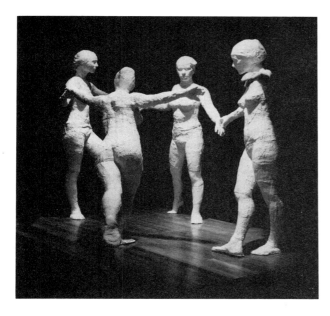

George Segal.
The Dancers, 1971–1973.
Plaster and wood, 72″ x 144″ x 96″.
Sidney Janis Gallery, New York.

The origin of George Segal's three-dimensional version of Matisse's *Dance* is described in *George Segal: Environments* as an example of how Segal has transformed a personal experience into a sculptural creation: "Inspired by Matisse's *Dance,* by its figures 'whirling in some kind of Dionysian ecstasy and by the painting, the vibrant colors, the magnificent shapes of the flat blue background, by the extraordinary statement of those girls dancing with abandon,' Segal thought, 'If I had four or five girls dancing in a circle in real life, if I started with the same impulse and put it through my own meat grinder, having real girls pose and have a three-dimensional circle, what would come out?' What did come out was quite different. None of the girls exhibits ecstatic abandon, but rather posed, haughty stances, and a self-conscious awareness of others and of themselves. The overall quality is rhythm in repose, the range of meanings appearing to be expressed by the spaces between the figures in the three-dimensional circle. The ring is literally made by the arms and hands, but they are distant and overlapped, touching, barely touching or about to touch. 'The connections and the almost connections,' Segal recalls, 'became the key.' " (Institute of Contemporary Art, University of Pennsylvania, Philadelphia, 1976)

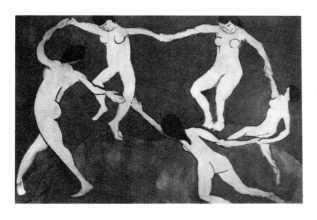

Henri Matisse. *Dance,* 1909.
Oil on canvas, 102½″ x 153½″.
The Museum of Modern Art,
New York; Gift of
Nelson A. Rockefeller.

109

Piet Mondrian was a primary source of ideas for many major artists, ranging from Alexander Calder to Roy Lichtenstein. Lichtenstein's series of paintings about Mondrian's geometric De Stijl style of the 1920s and 1930s is strictly adhered to with the exception of the trademark Benday dots. The *Non-Objective* paintings were not meant to be homages to Mondrian and are not exact compositional copies of Mondrian paintings, but were used only as subject matter. In an interview with Alan Solomon, Lichtenstein states: "When I do a 'Mondrian' or a 'Picasso' it has, I think, a sort of sharpening effect because I'm trying to make a commercialized Picasso or Mondrian or a commercialized Abstract Expressionist painting, let's say. At the same time I'm very much concerned with getting my own work to be a work of art, so that it has a sort of rebuilding aspect to it also. So, it's completely rearranged; it has become commercialized because the style that I switch it into is one of commercialization. . . . But the result that I work toward is one of creating a new work of art which has other qualities than the Picasso or the Mondrian or the Abstract Expressionist painting." (*Fantazaria*, July–August 1966)

George Segal's joint homage to Sidney Janis and Piet Mondrian is a literal combination of painting and sculpture. A full-figure portrait of Janis in white plaster is standing next to and touching an easel that holds an original Mondrian painting, *Composition*, which Janis bought from the artist in 1933. Segal's sculpture is appropriately reproduced on the cover of The Museum of Modern Art book devoted to the Janis collection, *Three Generations of Twentieth-Century Art*, and the catalogue description comments on it as a work about the art world: "Through the informal stance, the hand on the frame, the careful scrutiny of the picture, Segal has conveyed Mr. Janis's fondness for this painting, his connoisseurship, and his possessiveness as a collector, together with his showmanship. He has thus subtly delineated the complex relationship between a collector-dealer and . . . art and artists. . . ."

Tom Wesselmann combines a variety of techniques and materials to present an intimate view of mundane surroundings and juxtaposes collage from Pop culture with fine art reproductions so that they coexist on equal terms. *Still Life #20* presents the illusion of space with real space, real objects with reproductions of real objects. There is a poster reproduction of Mondrian's painting *Tableau I* (1921; Wallraf-Richartz-Museum, Cologne) and an actual painting of a star on a real cupboard door, and an illusionistic painted kitchen table for the collaged still life. Wesselmann's use of primary colors and rectangular divisions, in fact, parallels the compositional structure of the Mondrian reproduction that it includes. When asked, during an interview with Jean-Claude Lebensztejn, if the Mondrian reproduction was used in the work because of its discrepancy within the kitchen environment, Wesselmann replied: "No, never. Never any kind of literary connotation of any sort. . . . When it came to choosing a painting to put into a painting, it was always a visual response—as far as I was aware. I was very selective. You know, I wanted to have Mondrian, but it never worked. Finally I got a painting where it did work. Sometimes I kept trying to make a particular reproduction work, to find an excuse to use it because I liked it so much." (*Art in America*, July–August 1975)

George Segal. *Portrait of Sidney Janis with Mondrian Painting*, 1967.
Plaster figure with Mondrian's *Composition*, 1933, on wood easel; 69⅞" x 56¼" x 27¼".
The Museum of Modern Art, New York; The Sidney and Harriet Janis Collection.

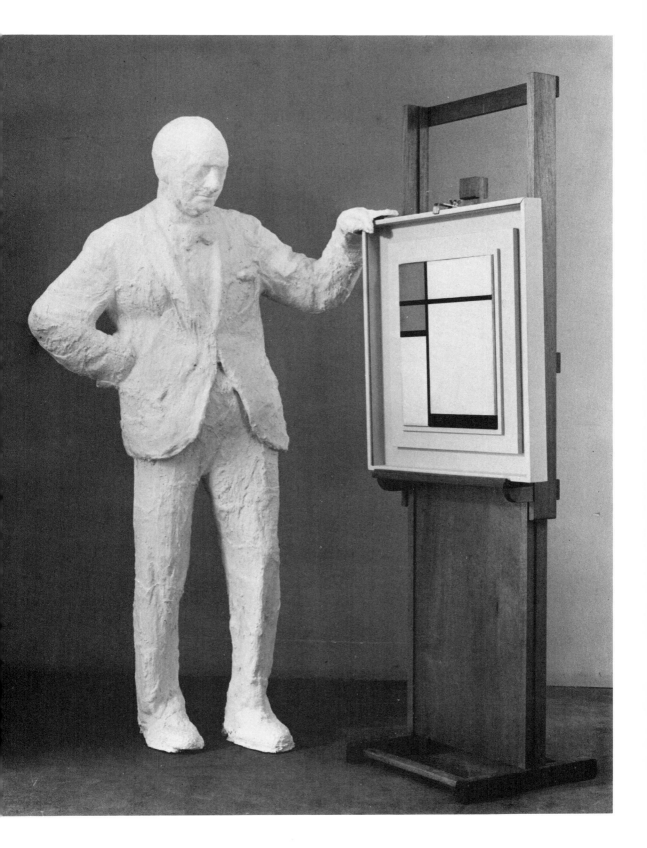

Tom Wesselmann. *Still Life #20,* 1962. Mixed-media construction, acrylic, enamel, and collage on composition board, 48″ x 48″ x 5½″.
Albright-Knox Art Gallery, Buffalo, New York; Gift of Seymour H. Knox.

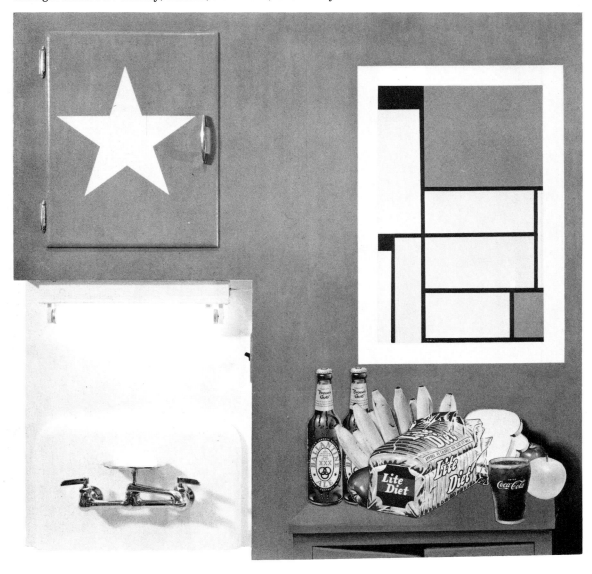

Roy Lichtenstein. *Non-Objective I*, 1964. Magna on canvas, 56″ x 48″.
Collection of Karl Ströher, Darmstadt, West Germany.

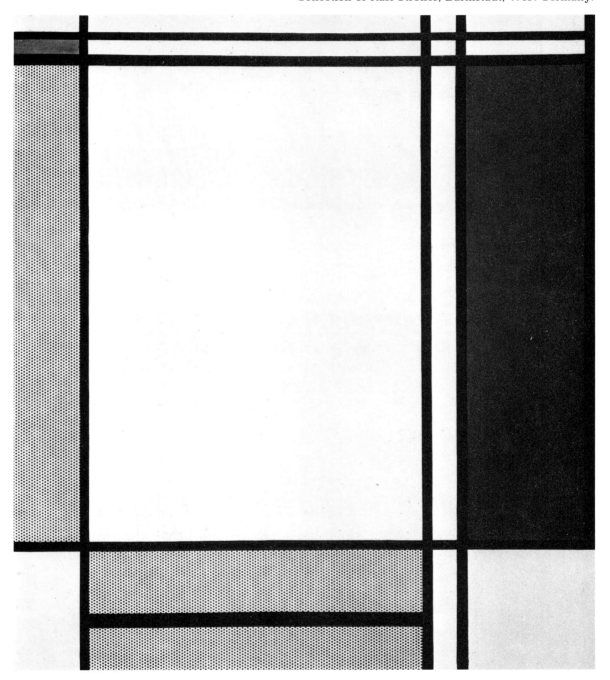

Picasso is a major source for artists who devote their work to the concept of paraphrasing or commenting on other art. The variety of ways Picasso has been utilized is sampled in the following pages.

Roy Lichtenstein has freely redesigned, from a reproduction, Picasso's *Woman with Cat.* By simplifying the allover design and details, he has, in effect, both exaggerated and emphasized the essentials of Picasso's style and produced a stunning painting that could be viewed as more than rivaling its distinguished source. Another Lichtenstein painting, *Femme d'Alger,* is abstracted from a detail of Picasso's *The Women of Algiers, K.* Lichtenstein has actually borrowed from two of Picasso's fifteen versions on this theme; the isolated figure of the smoker and some of the details of her clothing appear in *The Women of Algiers, L.* Lichtenstein has combined and restated elements of Picasso paintings, just as Picasso had drawn from and elaborated on Delacroix's two versions of *Femmes d'Algier* (1834 and 1849).

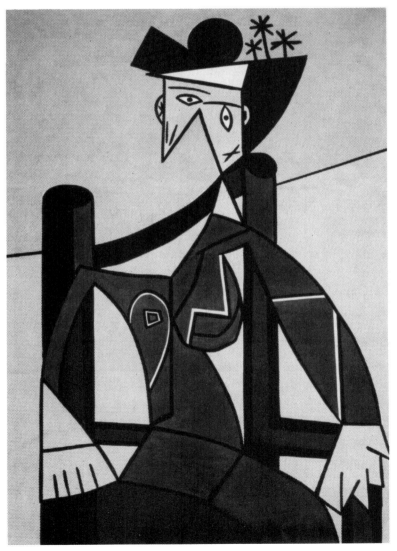

Roy Lichtenstein. *Femme dans un fauteuil,* 1963. Magna on canvas, 68″ x 48″. Private collection.

Pablo Picasso. *Femme assise au chat,* 1941. Oil on canvas, 51″ x 38¼″. Collection of Mr. and Mrs. Willard Gidwitz, Highland Park, Illinois.

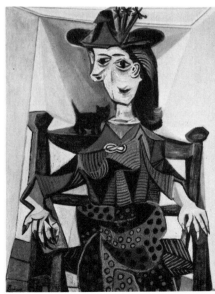

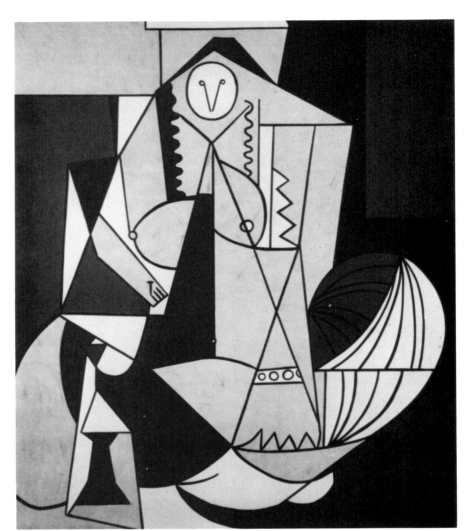

Roy Lichtenstein.
Femme d'Alger, 1963.
Oil on canvas,
80″ x 68″. Collection
of Mr. and Mrs.
Peter M. Brant,
Greenwich,
Connecticut.

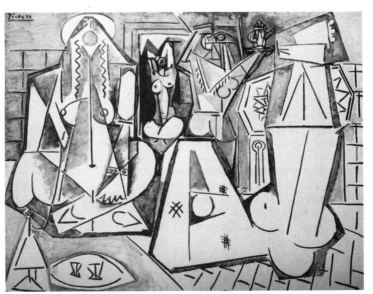

Pablo Picasso.
Femme d'Algiers, K,
February 6, 1955.
Oil on canvas,
51⅛″ x 63¾″.
Collection of Mr.
and Mrs. Victor W.
Ganz, New York.

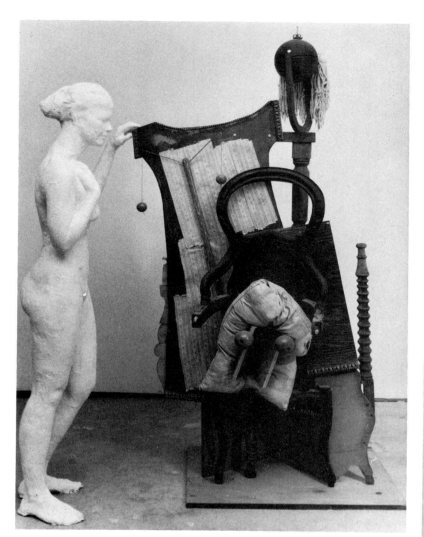

George Segal. *Picasso's Chair,*
1973. Plaster figure with
mixed-media construction,
78″ x 60″ x 33½″. The Solomon
R. Guggenheim Museum,
New York; Gift of Dr. Milton
D. Ratner.

Pablo Picasso.
Nude and Surrealist Sculpture,
May 4, 1933. Etching, 17½″ x 13⅜″.
The Museum of Modern Art,
New York.

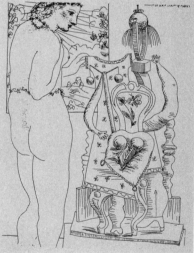

George Segal's sculpture is an extraordinary tour de force. His powerful work is based
exactly on a subtle linear etching by Picasso and translated item by item into three di-
mensions without losing the surrealist aura of the delicate print. The classical Picasso
nude is now a typically realistic Segal plaster casting from a live model, and the surreal
chair has become a strongly colored sculptural construction made up of ordinary found
objects. Shortly after he made this piece, he commented on it for Jan van der Marck's
George Segal: "A '33 Picasso etching stuck in my head. . . . I used the etching as a
blueprint and built it as a sculpture in real space. . . . All the little crevices made the
same packed rhythmic shallow space I liked in my Cubist quote."

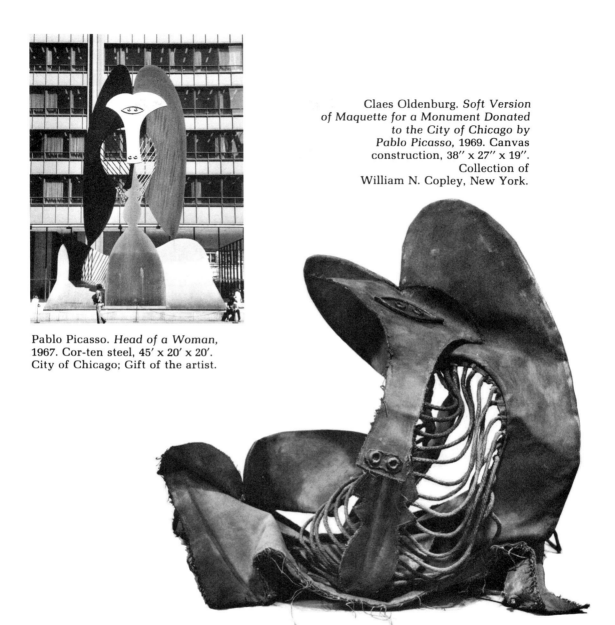

Claes Oldenburg. *Soft Version
of Maquette for a Monument Donated
to the City of Chicago by
Pablo Picasso,* 1969. Canvas
construction, 38″ x 27″ x 19″.
Collection of
William N. Copley, New York.

Pablo Picasso. *Head of a Woman,*
1967. Cor-ten steel, 45′ x 20′ x 20′.
City of Chicago; Gift of the artist.

Claes Oldenburg's soft Picasso is an especially appropriate comment on the whole
subject of monuments, for which this artist has made numerous tongue in cheek pro-
posals. He has described how he made his version of Picasso's *Head of a Woman* and
how he views his soft sculpture: "I obtained the measurements of the maquette and
built a 'hard' cardboard replica. From this I made patterns which were sewn in canvas
and then stained the rust color of the steel in the Picasso when it was relatively new.
Unlike the real Picasso, mine doesn't change color; it stays the colors of the postcard
you buy at the airport, taken early in the monument's history. I added a spine to my
Picasso, which enables the piece to be twisted into any shape, and the result is Super-
Cubism, an extremely flexible space. It also biomorphizes the subject." (Barbara Has-
kell, *Claes Oldenburg/Object Into Monument)*

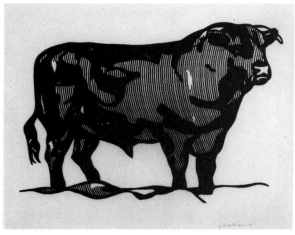

Bull I.

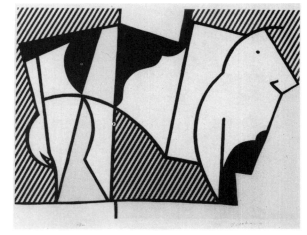

Bull III.

Roy Lichtenstein. *Bull Series,* 1973. Lithograph, silkscreen, and linecut; six prints, each 27″ x 35″. Gemini G.E.L., Los Angeles.

Pablo Picasso. *Le taureau,* 1945–1946. Lithographs; eleven states, each 11½″ x 16½″. Museum of Fine Arts, Boston; Lee M. Friedman Fund.

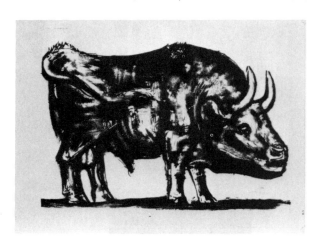

State 3.

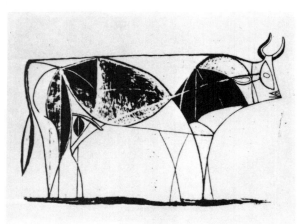

State 8.

Picasso again served as the inspiration for Lichtenstein's six-print *Bull Series,* which parallels and mimics the progressive abstraction of an image that Picasso explored in eleven varying stages. Comparing four from each series as reproduced here shows how Lichtenstein altered Picasso's idea. Picasso's bulls become progressively more linear and primitive, ending with a simple line drawing that looks like a prehistoric cave drawing; Lichtenstein's become more abstract and increasingly sophisticated.

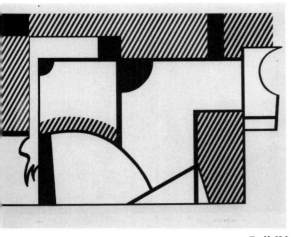

Bull IV.

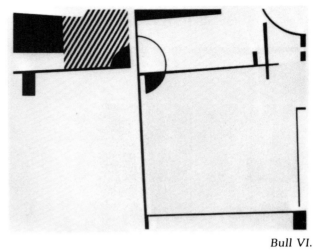

Bull VI.

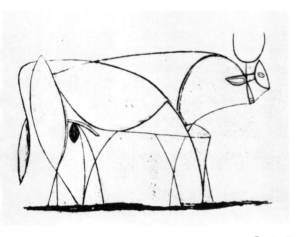

State 9.

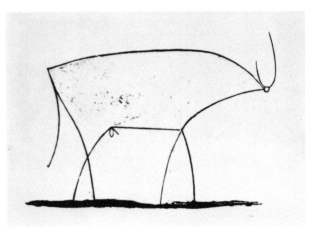

State 11.

119

In Tom Wesselmann's *Still Life #30,* a framed reproduction of Picasso's *Seated Woman* (1927; The Museum of Modern Art, New York) is equated as a popular symbol with 7-Up, a refrigerator and a skyscraper, Rice Krispies, hot dogs, diet bread, and other nationally popular commodities.

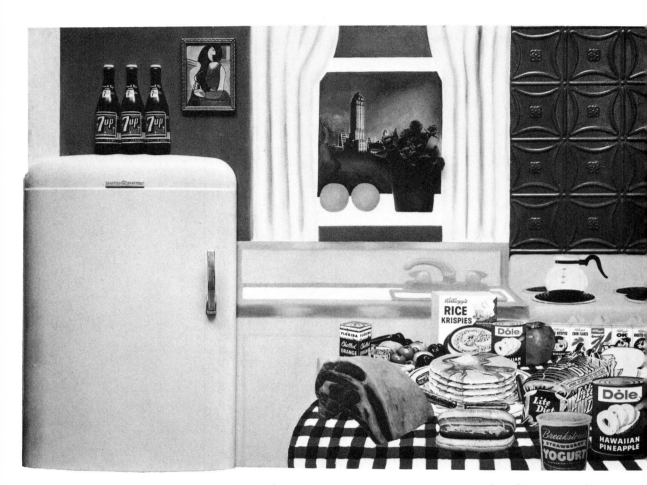

Tom Wesselmann. *Still Life #30,* 1963. Mixed-media construction, acrylic, enamel, and collage on composition board, 48½″ x 66″ x 4″. The Museum of Modern Art, New York; Gift of Philip Johnson.

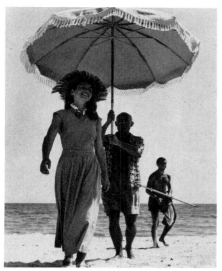

Robert Capa. *Picasso, Françoise Gilot, and Fin Vilato,* 1951. Photograph. Magnum Photos, Inc., New York.

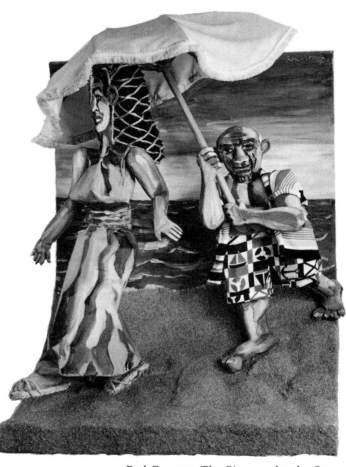

Red Grooms. *The Picassos by the Sea,* 1974–1975. Mixed-media construction, 51″ x 36½″ x 24″. Private collection.

Red Grooms has reconstructed in plaster, cloth, and paint Robert Capa's famous photograph of Picasso escorting Françoise Gilot on the Riviera seaside. He has revised her headdress to be Cleopatra-like, and Picasso, looking grim instead of smiling and gay, seems to be lunging to cast the floppy umbrella over Gilot's head like a net, unlike the photograph where he is holding it triumphantly upright to shield her as she moves gracefully in step with him. Grooms's beach landscape and figures have become gaudily colored: Mediterranean-blue sea and sky, bright yellow umbrella, Gilot's green dress, Picasso's red-and-black print shorts and sunburned red flesh. It is a beautiful Capa photograph translated into a boisterous sculptured cartoon.

121

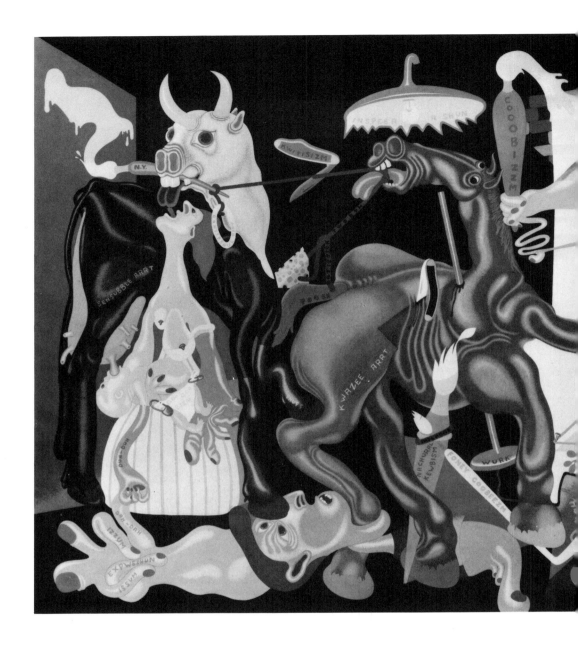

Liddul Gurnica was preceded by a similar version titled *Saul's Guernica* and both could certainly justify Peter Saul's claim that it is more his than Picasso's. The source for *Liddul Gurnica* has been outrageously altered to parody not only Picasso but art and art criticism in general. Labels read "arrt," "sensubble arrt," "bewtiffle arrt," "expweshun issum," "dah-dah izzum," "nachural kewbism," "foney coobeezm," and so on. The central figure, "Paablow," is carrying the torch of "coobizzm," and the overhead light reads "inspeer a shun." The artist wrote about *Saul's Guernica* for the Krannert Art Museum's 1974 exhibition catalogue *Contemporary American Painting and Sculpture*: "One thing about Picasso's *Guernica* is that it really is a kind of original Pop Art, before Pop, with its puffy, smooth exaggerations. I've brought this out in my version and helped his picture to be interesting to us now by giving it my style."

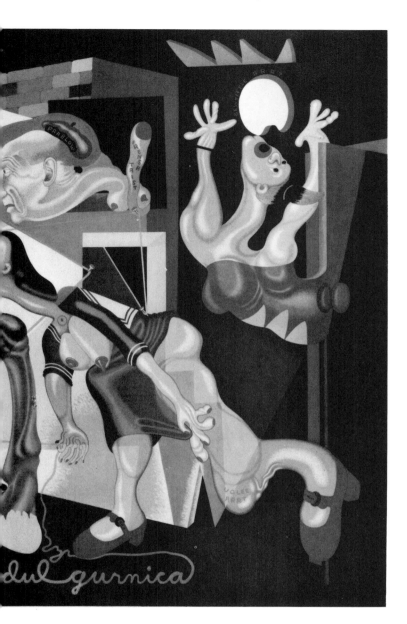

Peter Saul. *Liddul Gurnica,*
1973. Acrylic on canvas,
72″ x 121″. Collection
of Daniel Varenne, Paris.

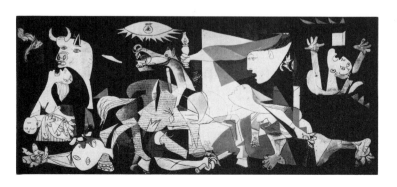

Pablo Picasso. *Guernica,*
1937. Oil on canvas,
137½″ x 305¾″. The
Museum of Modern Art,
New York; on extended loan
from the artist's estate.

Roy Lichtenstein. *Still Life
with Playing Cards,* 1974.
Oil and magna on canvas, 96″ x 60″.
Collection of the artist.

Georges Braque. *Still Life
with Playing Cards,* 1913.
Gouache and pasted paper
on canvas, 31½″ x 23¼″.
Musée National d'Art Moderne,
Centre National d'Art et de
Culture Georges Pompidou, Paris.

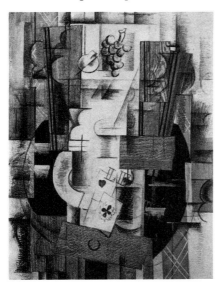

A number of reproductions of Cubist still-life
painting and collage were the source for this Licht-
enstein painting. He has made up an anthologylike
Cubist still life; but specific references to playing
cards, cloudlike outlines, and wavy wood graining
relate this painting to Braque's *Still Life with Play-
ing Cards* (1913; Musée National d'Art Moderne,
Paris). The character of Lichtenstein's painting,
however, depends more on an anthology of his own
personal style, with its bold black outlines, than on
any single source.

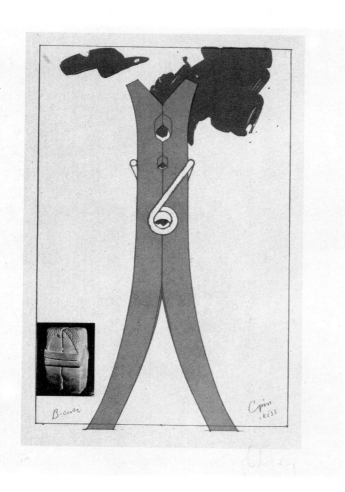

Claes Oldenburg. *Design for a Colossal Clothespin Compared to Brancusi's Kiss*, 1972. Silkscreen, 29⅝" x 21½". Philadelphia Museum of Art; Gift of the Friends of the Philadelphia Museum of Art.

The clothespin theme occurs in a number of Oldenburg's works, and has been realized as a forty-foot-high outdoor sculpture located near City Hall in Philadelphia. It appears in this print juxtaposed with a reproduction of Brancusi's *Kiss* (1912). In the catalogue for his 1975 exhibition at the Walker Art Center, Oldenburg states: "In preparing the silkscreen print for Philadelphia, I compared the *Clothespin* to Brancusi's *Kiss* because both contained two structures pressing close together and held in an embrace: in the case of the *Clothespin*, the parts were held by a spring. By fortunate coincidence it turned out that *The Kiss* was owned by the Philadelphia Museum of Art."

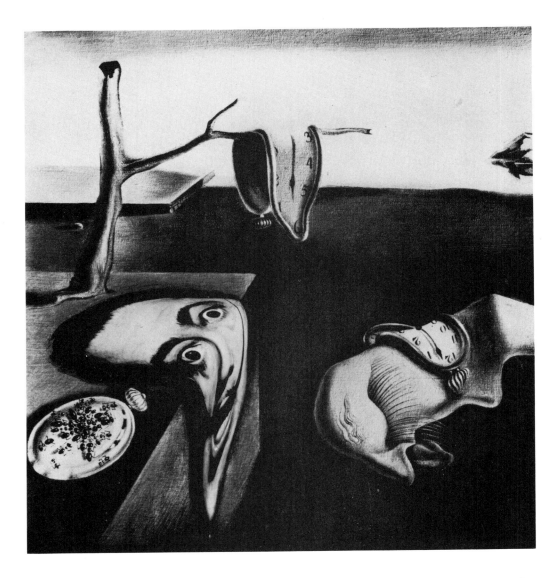

Philippe Halsman has been a photographic Boswell to Dali; during a quarter century he has made countless photographs, many at Dali's suggestion. In an article titled "Hello, Dali!," Halsman repeats some of Dali's queries and comments further: " 'Can you make me look like Mona Lisa? . . . Can you make a man whose one half would look like Dali and the other half like Picasso?' I could and did. . . . Dali and I are different in every respect . . . still, in some strange way, we are kindred spirits, and Dali is irresistibly attractive to me—especially when a camera is in my hands." (*Art in America*, April 1965) To alter this portrait photograph, after Dali's most famous painting, *The Persistence of Memory* (1931; The Museum of Modern Art, New York), Halsman carefully melted Dali's face by manipulating the negative to fit into the area of the distorted watch, pasted the photograph to a reproduction, and rephotographed the finished work.

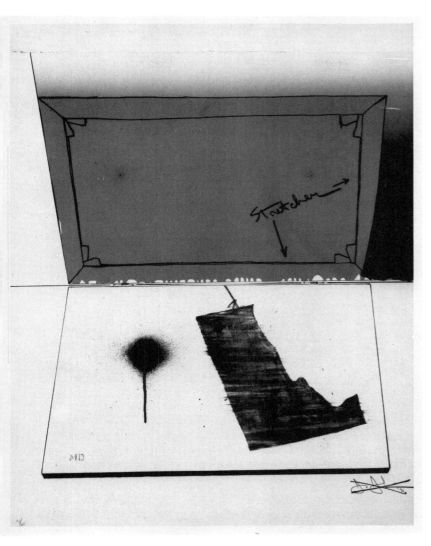

(*Opposite page*)
Philippe Halsman.
Le surréalisme c'est moi,
1954. Photograph.
Copyright © by
Philippe Halsman.

Jasper Johns. *Fragment—*
According to What—Hinged
Canvas, 1971.
Lithograph, 36" x 30".
Gemini G.E.L., Los Angeles.

The phenomenon of artists visually commenting on their own art represents a category within the art-about-art theme. This practice was notably exemplified by Marcel Duchamp in his *Large Glass,* from which he isolated fragments, and *Boîte-en-Valise,* a leather valise that included miniaturized replicas of his own work executed by himself. Jasper Johns has done a series of lithographs based on portions of his painting *According to What* (1964). Michael Crichton, in *Jasper Johns,* discusses lithographs that use images from paintings and vice versa, and quotes Johns as saying, "My work feeds upon itself." This *Fragment* print includes a portrait of Duchamp, an artist Johns greatly admires, which is based on Duchamp's collaged *Self-Portrait in Profile,* done in 1958 (Private collection). In the 1977 Gemini G.E.L. catalogue *Jasper Johns,* Barbara Rose writes: "In the lithograph of *Fragments—According to What,* this portrait reappears in a form that pays even greater homage to Duchamp. Cancelling out his own signature with a big blue 'X,' Johns stencils M. D. at the bottom of the print in the familiar stencil lettering he customarily uses to execute his own signature—as if to say the work is more that of Duchamp than it is his own."

127

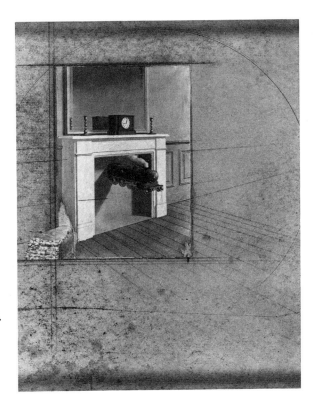

Joseph Cornell.
Mica Magritte II, 1965.
Collage and pencil on paper, 12″ x 9″.
Collection of Edwin Janss,
Thousand Oaks, California.

Cornell's collage, incorporating a reproduction of René Magritte's *Time Transfixed* (1938–1939; The Art Institute of Chicago), was made as a memorial for his brother Robert who had been a model-train enthusiast. The Magritte reproduction is set within a delicately outlined extension of the room, the Magritte mantel clock adding a fortuitous bonus to the meaning of the memorial collage.

The Ray Johnson work also features a reproduction of a Magritte painting that is collaged to an old photograph, superimposing it over the body of the child in a triple seating that not only features the Magritte image but echoes its surreal style.

The photographer Duane Michals greatly admired the paintings of Magritte, and the portrait shown here was made during a visit to the Magritte home in Brussels. The Wildenstein Gallery catalogue *Modern Portraits: The Self & Others* (1976) describes this Michals photograph: "In this particular image set in a room of the Brussels home, Michals shows the painter twice, through double exposure of the negative. In a fashion reminiscent of the paradoxes of Magritte's own work, however, neither image is 'real,' as one is transparent, and the other, to the left, is only a reflection in a mirror. . . . A further link to Magritte's painting lies in the placement of the easel and canvas before the window, an obvious reference to such Magritte works as *The Human Condition I* (1933; Choisel, collection of Claude Spaak) and *Euclidian Walks* (1955; The Minneapolis Institute of Arts), which deal with equivocal relationships between illusion, reality, and the images of art. The ideas of a picture within a picture (the calculated overlay of the head and shoulders on the bare canvas) and of the confusion of space and weight (the phantom sitter apparently depressing the chair cushion) reconfirm Michals's sympathy with Magritte's work and his desire to portray the painters in terms of Magritte's own imagery."

Ray Johnson.
Homage to Magritte, 1962.
Photograph with collage, 13¼″ x 6½″.
Collection of
Harry Torczyner, New York.

Duane Michals.
René Magritte, 1965.
Photograph.
Collection of the artist.

ABOUT EARLY AMERICAN ART

The early period of American art history has until recently commanded minimal interest both in the United States and abroad. Now, however, early American art and artists are being avidly studied, written about—and painted about. American art from the period of the Revolution is of interest to the contemporary artist, not so much for its technical expertise or advanced style, but because of its popular appeal as a symbol of the young nation. These patriotic images, so often overused—especially in conjunction with countless Bicentennial events—offer the artist a common base for making humorous and satirical statements. The Pop artists of the 1960s found images of George Washington and his exploits particularly appropriate for their use of popular, common, and hackneyed icons of American culture.

The ubiquitous Gilbert Stuart portrait of *George Washington* has had a phoenixlike rebirth. Tom Wesselmann has crossbred cultures in his *Still Life #31*—it includes an actual color reproduction of the Stuart portrait and collaged elements from Cézanne and Matisse paintings; Roy Lichtenstein's Pop version of George is based, instead of on the original painting, on a later woodcut of the same image; and Phillip Hefferton's spoof is a takeoff on a dollar bill that includes the same Stuart portrait. Emanuel Leutze's famous *Washington Crossing the Delaware* has also been a favorite subject. The examples shown here, by Rivers, Graziani, Wesley, and Colescott, all re-present Washington's crossing in varied and distinctive ways.

John Clem Clarke has redone John Trumbull's *The Battle of Bunker's Hill, Charlestown, Mass., 17 June 1775* (1786; Yale University Art Gallery, New Haven, Connecticut), but he focuses on the purely visual aspects of the picture rather than on its historical significance. Clarke's version, *Trumbull—Battle of Bunker's Hill* (color plate), concentrates on the color systems that transmit the shape and form of the images. This early American painting has been modernized by its translation through color photography, printing processes, and slide projection. Clarke has selected another Colonial painting, Copley's *Governor and Mrs. Thomas Mifflin*, and done a dozen different versions of it. Variations between each painting were determined by the color variations in the slides that Clarke used as his source material.

American folk art from the mid-nineteenth century was not even a subject for art history until the middle of this century, but since then it has become increasingly popular for historians and collectors, and for artists. Included in this chapter are two adaptations of Ammi Phillips's *Girl in Red with Her Cat and Dog*; and a collage by Joseph Cornell, who most frequently used reproductions of Renaissance paintings, that incorporates a reproduction of a masterpiece of American folk sculpture.

John Clem Clarke.
*Copley—Governor and
Mrs. Thomas Mifflin*, 1969.
Oil on canvas, 104" x 82".
Hirshhorn Museum and
Sculpture Garden,
Smithsonian Institution,
Washington, D.C.

When John Singleton Copley painted his portrait of *Governor and Mrs. Thomas Mifflin* (1773; Historical Society of Pennsylvania, Philadelphia), he was interested in their faces as individuals, their dress, and the room he posed them in with the view outside. John Clem Clarke chose this handsome composition purely as an interesting point of departure for his special technique, and in 1969 he exhibited at the Kornblee Gallery in New York no work other than a number of versions of the Copley painting. Jeanne Siegel described his actual process, and also this particular subject: "He projects a color slide of a painting, sideways, onto marking paper which is tacked to the wall. He enlarges it to the size he desires. When he has decided what are to be the first areas that 'he wants to take off' he draws their outlines in pencil and, using a rotary knife, he cuts them out to form his first stencil. He then takes the paper and lays it on top of a canvas on the floor and sprays or rolls paint onto the exposed areas. Proceeding in this manner, he may put on anywhere from three to seven layers of paint." She goes on to discuss the subject: "When I asked him why he chose it, he said, 'It had enough differences and yet it is simple enough to make comparisons. It's not confusing, it's got a little bit of architecture, a little bit of fabric, and a certain amount of flesh. It's very non-committal as a portrait, it's very American.' " (*Arts Magazine*, Summer 1969).

131

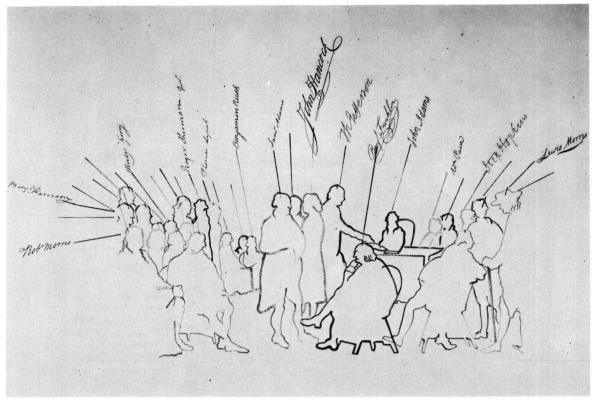

Larry Rivers. *An Outline of History*, 1976. Lithograph and silkscreen, 26½″ x 40⅜″.
Collection of Lorillard, a Division of Loews Theatres, Inc., New York.

The pun title is in keeping with the mood of Rivers's witty patriotic print. The exact outline copy of John Trumbull's well-known *Signing the Declaration of Independence, 4 July 1776* (1786; Yale University Art Gallery, New Haven, Connecticut), with signature labels for each participant, mimics and parodies the explanatory diagrams that often accompany textbook reproductions of historical paintings. Included is a Bob Morris "signature" among those of the original signers, a subtle compliment to a notoriously independent artist. Rivers has developed a casual art copy joke into an imaginatively conceived linear design drawn in a subtle rainbow of colors. He comments: "Although there is a generous amount of *blah* blended with affection that I feel for the 200th anniversary of a thing called country, I am glad to have the opportunity to express this. So, *An Outline of History* is based on the birth of the Declaration of Independence through an American primitive painting celebrating that hopeful document ten years after it was signed. For a moment it carried me back through all the tangles of our own mad history." (*Kent Bicentennial Portfolio,* catalogue, 1976)

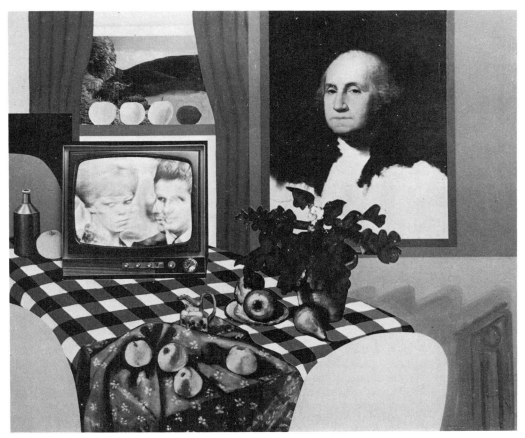

Tom Wesselmann. *Still Life #31*, 1963. Acrylic and collage on composition board with live television, 48″ x 60″. Private collection.

Gilbert Stuart's portrait of George Washington (1796; Museum of Fine Arts, Boston) quite naturally became a prime Pop art image, and the examples shown here make use of it in various ways. Tom Wesselmann's *Still Life #31* utilizes an actual collaged reproduction of the Stuart portrait as the predominant element in the painting. Juxtaposed with this mass-produced reproduction is a live television emitting popular images to a mass audience. Other elements in the painting include a pot of flowers and pears cut out from a reproduction of Cézanne's *Pot of Flowers with Pears* (1888–1890; Courtauld Institute, London). In the foreground is a still life with apples, resting on an overlapping cloth on which appears Matisse's signature.

The ubiquitous George Washington appears many times, and not always derived directly from the Stuart portrait. Roy Lichtenstein explained the source of his painting to John Coplans: "It is a woodcut version of one of Gilbert Stuart's portraits of Washington which I saw in a Hungarian national newspaper." (*Artforum*, May 1967) Lichtenstein has depicted Washington in a highly stylized manner with Benday-dot detail. The Sante Graziani painting parodies both the original portrait and Lichtenstein's familiar technique, while Phillip Hefferton paints a deflated George Washington sinking off a dollar bill.

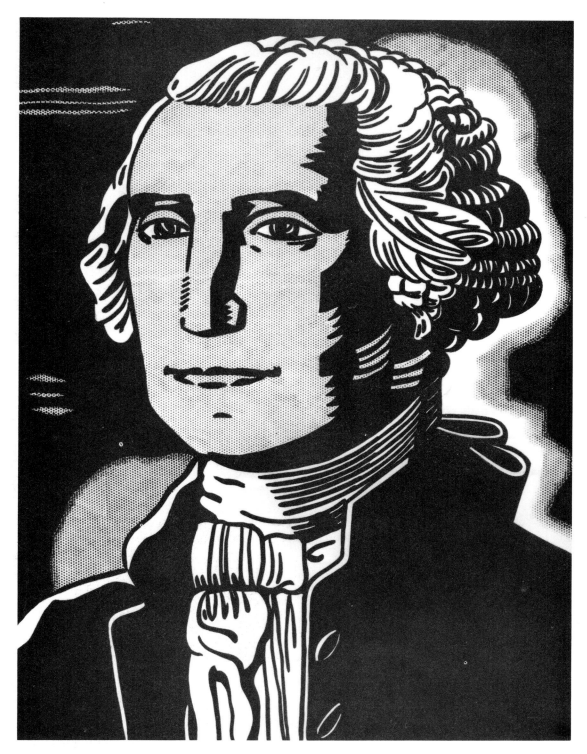

Roy Lichtenstein. *George Washington,* 1962. Oil on canvas, 51″ x 38″.
Collection of Jean Christophe Castelli, New York.

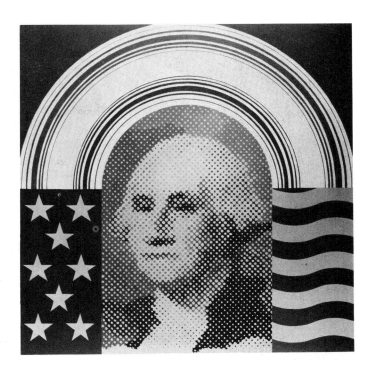

Sante Graziani.
Red, White and Blue Rainbow,
1970. Acrylic on canvas,
40″ x 40″. Collection of
Mr. and Mrs. Lewis A. Davis,
Haworth, New Jersey.

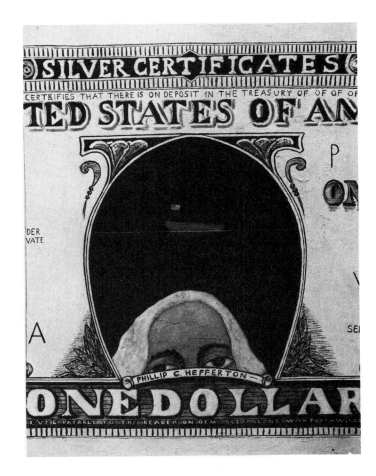

Phillip Hefferton.
Sinking George, 1962.
Oil on canvas, 90″ x 67½″.
Collection of Betty and
Monte Factor, Los Angeles.

Larry Rivers. *Washington Crossing the Delaware*, 1953.
Oil on canvas, 83⅝″ x 111⅝″. The Museum of Modern Art, New York.

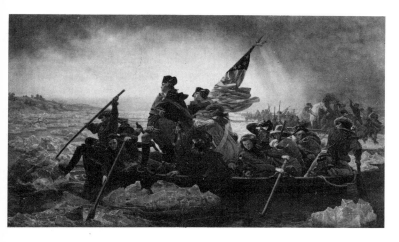

Emanuel Leutze. *Washington
Crossing the Delaware*, 1851.
Oil on canvas, 149″ x 255″.
The Metropolitan Museum of Art,
New York; Gift of John S. Kennedy.

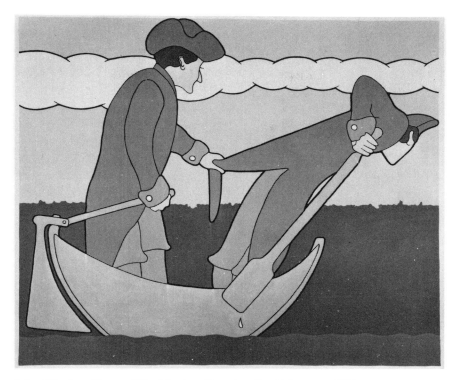

John Wesley. *George Washington Crossing the Delaware,* 1976.
Acrylic on canvas, 42″ x 50″. Robert Elkon Gallery, New York.

Emanuel Leutze's romanticized scene of *Washington Crossing the Delaware,* painted in Düsseldorf (1851; The Metropolitan Museum of Art, New York), became a widely accepted symbol of the American Revolution. An obvious target for Pop artists, the painting of Washington's heroic coup has been deromanticized with great variety.

Larry Rivers fractures, recombines, and blurs the ordinary Leutze ingredients to create a complex staccato composition and to display his bravura brushwork. Sam Hunter remarked in his 1971 book *Rivers* that "Rivers . . . had taken the unexpected step of making a deliberate 'history' painting, inspired by Emanuel Leutze's academic 'machine,' and by American folklore. . . . The painstaking manner in which Rivers deliberately built up his theme from a series of drawings of individual figures and groups seemed pedantic and secondhand. It called into question the whole cult of spontaneity, and the accidentalism of Abstract Expressionism." Hunter also quotes from an interview with James Thrall Soby, in which Rivers stated: "I kept wanting to make a picture out of a national myth, to accept the 'impossible' and the 'corny' as a challenge instead of running away. . . . I guess I wanted to paint something in the tradition of the Salon picture, which modern artists hold in contempt. Besides, there was plenty in *Washington Crossing the Delaware* to dazzle me—horses, water, soldiers, and so on."

Numerous other artists have found inspiration in the Leutze painting: John Wesley rethinks the whole idea as a hilarious cartoon in bold outline; Sante Graziani selects a detail and presents it in bright shorthand; and Robert Colescott crams his boat with stereotyped characters who fish, guzzle moonshine, smoke a big cigar, strum a banjo, and shine the boss's boots.

Sante Graziani. *Crossing with Multi Rainbows,* 1972. Acrylic on canvas, 46″ x 58″.
Collection of Mr. and Mrs. Norman Wolgin, Philadelphia.

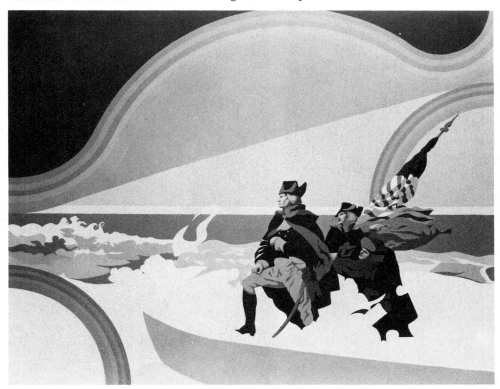

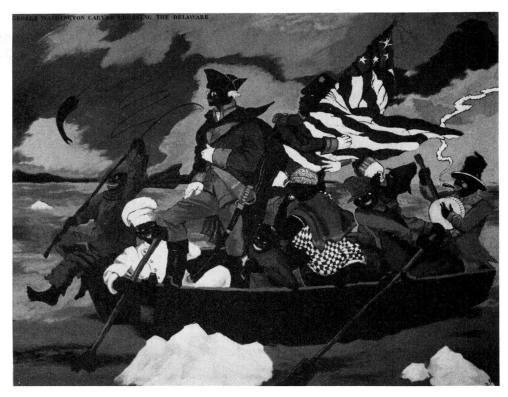

Robert Colescott. *U. S. History Text: George Washington Carver Crossing the
Delaware,* 1975. Acrylic on canvas, 78″ x 102″. John Berggruen Gallery, San Francisco.

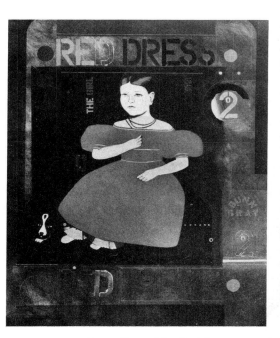

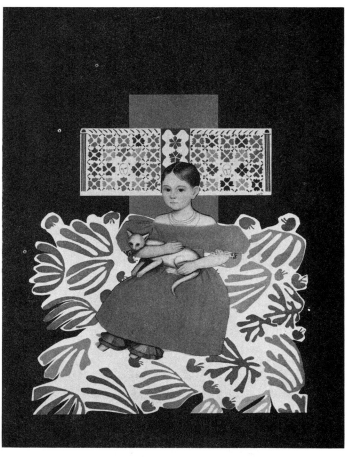

Bunn Gray. *The Red Dress*, 1977.
Acrylic on canvas, 60" x 48".
Collection of Richard Roemer,
New York.

Reginald Case. *Young Girl*, 1976.
Collage on paper, 18" x 13½".
Collection of the artist.

Folk art was first appreciated and collected by artists in the 1920s, and since then it has gradually become an acknowledged part of American art history. Now, fifty years later, artists are again taking a special interest in folk art. Ammi Phillips's *Girl in Red with Her Cat and Dog* (1834–1836; Private collection), which has been a very popular painting in recent folk art exhibitions and is often reproduced in color, was easy prey for artists such as Bunn Gray and Reginald Case who have specialized in the art-about-art theme. Gray added an avant-garde aura to his painting with stenciled lettering and numerals, while Case placed his collaged child on a rug cut out of a color reproduction of Matisse's cut-and-pasted work *The Parakeet and the Siren* (1953; Stedelijk Museum, Amsterdam) and used a reproduction of Matisse's *Large Decoration with Masks* (1953; National Gallery of Art, Washington, D.C.) as a background. One artist has omitted the little girl's dog, the other her cat. By retaining exactly the cat-holding arms, Gray deliberately made the awkward primitive pose quite a bit more so. Case, by using a catalogue reproduction in which the girl's shoes blended into the black background, has cut the feet off at the ankle so that they seem to be tucked through the Matisse "rug," making the figure more primitive than the original.

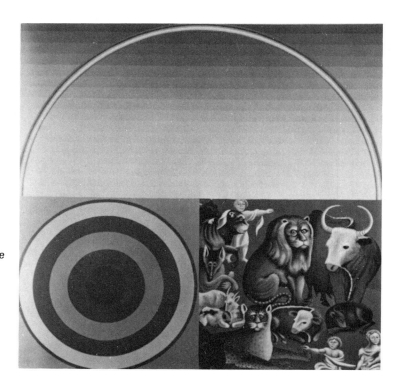

Sante Graziani. *The Peaceable
Kingdom,* 1964. Acrylic
on canvas, 46″ x 46″.
Collection of Alan Koehler,
Key West, Florida.

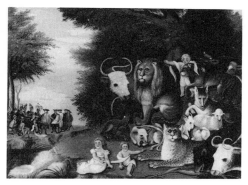

Edward Hicks. *The Peaceable
Kingdom,* 1830–1840.
Oil on canvas, 17¼″ x 23¼″.
Abby Aldrich Rockefeller
Folk Art Center,
Williamsburg, Virginia.

Sante Graziani's painting is one of a number that
recycle Hicks's *Peaceable Kingdoms,* the most pop-
ular and most published examples of American
folk art. Graziani has divided his painting into three
sections, with the primitive Hicks animals and chil-
dren, all reversed from the original, making up a
tapestrylike square that contrasts with the contem-
porary-looking target design—the two connected by
a stylized rainbow.

The Hicks is an especially appropriate source for
an art-about-art painting, for his series of *Peace-
able Kingdoms* could be seen as an unselfconscious
forerunner of the paintings-within-paintings idea.
A devout Quaker, Hicks conceived of William
Penn's treaty with the Indians as a fulfillment of
Isaiah's (11:6) Old Testament prophecy: "The wolf
also shall dwell with the lamb, and the leopard
shall lie down with the kid . . . and a little child
shall lead them." Hicks combined Isaiah's menag-
erie with his version of Benjamin West's great his-
torical canvas of 1772, *Penn's Treaty with the
Indians,* which he adapted from a popular engrav-
ing after the West painting. However, whereas
Hicks made his adopted picture a consistent por-
tion of the whole concept and composition, Gra-
ziani has squared off the Hicks detail and placed it
opposite and below abstract designs that are its re-
verse in style, technique, and impact.

140

Joseph Cornell. *Waxed,* c. 1965. Collage on paper, 11¼″ x 8¼″.
Collection of Jorge Newbery, Los Angeles.

This collage features a masterpiece of American folk sculpture, a ship chandler's sign
made in New England about 1850 (Mystic Seaport, Inc., Mystic, Connecticut). The enig-
matic word *waxed* seems oddly juxtaposed with the reproduction of the carved mari-
ner who is circled as if seen through his own telescope lens. Cornell always refused to
explain his works, and this is one of the few instances in which he used a reproduction
of an early American work rather than the more familiar Renaissance images. One is
aware that everything combined logically and provocatively in his mind, and, although
the logic may be lost, his collages retain and communicate the magic they held for the
artist.

ABOUT RECENT AMERICAN ART

Not surprisingly, there are fewer contemporary works that borrow from recent American art than from earlier art. However, as noted in previous chapters, the artists who are the most famous, most respected—and most reproduced—are those used as the subjects for new interpretations. The dominance of the modern mass media in the transmission of images and ideas accounts, in part, for the familiarity and acceptance of relatively new art. This rapid communication of new art forms is illustrated by some examples shown here that were done within a year or two of the original on which they are based.

This chapter presents contemporary works about recent American art from the late 1920s through the 1960s. The major American art movements—Regionalism, Abstract Expressionism, Color-Field, Hard-Edge, and Pop—are well represented; artists whose work has been recycled include Demuth, Wood, Kline, de Kooning, Newman, Johns, Rauschenberg, Lichtenstein, Oldenburg, Noguchi, Chamberlain, and Stella.

The ways in which these artists have been restated are as diverse as the individual styles of their art. Grant Wood's *American Gothic* has been irreverently manipulated by Howard Kottler in the form of decals; a framed reproduction of Wood's patriotic *Midnight Ride of Paul Revere* is unexpectedly incorporated into an interior scene in Wesselmann's *Great American Nude #2*; a de Kooning drawing has been erased and re-presented as an *Erased de Kooning Drawing* by Robert Rauschenberg; a de Kooning *Woman* has been slickly updated by Mel Ramos and titled, in a Pop-style homage, *I Still Get a Thrill When I See Bill #3*; another de Kooning, *Woman and Bicycle*, has been drastically altered, not in content, but by Peter Saul's distinctive style; Franz Kline paintings have been respectfully recalled in Aaron Siskind's photographs; Jasper Johns's *Three Flags* reappears as a favorite subject; and Frank Stella's bold geometries are often quoted.

Roy Lichtenstein, known for his interest in reworking Modern Masters, has not allowed even his own work to escape updating. He has redone his "classical" Pop *Girl with Ball,* originally derived from an advertisement for a summer resort, in an exaggerated surrealist style. George Segal has done a sculpture about his own art—a self-portrait at work—and a sculpture about another artist, John Chamberlain.

Robert Indiana's *The Demuth Five* (color plate) is one of a series of paintings, which also includes *The X-5,* inspired by Charles Demuth's *I Saw the Figure 5 in Gold.* Indiana's homage to Demuth's painting, which was inspired by a William Carlos Williams poem, retains the telescoped gold 5 and is placed on a red star surrounded by stenciled letters. Indiana has combined an interest in American literature—another painting is based on a poem by Walt Whitman—with a painting style derived from commercial design, which utilizes stenciled lettering to achieve a bold and colorful effect. Indiana's formal design and layout are quotations from commercial techniques in the same way that the visual images are quoted from Demuth. He has also borrowed from a third source—the signs of the American highway—and his inclusion of the signs and symbols HUG, EAT, USA, ERR, and DIE reflect an iconography rooted in the American experience. In this sense, Indiana's *Demuth Five* is about American art, literature, and design.

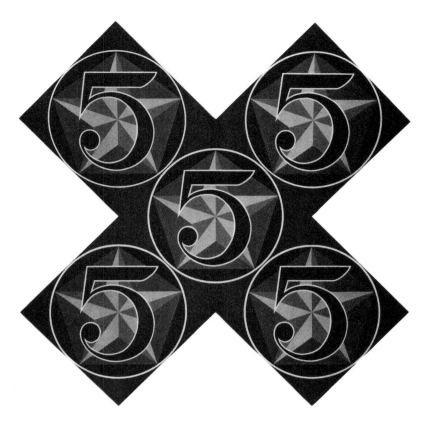

The X-5, painted entirely in shades of blue-gray, is one of five oil paintings executed by Robert Indiana in 1963 as a serial homage to Charles Demuth's *I Saw the Figure 5 in Gold*. Indiana wrote about his "Fifth Dream" suite: *"I Saw the Figure 5 in Gold* by Charles Henry Demuth is my favorite American painting in New York City's Metropolitan Museum. *The Demuth American Dream No. 5*, the central painting of the five in my 'Fifth Dream' suite, is in homage to Demuth and in direct reference to the same painting which his own object of acclamation, the American poet William Carlos Williams, thought one of his best works.

"I did my painting in 1963, which when subtracted by 1928 leaves 35—a number suggested by the succession of three fives (5 5 5) describing the sudden progression of the firetruck in the poet's experience. In 1935 Demuth died, either from an overdose or an underdose of insulin (he suffered for years from diabetes) according to Doctor Williams, the pediatrician-poet who birthed thousands of babies as well as hundreds of poems, and then in 1963 the venerable doctor died, completing the unpremeditated circle of numerical coincidence woven within the 'Fifth Dream.' " (Emily Farnham, *Charles Demuth—Behind a Laughing Mask*, 1970)

Robert Indiana. *The X-5*, 1963. Oil on canvas, 108″ x 108″. Whitney Museum of American Art, New York.

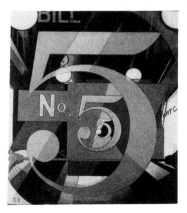

Charles Demuth. *I Saw the Figure 5 in Gold*, 1928. Oil on composition board, 36″ x 29¾″. The Metropolitan Museum of Art, New York; The Alfred Stieglitz Collection.

143

Howard Kottler. *Look Alikes,*
1972. Porcelain blank with ceramic
decal, and luster glaze, 1″ x 10¼″
diameter. Private collection.

Grant Wood's *American Gothic* (1930; The Art Institute of Chicago) has been ex-
tremely popular as a color reproduction since it was first painted. In this witty spoof of
the straitlaced American farm family the vertical lines of the house seem to be echoed
in the elongated glum faces of the couple, and the Gothic window in the tines of the
pitchfork. Wood's sister and a family friend, a dentist, posed for the painting, and
Wood selected all the clothing for its details: severe rickrack-trimmed apron, and
striped shirt for the man, with a dark coat opening to make parallel vertical stripes.
When the picture was exhibited at the Art Institute, it won a prize, was bought for the
collection, and created a storm of protest because of its satirical intent. Howard
Kottler, an artist who has done a number of art parodies using ceramic decals on plates,
has duplicated the dour dentist's face and nimbly satirized the satire.

Tom Wesselmann's *Great American Nude #2* includes a collaged color reproduction
of Grant Wood's *Midnight Ride of Paul Revere* (1931; The Metropolitan Museum of
Art, New York). This much-reproduced painting is a deliberately stylized version of
American landscape and historical painting, done by Wood in much the same spirit of
satire as Wesselmann's abbreviated styling of a Matisse-type nude. The portion of
American flag emphasizes the connection between the patriotic American scene and
the "great American nude."

This life-size portrait of museum director Walter Hopps features small reproductions of a de Kooning and a few other paintings that are literally close to his heart. Edward Kienholz seems to suggest that these avant-garde paintings are surreptitiously offered to the wary art public.

Tom Wesselmann. *Great American Nude #2*, 1961. Enamel, oil, and collage on plywood, 59⅝" x 47½". The Museum of Modern Art, New York; Larry Aldrich Foundation Fund.

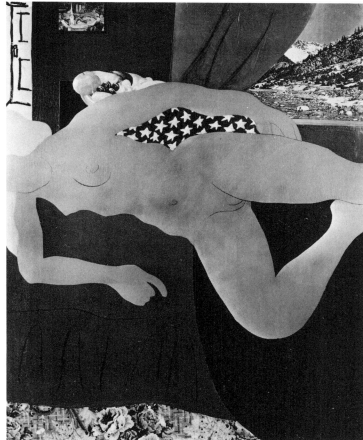

Edward Kienholz. *Walter Hopps, Hopps, Hopps*, 1959. Mixed-media construction, 78" x 34". Collection of Edwin Janss, Thousand Oaks, California.

Aaron Siskind, a celebrated photographer now in his mid-seventies, has done a series of photographs of found images that suggest and pay tribute to the paintings of his friend Franz Kline. These are not photographs of paintings, but photographs of random brushstrokes that Siskind found on the walls of buildings in Mexico. Hilton Kramer poses and answers the questions raised by Siskind's photographs: "Is it because of the closeness of Mr. Siskind's work to the paintings of the New York School, which 'prepares' us for what we see in many of these images? Perhaps. Many of these photographs belong to the copious 'Homage to Franz Kline' series that has occupied Mr. Siskind for some years; others pay homage to Joseph Cornell, and all observe a mode of formality we have learned to recognize and appreciate—a formality that plays on the improvised and the unexpected. Yet these are not simulated paintings; they are photographs so deeply entrenched in the technical and material processes of photography that in the end they leave us conscious of that medium and its possibilities rather than any other. They pay their respects to painting from the distance of another world." (*The New York Times*, December 12, 1976)

Aaron Siskind. *Jalapa 37 (Homage to Franz Kline)*, 1973. Photograph. Collection of the artist.

Franz Kline. *Mahoning*, 1956. Oil on canvas, 80" x 100". Whitney Museum of American Art, New York; Gift of the Friends of the Whitney Museum of American Art.

Robert Rauschenberg.
*Erased de Kooning
Drawing,* 1953. Traces
of ink and crayon on
paper, 19″ x 14½″.
Collection of the artist.

Like Duchamp's *L.H.O.O.Q.,* Robert Rauschenberg's *Erased de Kooning Drawing* is a neo-Dada precedent for the manipulation of one artist's work by another. Rauschenberg's career, at that time, was somewhat outside of the main current of Abstract Expressionism, and the fact that he chose to erase a work by the most revered of the Abstract Expressionists cannot be ignored. However, Rauschenberg contends that this relatively aggressive action was done on a purely aesthetic level. As he explained to Calvin Tomkins: "I had been working for some time at erasing, with the idea that I wanted to create a work of art by that method. Not just by deleting certain lines, you understand, but by erasing the whole thing. Using my own work wasn't satisfactory. . . . I realized that it had to be something by someone who everybody agreed was great, and the most logical person for that was de Kooning. . . . Finally he gave me a drawing, and I took it home. It wasn't easy, by any means. The drawing was done with a hard line, and it was greasy too, so I had to work very hard on it, using every sort of eraser. But in the end it really worked. I liked the result. I felt it was a legitimate work of art, created by the technique of erasing." (*The Bride & the Bachelors,* 1965)

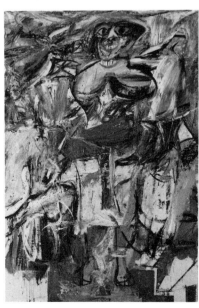

Peter Saul. *De Kooning's Woman
with Bicycle,* 1976. Acrylic
on canvas, 101″ x 75½″.
Allan Frumkin Gallery,
New York.

Willem de Kooning. *Woman
and Bicycle,* 1952–1953.
Oil on canvas, 76½″ x 49″.
Whitney Museum
of American Art, New York.

Peter Saul's garish version of de Kooning's *Woman
and Bicycle* looks as if neon-bright paint straight
from the tube had been looped and swirled like spa-
ghetti in a parody of de Kooning's Abstract Expres-
sionist brushwork to create a woman even more
alarming than the original. From the three sets of
tombstone teeth and tripled tongue to the rubbery
slippered feet, she outdoes even Saul's most out-
landish parodies.

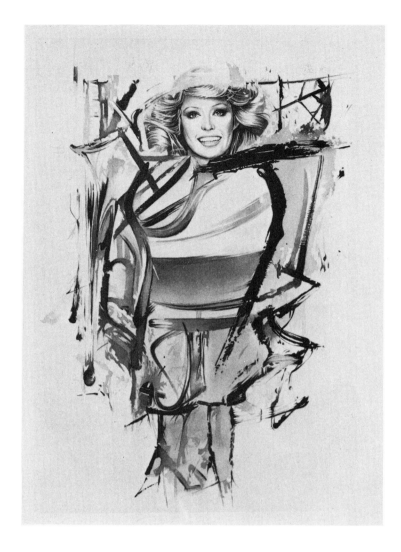

Mel Ramos. *I Still Get a Thrill When I See Bill #3*, 1977. Watercolor on paper, 30½″ x 22½″. Collection of Mr. and Mrs. James S. Morgan, Prairie Village, Kansas.

Willem de Kooning. *Woman I*, 1961. Oil on paper, with pasted color photoengraving, mounted on canvas, 29″ x 22⅜″. Collection of Thomas B. Hess, New York.

Mel Ramos has given his de Kooning parody a minimally slashed-out body in monochrome watercolor. The head, however, is reproduction-real in full color, with typical cover-girl blonde hair and brilliant smile. This painting follows closely a number of relatively unknown de Kooning *Women* that are done in oil on paper with pasted-on heads cut from magazine illustrations. Ramos's watercolor is exactly the same size as the de Kooning original; it evidently interested Ramos, not as being totally different from his paintings, but because of a peculiar similarity. Ramos has parodied not only the de Kooning, but perhaps his own work also.

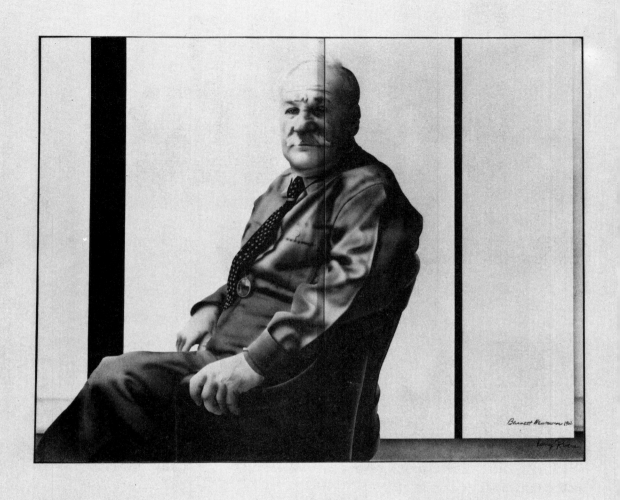

Larry Rivers. *The Stripe Is in the Eye of the Beholder,* 1975.
Acrylic on canvas, 85¾″ x 100½″. Marlborough Gallery Inc., New York.

Larry Rivers's portrait of Barnett Newman, an artist he knew and admired, is based on
a photograph of Newman in his studio taken by Paul Katz. On two connected canvases
inset into a third—a matlike border—Rivers depicts Newman sitting in front of his
painting *Sixth Station* (1962; Private collection) from *The Stations of the Cross* series.
The composition of the painting and subsequently its title were the result of Rivers's
preparatory drawing for the work. He began sketching the image on two contiguous
pieces of paper and it happened that Newman's eye fell at the break between the
papers. Recognizing the irony and references contained in this occurrence, Rivers re-
tained this configuration in the final painting. The work has many art-about-art fea-
tures: it is a painting based on a photographic portrait of an artist that deliberately
keeps the look of a matted photograph, and features a painting within a painting.

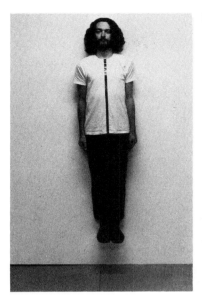

Barnett Newman

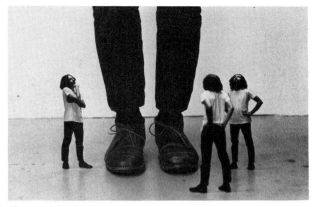

Claes Oldenburg

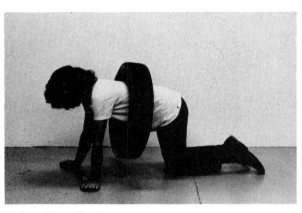

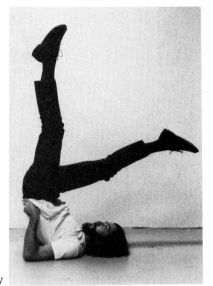

Robert Rauschenberg

George Rickey

Scott Grieger. *Impersonations,* 1970. Photographs. Collection of the artist.

Scott Grieger has done a number of works spoofing contemporary American art. These photographs, from his widely exhibited *Impersonations* series, show Grieger acting out typical characteristics of some well-known artists' works: Newman's famous stripes; Oldenburg's proposals for colossal monuments; Rauschenberg's tire-encircled ram, *Monogram* (1959; Moderna Museet, Stockholm); and Rickey's kinetic stainless steel blades. Grieger described these works: "When I'm impersonating a work of art, I don't consider the use of my body as a significant contribution to Performance or Body Art. What's important for me is making the viewer conjure up works of art through a form of deception or entertainment. You see, impersonation is only interesting because the thought and strategy is directed toward a common image—one which everyone in the know will recognize." (*Art in America,* March–April 1973)

151

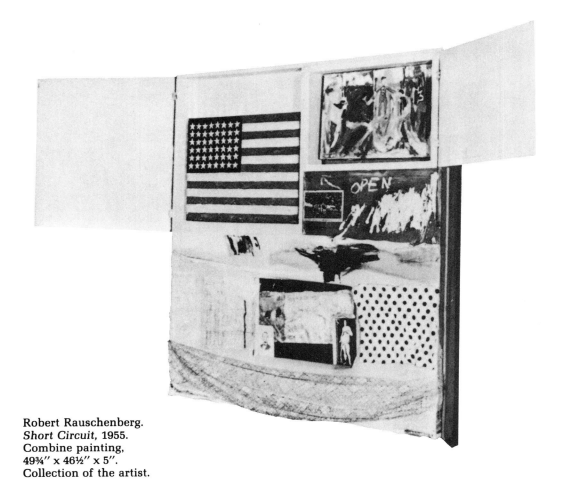

Robert Rauschenberg.
Short Circuit, 1955.
Combine painting,
49¾″ x 46½″ x 5″.
Collection of the artist.

Jasper Johns's *Three Flags* (1958; Private collection) is a much-reproduced work and an acknowledged masterpiece of contemporary American art. The works illustrated here make use of Johns's *Flag* in various ways. Rauschenberg's *Short Circuit* is a collaborative work, incorporating original pieces by three artists, including a small, single flag image by Johns. At the upper right is an oil painting by Susan Weil, at the lower center a collage by Ray Johnson, with additional collage and painting by Rauschenberg. The original Johns flag was stolen and then replaced by a replica painted by Elaine Sturdevant. Rauschenberg recently said that some day he would paint the flag himself.

Josef Levi's composition spans art history with painted reproductions of a reliquary, Matisse's *The Blue Window* (1911; The Museum of Modern Art, New York), and a detail of *Three Flags*.

Tom Wesselmann has used a reproduction of *Three Flags* in his *Great American Nude #43*, done in 1963 when the Johns painting was becoming widely known; it is one of the few times that Wesselmann incorporated a reproduction of a contemporary work of art in one of his paintings. The presence of the American flag in Wesselmann's stereotype interior reinforces the implications of his standardized American nude.

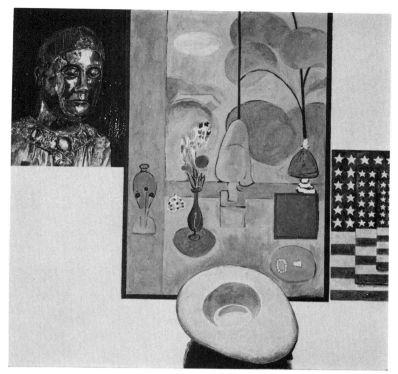

Josef Levi.
Still Life with Matisse,
French Reliquary and Johns,
1975. Acrylic on canvas,
14¾″ x 14¾″. A. M. Sachs
Gallery, New York.

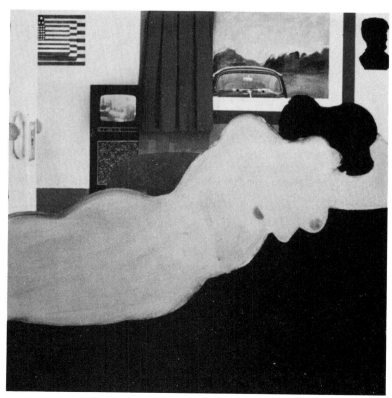

Tom Wesselmann.
Great American Nude #43,
1963. Oil and collage
on composition board with
live television, 48″ x 48″.
Collection of Mrs.
Robert B. Mayer, Chicago.

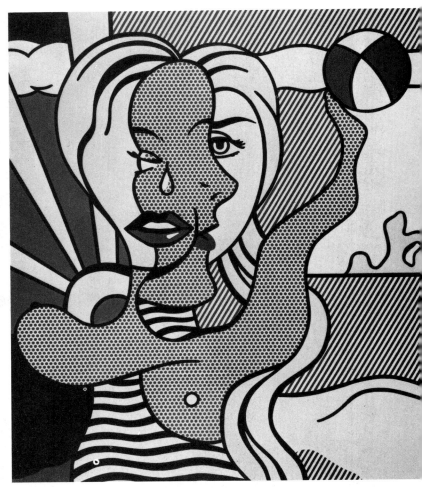

Roy Lichtenstein.
Girl with Beach Ball II, 1977.
Oil and magna on canvas,
80″ x 66″. Thomas Segal
Gallery, Boston.

Roy Lichtenstein.
Girl with Ball, 1961.
Oil on canvas, 60½″ x 36½″.
Private collection.

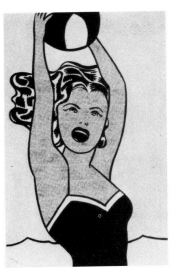

Lichtenstein first became famous as the Pop artist who transformed comic strips and commercial advertisements into paintings that required serious consideration as works of art. His Benday-dot comics characters are now better known than the originals he copied. Since that early stage in his career, he has become primarily interested in painting parodies of art-historical masters. He has done series of Benday-dot paintings about Cubism, Abstract Expressionism, Impressionism, Futurism, and, most recently, Surrealism. His *Girl with Beach Ball II* is a Surrealist distortion and interpretation of his own *Girl with Ball*. The evolution to Surrealism of an image from his own "classic" Pop art, which had in turn evolved from a comic-book and advertising style, is a personalized parody of recent art history.

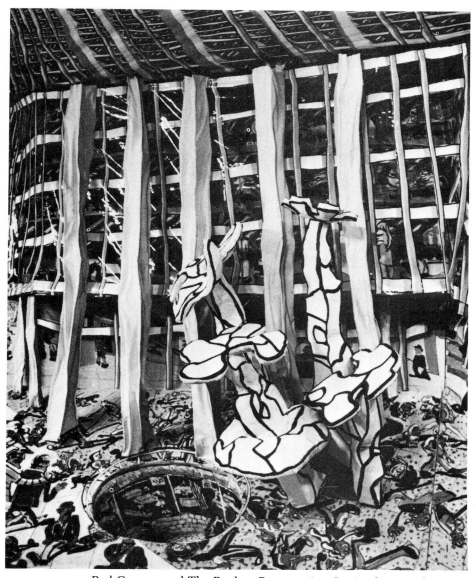

Red Grooms and The Ruckus Construction Co. *Ruckus Manhattan—*
Chase Manhattan, 1975–1976. Mixed-media construction, 130″ x 246″ x 48″.
Marlborough Gallery Inc., New York.

Red Grooms's *Ruckus Manhattan* is a sprawling environmental work that depicts the streets, buildings, and inhabitants of the financial district of Lower Manhattan. Situated among the towering and twisting buildings, peopled parks and plazas, and garish storefronts are Grooms's renditions of outdoor sculptures on the Chase Manhattan Plaza. Isamu Noguchi's *Rock Garden* (1963) and Jean Dubuffet's *Four Trees* (1972) take on new characteristics when interpreted by Grooms. The Dubuffet, originally built in steel and concrete, has become limp and unsteady, appearing ready to topple into Noguchi's sunken garden.

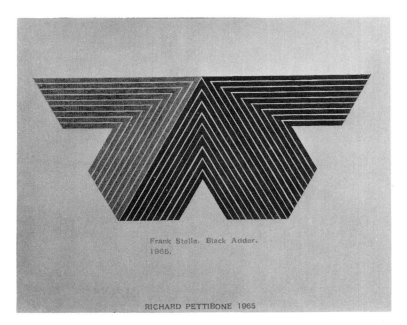

Richard Pettibone.
*Frank Stella. Black Adder.
1965,* 1965. Metallic
paint on canvas, 8⅛″ x 10⅛″.
Collection of the artist.

Frank Stella's work has been of special interest to artists; each series of his paintings challenged all previously held criteria, and the combination of complex planning and seemingly simple solutions was admired by his contemporaries.

Richard Pettibone chose various Stella paintings as the subjects for many of his paintings; this artist, along with Warhol and Lichtenstein, dominates his work. Pettibone chooses artists and works that he especially likes. He uses color reproductions and traces the exact size of the reproduction, following as carefully as possible the artist's colors, medium, and technique. For his copy of *Black Adder* (1965; Private collection) Pettibone has followed Stella's work method exactly: lightly penciled outlines of the stripes are filled in freehand with metallic green and gold paint for the outer chevrons, blue for the center chevron. Pettibone has also rubber-stamped the title of the Stella painting, in addition to his own name, on the surface of the painting, emphasizing its origin from a reproduction and making a significant antipersonal comment in keeping with the ideas behind his work.

The small Richard Estes gouache, a Photo Realist depiction of a bank facade, is typical of this artist's work; his paintings of complex reflections on a glass facade are both illuminating and confusing. The large Stella painting, *Saskatoon II* (1968; Private collection), which decorates the interior of the building, seems at times to merge with the reflection of the opposite building, so that it simultaneously adorns an exterior and an interior.

John Baldessari's *A 1968 Painting* is a deadpan presentation of Stella's *Takht-I-Sulayman 1* (1967; Private collection). The Stella painting has been photographically reproduced on canvas in black and white from a double-spread reproduction in *Life* magazine; the pushpins that held the reproduction to his studio wall are visible at the top. Baldessari described this work to the authors: "I had planned to do a whole series which would show the fashionable work of art for that year, like a new car—a 1968 Ford. Stella seemed modish for that year—where the public taste was." The ambiguous title can refer to either the Stella or the Baldessari painting.

Richard Estes.
Boston Five Cents Savings Bank, 1974. Gouache on paper, 16½″ x 17″.
Stephen Mazoh and Co., Inc., New York.

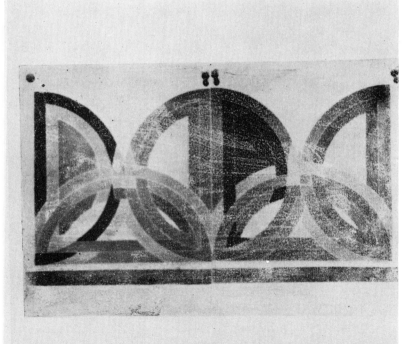

A 1968 PAINTING

John Baldessari.
A 1968 Painting, 1968.
Acrylic and oil on canvas, 59¼″ x 45½″.
Collection of the artist.

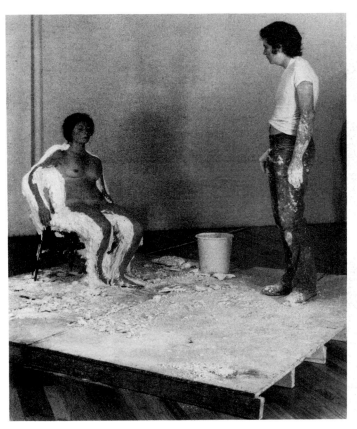

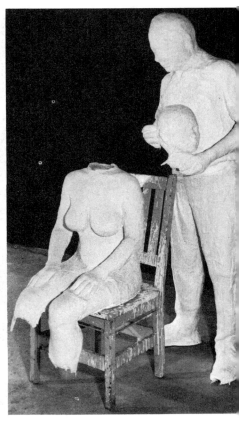

John de Andrea. *Clothed Artist and Model,* 1976. Mixed-media construction, plaster, vinyl, cloth, and wood, 77″ x 96″ x 96″. Collection of Mr. and Mrs. William Jaeger, Hewlett Harbor, New York.

George Segal. *Self-Portrait with Head and Body,* 1968. Plaster figures and chair, 66″ x 32″ x 42″. Collection of Carter Burden, New York.

This tableau is about John de Andrea's own Super Realist figurative sculpture: the sculptor appraises and checks his work before his model may emerge from the back half of the mold. De Andrea makes his lifelike reproductions of human bodies in polyester by a process of direct casting from the model, followed by spray-painting and the addition of glass eyes, plastic nails, hair, and cosmetics. In this piece the technical wizardry is emphasized by the model's uncannily real bikini tan. The title mentioning the "clothed artist" refers to the fact that De Andrea's figures are always nude.

Segal's portrait describes another factual scene: it shows the actual process of the sculptor's work. Segal's casting of himself is complete, and he is about to attach the head to the seated model, whose legs also remain unfinished.

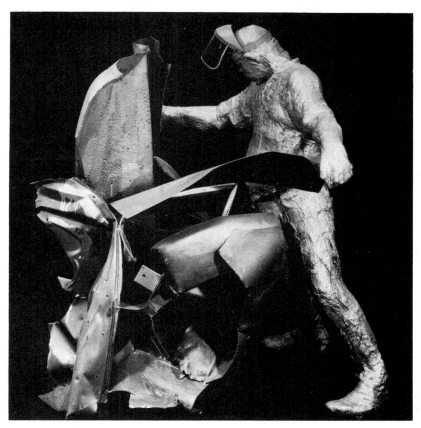

George Segal. *John Chamberlain
Working,* 1965–1967. Plaster, metal,
plastic, and aluminum paint,
69″ x 66″ x 56″. Collection of
Mr. and Mrs. William Rubin, New York.

A sculpture about another sculptor and his work is unique, although George Segal's portrait of collector Sidney Janis with Mondrian's painting is related in concept. The origin of this powerful portrait of John Chamberlain was quite accidental. Its beginning and completion are described by Jan van der Marck: "Segal asked Chamberlain to fix a sculpture of Chamberlain's which Segal had been storing for him. . . . As the repair work progressed, Chamberlain kiddingly proposed that Segal do a sculpture of him which they would own jointly. . . . Incorporating somebody else's work in one's own, as Segal discovered, is a tricky proposition. . . . The Chamberlain sculpture seemed a tangle of small parts—too much of a contrast with the solidity and whiteness of the plaster. . . . More than a year later, with Chamberlain's permission [Segal] chopped off part of the sculpture and gave it and the figure a coat of aluminum paint, in which some flat black had been mixed to lend a leaden look to what once was colored metal and white plaster. . . . Only by cutting it down to size and obliterating its colors could Segal force his identity upon Chamberlain's sculpture and make it, in combination with the cast, into a work of his own. Thus what had begun as a joint venture of two sculptors could succeed only as the product of one, Segal." (*George Segal,* 1976)

INDEX OF ARTISTS